SNAFFLES

The Life and Work of Charlie Johnson Payne
1884-1967

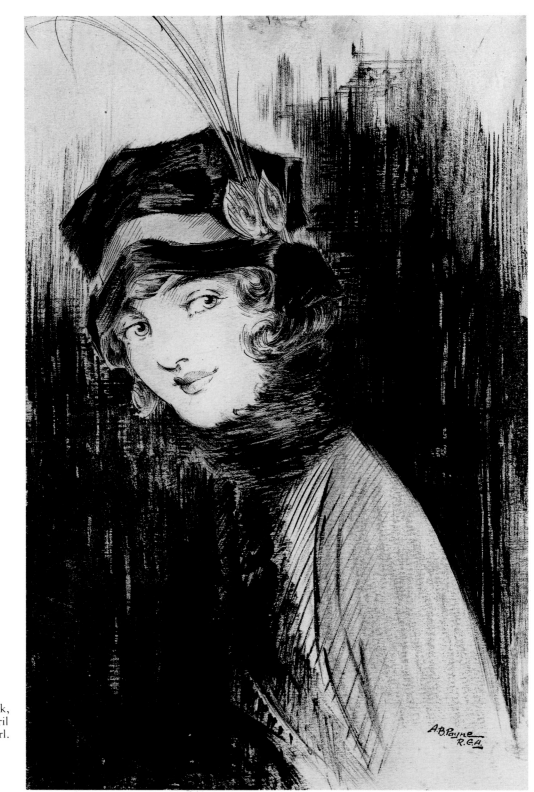

'Margaret'. Snaffles' earliest dateable work, a painting of his sister – January/April 1905 – his only known portrait of a girl.

SNAFFLES

The Life and Work of Charlie Johnson Payne
1884-1967

John Welcome and Rupert Collens
with a foreword by Vincent O' Brien

Stanley Paul
London·Melbourne·Auckland·Johannesburg

Stanley Paul & Co. Ltd
An imprint of Century Hutchinson Ltd
62–65 Chandos Place, London WC2N 4NW

Century Hutchinson Australia (Pty) Ltd
PO Box 496, 16–22 Church Street, Hawthorn, Melbourne
Victoria 3122

Century Hutchinson New Zealand Limited
PO Box 40–086, Glenfield, Auckland 10

Century Hutchinson South Africa (Pty) Ltd
PO Box 337, Bergvlei 2012, South Africa

First published 1987
© Illustrations Jack Brendon
© Text John Welcome
© This edition Antler Books Ltd
A limited edition of 275 signed and specially bound copies is published by
The Marlborough Bookshop and Sporting Gallery
6 Kingsbury Street, Marlborough, Wiltshire

Produced by John Stidolph
Editor – Nicki Harris
Assistant – Charlie Jacoby
Designed by Peter Hedges
Photography by David Warren

Typesetting by TJB Photosetting Ltd
Colour Origination and Printing by Motta, Milan, Italy

British Library Cataloguing in Publication Data
Welcome, John
 Snaffles.
 1. Payne, Charlie Johnson – Criticism
 and interpretation
 I. Title II. Collens, Rupert
 759.2 ND497.P36

ISBN 0–09–172667–0

Acknowledgments

First and foremost, we would like to express a great debt of gratitude to The British Sporting Art Trust for producing the excellent essay and listing of prints in the catalogue for their exhibition of Charlie Johnson Payne's work held in 1981, without which this book would have been virtually impossible to produce.

The authors and their research assistant, Annabel Buchan, wish to express their sincere thanks to all those who went to great trouble in answering their letters, returning telephone calls, providing them with information, lending them letters and Christmas cards from Snaffles, photographs or books with pictures of Snaffles in them, granting them interviews and arranging for transparencies to be made of their paintings or prints, and to the occupiers of Snaffles' two main residences after 1918 for allowing access for photographic purposes, and in particular to:
Lieutenant Colonel A.G.S. Alexander, Mrs B. Allen, Mrs Diane Alley, Sir Richard Body MP, Brigadier Lyndon Bolton DSO,DL, Mrs Bowes Daly, Captain W.W.F. Chatterton Dickson RN, Mrs H. Cleeve, Tim Corballis, Mrs. J. Gibson, Miss D. Gibson, Miss Daphne Hall-Dare, Lieutenant Colonel W. Harris, Mrs Jean Holt, Major N. Jackson RA, Mrs J. Jackson, Mrs Molly Keane, Harry S. Kenny, Miss Naomi Kerans, Victor Lakin, Lieutenant Colonel Patrick Langford, Mrs Winifred Langford, Jack Leonard, Major A.C. Lynch-Staunton, Mrs Suzie Monkland, Lieutenant Colonel W.L. Newell DSO, Mrs Norah Pearson, Mrs Patsy Scott-Cockburn, Mrs Susan Sloman, Colonel G.B. Thatcher DSO, Mrs. Marjorie Waller, Lieutenant Colonel W.G. Watt, the Curators of the National Army Museum, the Leicester Museum and the Chisolm Polo Gallery of Palm Beach USA.

I, John Welcome, have a special debt of gratitude to Lady Clive for her assistance over 'The Finest View in Europe' and her permission to reproduce Snaffles' letter to her; and to Peter Walwyn for the loan of his scrapbook and his permission to quote from Snaffles' letters to him. I also acknowledge with thanks permission from Major-General J.G. Elliott to reproduce the paragraph from the chapter on pigsticking by C.R. Templer included in *Field Sports in India 1800–1947*, published by Gentry Books 1973.

I, Rupert Collens, would particularly like to thank Mark Flower of the Court Gallery, undoubtedly the most knowledgeable person on Snaffles' life and work, for the many hours he spent giving me information and correcting lists and drafts, all of which he did with remarkable good humour. I would like also to thank Stephen Ling of Fores, the Sporting Gallery associated with Snaffles throughout most of his life.

Both the authors would like to express their gratitude to Annabel Buchan for all the research work which she has undertaken so diligently.

Paintings and prints

With a few exceptions, the colour transparencies of original works and prints have been kindly supplied by three specialist dealers in Snaffles' works: The Court Gallery, 8 Lancashire Court, New Bond Street, London W.1; Malcolm Innes Gallery, 172 Walton Street, London S.W.3; and the Marlborough Sporting Gallery and Bookshop, 6 Kingsbury Street, Marlborough, Wiltshire.

Contents

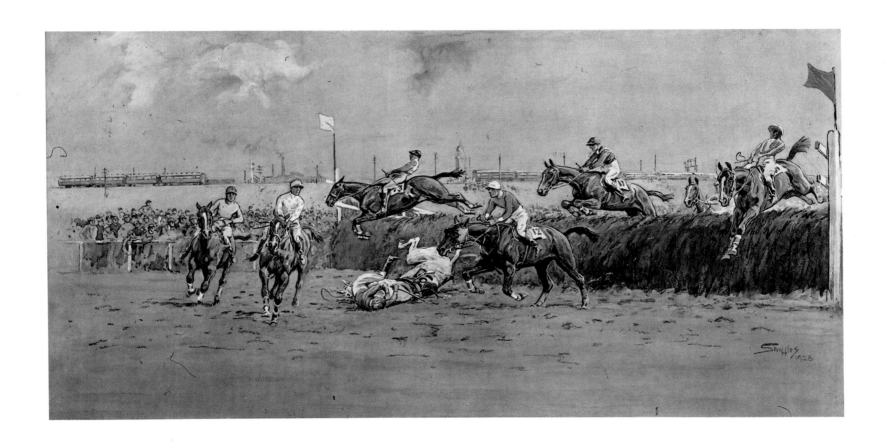

The Grand National
The Canal Turn

The Grand National was one of Snaffles' favourite annual outings: he
regularly went to it with three other great sporting artists, Cecil Aldin,
Lionel Edwards and Gilbert Holiday. This represents the race in 1926 when
it was won by Jack Horner.

Foreword

For many years I have been an admirer of Snaffles' work. His spirited pictures of the Grand National, Sandown and Cheltenham together with those of great horses such as Sergeant Murphy, Easter Hero and Prince Regent bring vividly to life all the thrill and excitement of steeplechasing at its best.

He had a wonderful sense of humour, and his sporting prints are full of the laughter and enjoyment he derived from all forms of field sports. 'The Finest View in Europe' together with its companion 'The Worst View in Europe' must be two of the most famous sporting pictures in the present century.

Snaffles lived his long life to the full, whether as soldier, sailor, sportsman or traveller. Everywhere he went he found the material for his pencil and brush, which provided a unique record of the sporting scene going back to the days when Queen Victoria was on her throne. He was still writing and painting when he died in 1967, aged eighty-three.

John Welcome, Rupert Collens and their researchers have done a very good job in recording his long life, and have set out with sympathy his early struggles, culminating in the great success his sporting prints enjoyed in the nineteen-twenties and thirties. These prints are most eagerly sought after by collectors everywhere today. This is a beautifully produced and authoritative book and I wish it every success.

Vincent O'Brien

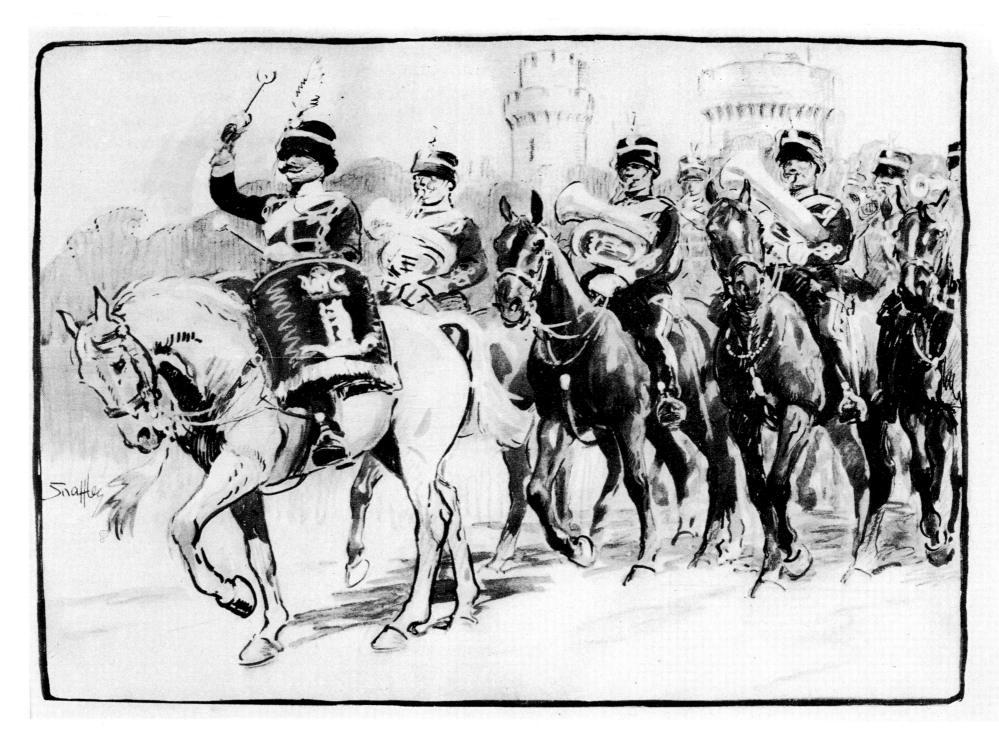

The Warwickshire Yeomanry, one of the earliest sights to fire the imagination of
the young Charlie Payne. 'There was peace in the land and the band played.'

The Early Years

'Snaffles' was born at 45 Bath Street, Leamington, Warwickshire, on 17th January, 1884, when as he said himself, 'Good Queen Victoria was on the throne, there was peace in the land and the band played.' He was christened Charlie Johnson (Payne) and not 'Charles' as people often mistakenly assume, but sometimes in later life he signed himself Charles. He was the fourth of a family of eight children; six girls and the younger of the two boys. His father's occupation is given on his birth certificate as 'bootmaker' and there appears to have been a family bootmaking and repairing business at Leamington, though the father had previously worked as a photographer's assistant and had always had artistic and musical leanings.

Throughout his long life, Snaffles was always extremely reticent about his origins and upbringing and was reluctant to speak of them. The information therefore has to be pieced together from research and from the few autobiographical hints he let fall in his writings, or in conversations with friends. What is certain is that from a very early age he was fascinated by soldiers and horses and all that went with them. He himself has recorded: 'I have no doubt it was the annual visit with my school-fellows to see the review of the Yeomanry on Warwick Common which set the flame alight in me to delineate horse soldiers and fox-hunters. For didn't the two go together in those days?' He has also told, how once, as a schoolboy, he was working at the kitchen table industriously copying a dashing picture of the Charge of the Light Brigade, when a voice spoke over his shoulder: 'No, no, my boy, I was there. It wasn't like that. We never went out of a trot!' It was his great uncle, a veteran of the Crimean War, who continued to fire his youthful enthusiasm for all things military with stories of the battles of the Alma, Inkerman and Bala-clava. He explained to him, too, that the reason why the Charge could not get into a gallop was a shortage of food for the horses, since he recalled feeding his own horse the meagre day's ration of oats from his forage cap.

Snaffles' schooldays appear to have been unsettled since, when Snaffles was in his early teens, his father abandoned the bootmaking business to become licensee of the Plough Inn at Banbury, while his elder brother, Norman, seven years his senior, had secured a clerkship with the Midland Bank and remained at Leamington. Nor were they entirely happy days; small, slight of stature and delicate-looking, Snaffles was an obvious target for late Victorian schoolboy toughening up and bullying. It is clear that he received both of these in full measure and remembered them. Many years later he was

to write to his godson, Peter Walwyn, son of his great friend Taffy Walwyn and then a schoolboy, 'I remember when I was at school I used to get it from the Head as well as from some of the other boys – I think it all did me good though I hated it at the time. However I soon put some muscle on and could look after myself.'

He was to say too – in one of his fragmentary reminiscences – of his schoolboy attempts at painting a battalion of Highlanders in full dress marching across the Long Valley at Aldershot: 'I must have achieved a certain amount of success, for my headmaster, from then on, promoted me to the sixth form for drawing. But, may I add, in all other subjects I remained in the lower fourth for the rest of my school days.'

This, he recalled, was in the late nineties of the last century and shortly afterwards, aged fifteen, at the outbreak of the Boer War, he tried to enlist. Though he added several years to his true age on his declaration form, the deception was easily seen through on account of his slight build and youthful appearance. 'Go back to the nursery!', the Attesting Officer told him.

But his fascination with the Army persisted. He became a schoolboy cadet with the 2nd Battalion of the Oxfordshire Light Infantry, presumably because he was then living with his father at Banbury, and in 1902, giving his age as eighteen years and three months and his civilian occupation as 'clerk', he did enlist – as a Gunner in the Royal Garrison Artillery. At first sight, joining that arm of the Artillery appears a strange decision.

At an early age Snaffles was drawing scenes of the Crimean War from his great uncle's vivid descriptions. Here a soldier feeds a meagre portion of oats to his horse from his forage cap.

India and the Indian Army were always fascinating for Snaffles, from his late teens onwards. When he first visited the subcontinent is the subject of some confusion.

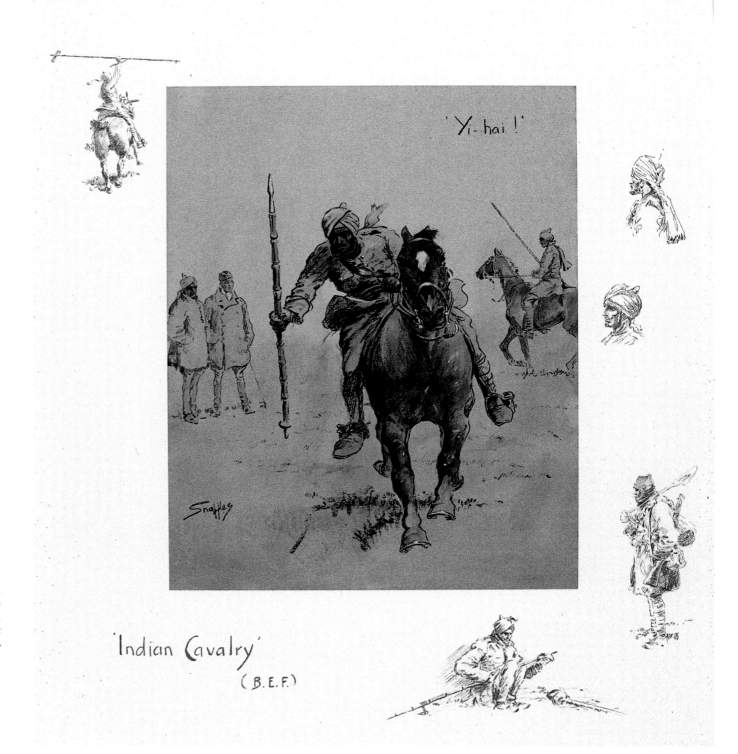

'Yi-hai!'

Snaffles

'Indian Cavalry'

(B.E.F.)

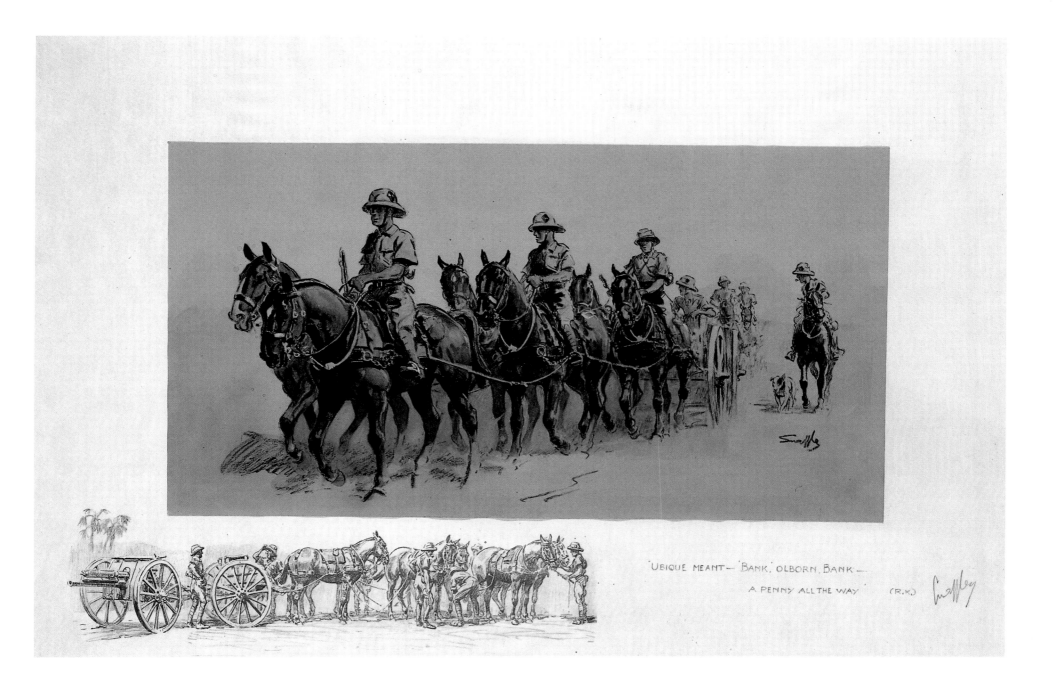

'UBIQUE MEANT — 'BANK, 'OLBORN, BANK —

A PENNY ALL THE WAY' (R.K.)

Snaffles was one of the most precise painters of this century. Every piece of
equipment and harness is accurate, every uniform correct.

'Off to the wars in good style.'

Snaffles tried to join the Army for the Boer War but, being of small stature, was clearly under age and was refused. It is possible that if he made a trip to India prior to the First World War his ship would have stopped in South Africa.

'But from all accounts Johnny de Wet soon had 'em lightening ship and pulling their leathers up a couple of holes.'

The Royal Regiment was then divided into three branches: The Royal Horse Artillery (the 'Horse Gunners' or R.H.A.) at the right of the line, the élite of the service who lived and fought with the Cavalry; the Royal Field Artillery, (R.F.A.), who served with the Infantry divisions; and the Royal Garrison Artillery, (R.G.A.), who were the static branch based mainly in coastal forts around the shores of the homeland and Empire. Moreover, the other ranks of the R.G.A. were recruited mostly from men of a physique strong enough to heave and carry the heavy shells that were the ammunition of the 6 inch and 9.2 inch coastal guns.

Snaffles' ambitions lay with horses. His was an ardent spirit that longed for the creak of leather, the jingle of harness and all the excitement which horses bring with them. He would not have cared for the life of a 'concrete gunner' shut up in a fort. He remained small and slight, for he had grown little since his abortive attempt to enlist three years earlier. His height is given on his attestation form as 5 foot 6½ inches and his weight 8 stone 5 pounds – hardly suitable statistics for one whose chief tasks would be to carry and load heavy shells. He must have been one of the most unlikely recruits, both in character and physique, ever to have been sworn into the Royal Garrison Artillery. Perhaps this was the reason his enlistment was a short service one only – three years with the Colours and nine with the Reserve. He himself never vouchsafed any explanation to friends or acquaintants for his choice of that particular branch of the Armed Forces, but in later life he did at times recall his serving in Fort Widgely at Portsmouth.

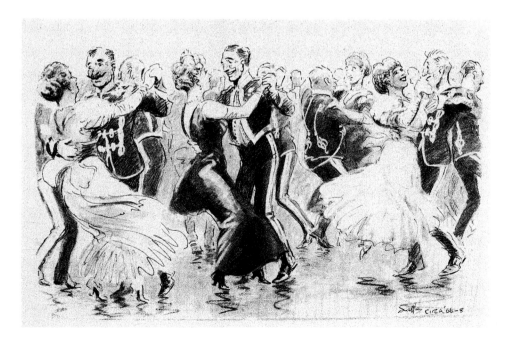

Everybody went a great gallop until the morn's early hours!
Thus Snaffles described the annual Warwickshire Yeomanry Ball.

Fort Widgely was one of the old Napoleonic forts guarding Portsmouth Harbour and was, at the time of which Snaffles spoke, the headquarters of the heavy regiment responsible for manning all the forts guarding Portsmouth and the Solent. Thus it seems that Snaffles was employed in some sort of administrative capacity for which his civilian occupation of 'clerk' would have fitted him. The fact that he was soon sent on a telephonic course, and it is so marked on his Army record of service, lends strength to this supposition. There was at Fort Widgely a rudimentary riding school and there he learned to ride. It was rough and ready in the extreme and Snaffles later had some fairly harsh things to say about the Army's methods of teaching equitation. Nevertheless, during those years he acquired an affection for the Royal Artillery in all its branches, Horse, Field and Garrison, which he never lost. 'Once a Gunner, always a Gunner,' was never more truly said of anyone than of Snaffles. He also acquired, as was the fashion in those days, tattoos on his hands and wrists, of which he was to be shy later and adept in concealing.

During those years, he commenced a lifelong love affair with Kipling's verse. *Barrack Room Ballads* had been published some years earlier and soon he had the whole of them by heart. He was blessed with an extraordinarily retentive and photographic memory and he later recalled how he would, in the evenings in barracks, recite at length from Kipling to an admiring audience of fellow Gunners. Always a voracious reader of subjects which interested him, when *The Reminiscences of an Irish R.M.* and its successors appeared at the turn of the century, he was entranced by them too and soon could quote from them verbatim and at will. Kipling, Somerville and Ross were to remain standbys all his life and, at times freely adapted, were to provide him with captions to some of his most famous prints. Later he was to add Surtees, Kingsley and Whyte-Melville together with the hunting poets Egerton-Warburton and Bromley Davenport to the list of his favourite writers whose works he stored in his memory.

We know that from an early age, Snaffles spent much time sketching and painting. Alas, nothing datable is currently available prior to 1905; the earliest datable work which survives is a portrait of his sister, Margaret Payne, later Margaret Priest, which is reproduced as a frontispiece to this book and is signed 'A.B. [Acting Bombardier] Payne R.G.A.' This must have been completed in the months of January to May, as he was placed on the Reserve on 7th May 1905, having completed his three years with the Colours.

Snaffles always said that he had no formal art training. However, undoubtedly the art teachers at his schools must have been highly competent and Snaffles blessed with natural artistic ability. The portrait of his sister is an able work for any artist aged twenty or twenty-one, let alone one who had spent the last three years of his life in the Gunners and had no training after school. Snaffles taught himself mainly by copying the work of the leading sporting artists of that time, who were G.D. Giles, Finch Mason and John Sturgess, with varying degrees of success. All were basically nineteenth century artists, and their method of delineating horses and their riders was very stylised. This shows clearly in Snaffles' early work.

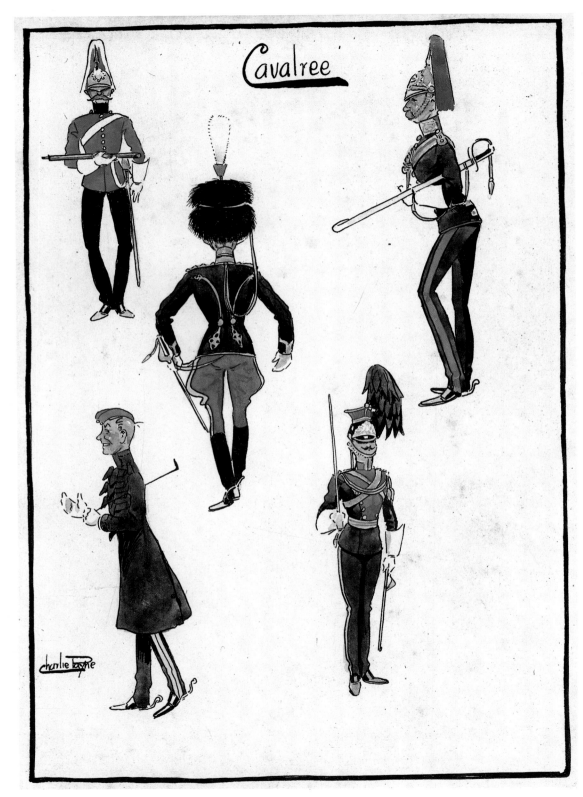

This watercolour was executed in late 1905 or early 1906 and is signed 'Charlie Payne' although at this time he used to sign similar works 'Charlie Johnson Payne'.

"Whatever ye de keep t'owd tamboreen a rowlin."

One of a set of five small prints published by Fores in 1908. Many of them were individually dedicated to the purchaser.

The Missing and Struggling Years

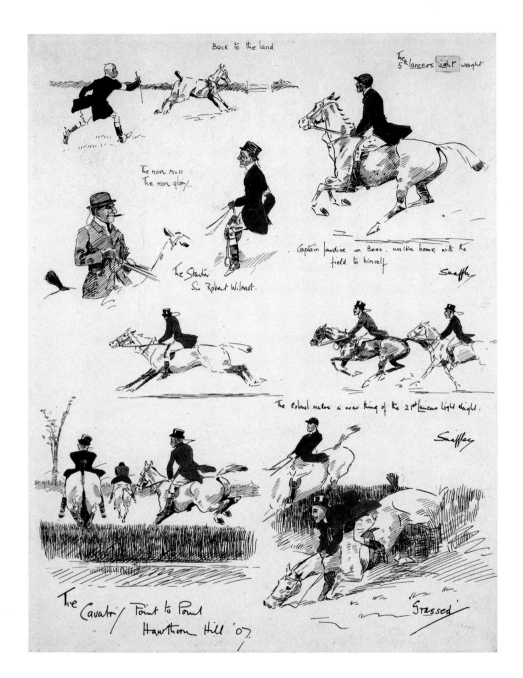

The Cavalry Point to Point – Hawthorn Hill 1907.

Snaffles never divulged any information about how he lived or survived for the first few years after going onto the Reserve in May 1905, so this period may well be termed 'the missing and struggling years'. One thing we do know about that time is that he continued to draw and paint and by the end of this period was making a living from his pencil and brush.

It was a desperate struggle for he had nothing but his natural talent, his belief in himself and his own buoyant spirit to keep him going. Most of his subjects were of the Army, for this then was the only life he knew. He would have done his annual service with the Reserve which would have given him an opportunity of studying the various uniforms and insignia. There are in existence, surviving from this time, or possibly from earlier when he was still serving in the R.G.A., paintings signed in a schoolboy hand 'Charlie Johnson Payne' of officers in their parade uniforms which had not yet been entirely superseded by the ubiquitous khaki. The drawings are immature but already display the characteristics which were to infuse all his work – dash, colour, humour and scrupulous accuracy of detail.

During those formative years he appears, to some extent, to have distanced himself from his family. He never spoke of his parents, and his relations with his elder brother were never close. He did, however, remain on friendly terms with two of his younger sisters, both of whom were artistic, and who helped with the hand-colouring of some of his early prints.

There is some evidence that on leaving the Army he went to India, or the western part of it which is now Pakistan, perhaps as a civilian groom or clerk. He was, of course, at this stage enchanted with the world of his favourite author, Kipling, and the chance to see Africa and/or India in however humble a capacity might well have accounted for him leaving the Army at the earliest opportunity. The lure of the faraway was always to hold a fascination for him but it must remain pure speculation whether it was in the 1905–1906 period, or in the years 1911 or 1912 that he managed to embark on his first major foreign journey.

The struggle for existence remained a tough one and he was very hard up. One of the first times we can accurately date his whereabouts was during the spring of 1907 when he was sketching the Cavalry point-to-point at Hawthorn Hill. He was so short of money, he did not even have enough for a night's lodgings. Captain J.B. Jardine, of the 5th Lancers, hearing of this,

16

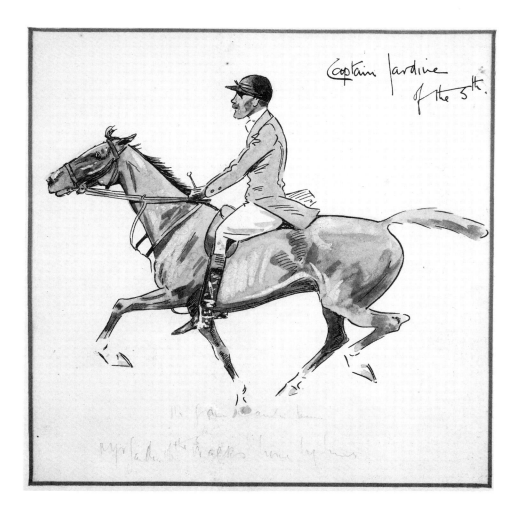

Captain Jardine
of the 5th.

This pair of watercolours was given to Captain Jardine who allowed Snaffles to sleep in his stables when the latter was a penniless, unknown artist.

took pity on him and when Snaffles asked for permission to doss down in his stables with the horses he readily granted it. So grateful was the artist that he presented Captain Jardine with the originals of his sketches together with a pen-and-ink drawing of his benefactor riding his good mare, Bess.

Snaffles never forgot a kindness or a good turn and all his life remembered those who had helped him during his years in the wilderness. Two or three years later, when he had begun to make his way and an early print entitled 'A Point-to-Point' appeared, he sent one to Major Jardine, as he had then become, inscribed 'With the artist's compliments. 1910'. It was a typically generous gesture; indeed, throughout his career Snaffles was too lavish with presentations of his prints and pictures for his own financial good.

Soon after that point-to-point, whether through an introduction from Captain Jardine or some of his fellow officers who had seen his sketches, or from some other source which will never be known, the first small break-through came. On 5th June 1907 *The Bystander* published a page of carica-tures entitled 'Some attitudes at the Royal Military Tournament' by Snaffles. This appears to be the first clear use of the pseudonym though why he adopted it or how he came upon it he never revealed. Amongst the Surtees characters there was a well-known horse dealer called 'Snaffles' and he may have taken the name from him.

These sketches apparently proved popular enough for *The Bystander* to ask for more, since on 19th June another page appeared entitled 'Polo at Aldershot – Impressions of the First Cavalry Brigade'. This was followed, on 17th July, by 'Polo at Hurlingham – some impressions at the Inter-regimental Final', and in August by 'The Otter Hunting Season' which showed a day's sport with Mr Courtenay Tracy and his well-known pack on the Wey. On 2nd October there was another, rather grander page portraying the principals at the Army manoeuvres near Aylesbury, where he was near enough to obtain likenesses of men such as General Sir John French (in command) and the Duke of Connaught. At this stage of his career his portraiture was very much stronger than his drawings of horses, although the latter were displaying the thrust of action and play of light and shade on coat and muscle which he was to develop over the next six years and which in maturity distinguished his work.

Payment from *The Bystander* for monthly contributions did not go very far towards providing a living wage. Moreover, as he freely confessed, finance was never his strong point and any money he made slipped through his fin-gers like water. He spent whatever he had, though that was precious little, and the uphill struggle continued. Early in 1908, another breakthrough came when he called on Fores Gallery in Piccadilly to offer some of his drawings. During the conversation he confessed he did not even have enough money in his pocket to pay his fare back to Aldershot, the home of the British Army where he had based himself. His asking price for each of the five drawings was half a guinea. Fores offered fifteen shillings to include the return fare and this was promptly accepted. It is possible that these five drawings became the five modest prints Fores published for Snaffles that year. (See Appendix A numbers 1–5).

Impressions of the Army.

The Shropshires

ChalieP

"Mear."

Snaffles

These watercolours and similar works were probably Snaffles' main source
of income during the years 1905–1910. This pair dates from around 1908/09
and if compared to the watercolour on page 14 one immediately notices what
a quick learner Snaffles was.

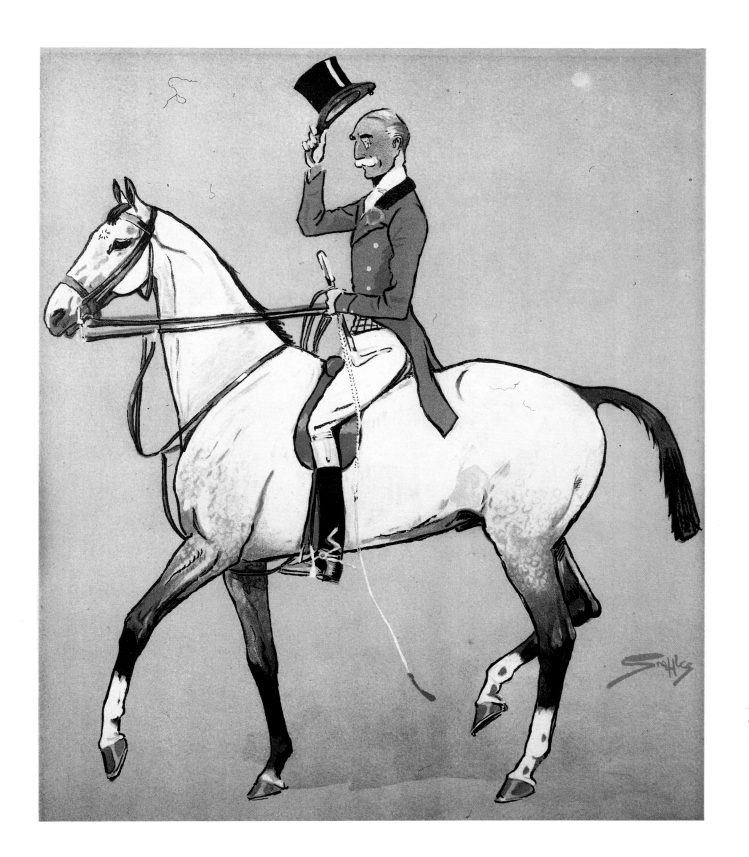

Blood and Quality

This print was one of a set of 'Four Hunting Types' published in 1910. The gentleman depicted is Lord Ranksborough. The popularity of this set was to be a minor turning point in Snaffles' career as a sporting artist.

'Surrey 'unting. A jolly day with jelly dogs.'

Snaffles started hunting in Surrey and Hampshire soon after leaving the Army.

The year 1910 was a turning point in his career as an artist and for the next thirty years Snaffles never looked back until his career was so rudely interrupted by the Second World War. Early in 1910 the leading publishing house of Lawrence & Jellicoe were to produce a set of four medium-sized prints of hunting types – 'Blood and Quality', 'The Gent with 'osses to Sell', 'Old Tawney' and 'Hogany Tops'. (Numbers 8–11 in Appendix A.) These were an immediate success and Snaffles and his two sisters were hard-pressed in colouring them to meet the demand. They were to lead to his long association with the famous weekly magazine *The Illustrated Sporting and Dramatic News*. Late in 1910 the magazine republished these prints as 'Hunting Types' endorsing them 'By permission of Lawrence & Jellicoe'. If one compares these with his work of only three or four years earlier one can see how quick a learner Snaffles was. At this time he had not yet developed his own style and it was not until after the First World War, at the comparatively old age, for an artist, of thirty-five that he was to develop his own distinctive style. The lack of formal training was, of course, a tremendous disadvantage when comparing his work to his near contemporaries such as Aldin and Edwards. These four 'Hunting Types' were obviously greatly influenced by Lionel Edwards' 'Hunting Types'. The similarity is also apparent in his next major prints which were again published by Fores. 'Thrusters' and 'Roadsters' clearly show Cecil Aldin's influence, with whom he was by now already friendly.

Slowly, helped by his connections with Lawrence & Jellicoe, Fores and *The Illustrated Sporting and Dramatic News*, things began to improve. His passionate interest in all forms of hunting had not abated and he was a keen follower, not only of foxhounds and harriers, but of beagles and otterhounds.

Snaffles had begun to ride to hounds, mostly on borrowed mounts, with provincial packs around Aldershot such as the Knaphill and Ripley Harriers, the Garth, the Chiddingfold and the H.H. Foxhounds, 'Where, if and when', as he records, 'we did get a gallop over half a dozen fields we were usually brought up by wire or some obstruction which had to be circumnavigated by some other way than by jumping'. Soon, too, he had acquired a hunter himself. This was the mare, Connie, for whom he formed an affection which remained firmly in his memory. Writing of her over forty years later he said: 'I acquired her for a fifteen pound cheque (post-dated) and a picture. She made a noise, had string-halt on both hind legs and she was almost as slow as a man. But what she lost on the flat she gained on the obstructions and we could cut off corners and always keep hounds in sight. I loved her dearly – far beyond the price of gold.' With his ear for a telling phrase which was as acute as his eye for a sketch he could not help adding that a season or two later, on his way to a meet at Barleythorpe, Lord Lonsdale's hunting box, he heard his Lordship's coachman remark to his companion: 'There goes that sportin' old mare, don't she wind 'er 'ocks!'

Snaffles was to draw Connie often during the rest of his life and she was to appear not only in his prints, but in his books and it is safe to assume the drawing opposite, ''Andsome is What 'Andsome Does' in his book *'Osses and Obstacles*, is Snaffles on Connie over the timber, although Snaffles was seldom to wear a top hat.

He mentions, in recounting the purchase of Connie, that he had used one of his pictures for barter and it is an indication that he was now, at last, beginning to find a market for his work. His hunting, too, was taking him further afield, giving him experience of different packs and the characters of their followers.

By 1911 his career had got into its stride. During that year he had nine full pages and one half page of sketches in *The Illustrated Sporting and Dramatic News*, many of these being later published as prints. Several are of the caricature type, representative of his very early work, with impressions scattered all over the page, but the more interesting and powerful contain a central scene depicting an incident during a day's hunting, racing, or polo. These scenes, carefully drawn, are usually surrounded by vignettes caricaturing the people who made up the day's sport. Snaffles worked endlessly at these before they were ready to be reproduced as prints, mainly hand-coloured in watercolour by himself and his sisters, and thus there are often several variants. 'A Point-to-Point', first published in 1909, is a perfect example of a print which was continually changed over the years. We have illustrated the very scarcely found 1909 edition which shows the horses in the centre scene going from right to left, rather than left to right as in all the other editions.

Sometimes the prints were published by Fores and sometimes by Snaffles himself. In fact the prints Snaffles produced himself were often made in very limited editions, perhaps with a print-run of only twelve or fifteen and are, in many cases, very rare. Where very few were produced they could nearly be termed 'watercolour on printed base' as Snaffles took incredible pains to colour up these smaller print runs himself and, even to the experienced eye, it is often hard to tell if there is a printed base below the excellent colouring. To add to the cataloguer's problems, Snaffles was a continual improver and fiddler and thus there are often several variants of the same print. We know from printers who worked with him that he liked to be in the machine-room, fiddling and changing the plate on a regular basis.

The original of one such illustration, published on 11th March 1911 in *The Illustrated Sporting and Dramatic News*, 'The Soldiers, Sandown', is of especial interest in showing Snaffles' methods. The centrepiece is of Major Dermot McCalmont winning the Grand Military Gold Cup on Vinegar Hill and is in the possession of Colonel Bill Harris of Nanyuki, Kenya. Snaffles later referred to his painting of horses at this time as his 'rocking horse' period and he was evidently dissatisfied with one of the vignettes as published in the magazine (which does indeed resemble a rocking horse), for he replaced it in the original, and another portion of the margin had a piece of paper imposed upon it evidently awaiting a further vignette which was never completed. This painting is also of interest since it bears the first sketch of Taffy Walwyn of the Horse Gunners who was later to become such a close friend and the most influential of his patrons. All these illustrations already bear the stamp of the man himself. They are infused with the humour of one who is prepared to laugh with, but not at, others; they are cheerful and carefree, and exemplify his philosophy that somewhere there is to be found the fun behind the fall.

TOSS'D ABOUT THE WORLD LIKE AN OLD AT.

LEPPIN POWDER.,

THE LAST FENCE
TUCKED UP

Snaffles

SLAP AT IT FOR THE HONOUR OF HITEM-AN-HOLDEMSHIRE.

A
POINT-TO-POINT.

THE MORE MUD, THE MORE GLORY

BACK TO THE LAND.

THE WRECKERS.

Copyright.

'A Point-to-Point', based on the above original print was to be reproduced
in many variant versions by Snaffles over approximately twenty years from
1909 to the late twenties. The above edition is the very scarce 1909 edition
and the only one where the horses in the centrepiece are running right to
left rather than left to right.

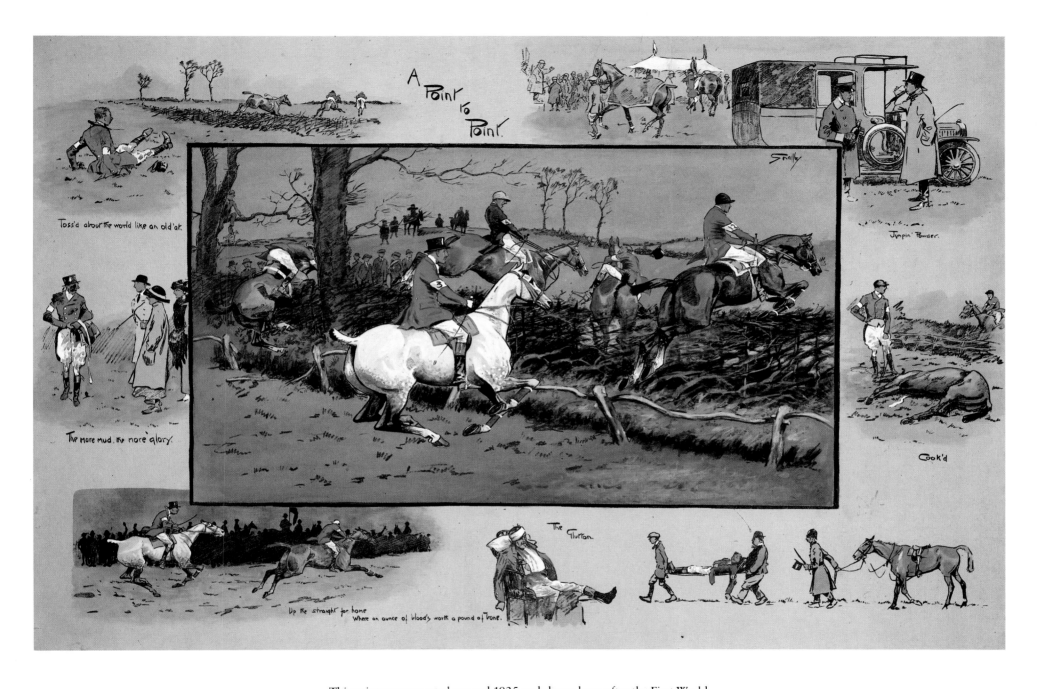

A Point to Point

Toss'd about the world like an old 'at.

The more mud, the more glory.

Snaffly

Jumpin' Powder.

Cook'd

The Glutton.

Up the straight for home
Where an ounce of blood's worth a pound of bone.

This print was executed around 1925 and shows how, after the First World War, Snaffles' work had become very much more sophisticated compared to his pre-war work. This hand-coloured print compares favourably with the work of Snaffles' contemporaries when it comes to producing popular work simply to give pleasure to hunting and racing folk.

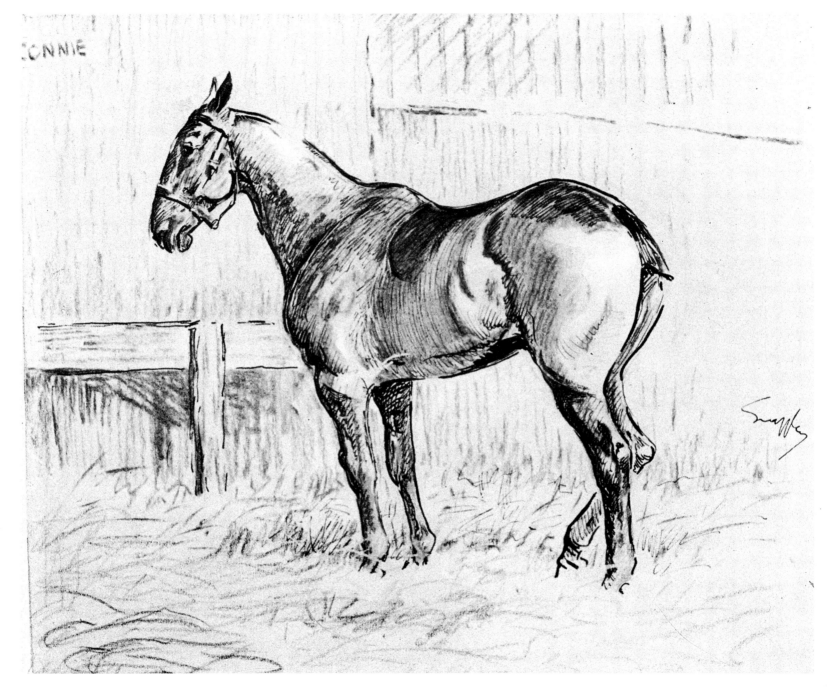

'Andsome is —

Connie was Snaffles' first horse and, although slow, she was a great performer.

Wot 'andsome does

This self portrait is of Snaffles hunting Connie in Leicestershire just before
the First World War. After the war it is doubtful if he wore a top hat for
reasons which can be found on pages 28 and 29.

The Tiger.

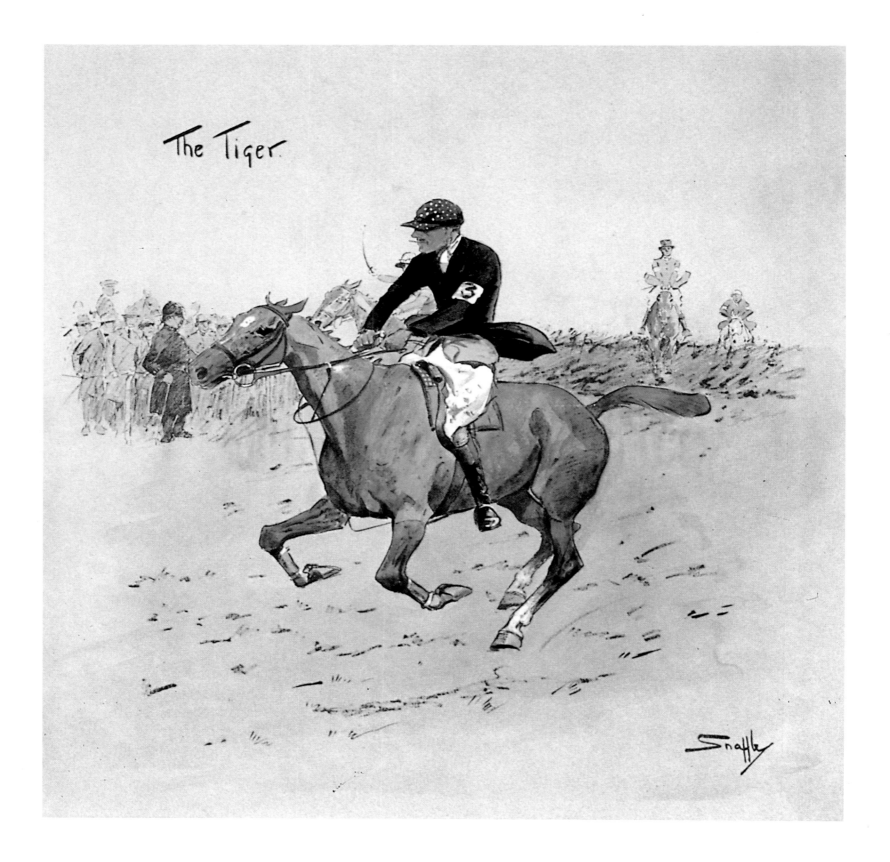

Snaffle

26

Making His Mark
In High Leicestershire

By September 1911, Snaffles, as he told a friend much later, was making enough from his drawings and paintings to buy himself out of the Reserve and terminate his Army career. This he did on payment of £25, his Army record of service read: 'Discharged at his own request'. The date, 9th September, almost coincides with the publication in *The Illustrated Sporting and Dramatic News* of the first of his purely military illustrations 'Mounted Infantry', which bears, too, the first of his many quotations from Kipling with whose verse he was to take considerable liberties down the years: 'You couldn't spot us at 'alf a mile, from the crackest cavalree'. It also contains a vignette showing troopers parting company with their mounts in all sorts of uncomfortable positions entitled 'Six days to learn equitation – and four months of bloomin' well trot!' This feeling remark must surely have recalled his own experiences at Fort Widgely.

It is interesting to compare his fortunes at this period with those of his near contemporaries, Cecil Aldin and Lionel Edwards. Both of them were older men, Aldin having been born in 1870 and Edwards in 1878. Both had easier upbringings and formal art training after leaving school. Aldin had studied under Albert Moore and Frank Calderon, who founded the school of animal painting and held summer seminars which Edwards also attended after studying under A.S. Cope. Both were members of the London Sketch Club and mixed freely with leading artists of the day, such as Phil May, John Hassall and William Nicholson. Snaffles had none of these advantages and had to teach himself by observation, trial and error. Of the three, Aldin, though he had struggled in the early part of his career, was by then the most successful, and had made a name for himself as a poster artist, an illustrator and a portrayer of the hunting scene after the manner of G.D. Giles or John Sturgess. His work was nothing like as stylised as Snaffles'. Edwards was still something of a caricaturist, much as Snaffles was, and he had not yet quite found his métier as a superb portrayer of the sporting landscape with men, horses and hounds crossing it.

All three were hunting men: Edwards with the South Oxfordshire; Aldin and Snaffles with the Garth and neighbouring packs. It was with the Garth that Snaffles first made the acquaintance of Aldin and there formed a friendship which lasted to the end of Aldin's life in 1935. Snaffles was much influenced by Aldin in his early works and was sustained by his help and encouragement. At this period of his artistic career Snaffles was the equivalent of a sporting journalist and humourist in the tradition of Leech and Finch Mason, though he was a far better draughtsman than Mason. In fact Snaffles' work up to the mid-twenties was in many ways similar and equal to John Leech's. They both had equally sharp eyes, a keen wit and the extremely rare ability to catch and portray horse and man in action, even if this action was at times cartoonish and rather crude. Of course Snaffles would have been very familiar with John Leech's work as Leech illustrated so many of Surtees' books. One particularly notices Leech's influence on Snaffles and G.D. Armour when they used Surtees' characters as inspiration, as Snaffles did right up to the 1950s.

Snaffles could, perhaps best be compared to another near contemporary who was working in a different sphere – H.M. Bateman. Both shared a sharpness of line together with the ability to caricature and raise a wry chuckle or even, at times, a loud laugh. Bateman, however, who was some three years younger than Snaffles and had begun to sell his work at the early age of sixteen when still at art school, was at this time well-established in the magazine market where Snaffles was trying to make his way. Perhaps the greatest common link between Bateman and Snaffles was the very 'Britishness' of their work. They were as British as Surtees or Dickens, Stubbs or Alken.

Aldin was by now prosperous and was shortly to take over the joint mastership of the South Berks Foxhounds – a step up indeed in the career of a sporting artist. But meanwhile Snaffles, too, was moving upwards financially and socially. He was now mixing with the officer class and being accepted by them. This social advancement must have led to some teasing by his sisters,

This photo shows Snaffles in uniform, as a corporal at a Leicestershire Yeomanry Camp, prior to the First World War.

Pride cometh –

Self portraits of Snaffles in 1912 at the opening meet of the Cottesmore on
his thoroughbred ex-hurdler, The Colonel, which he nicknamed 'Flash Harry'.

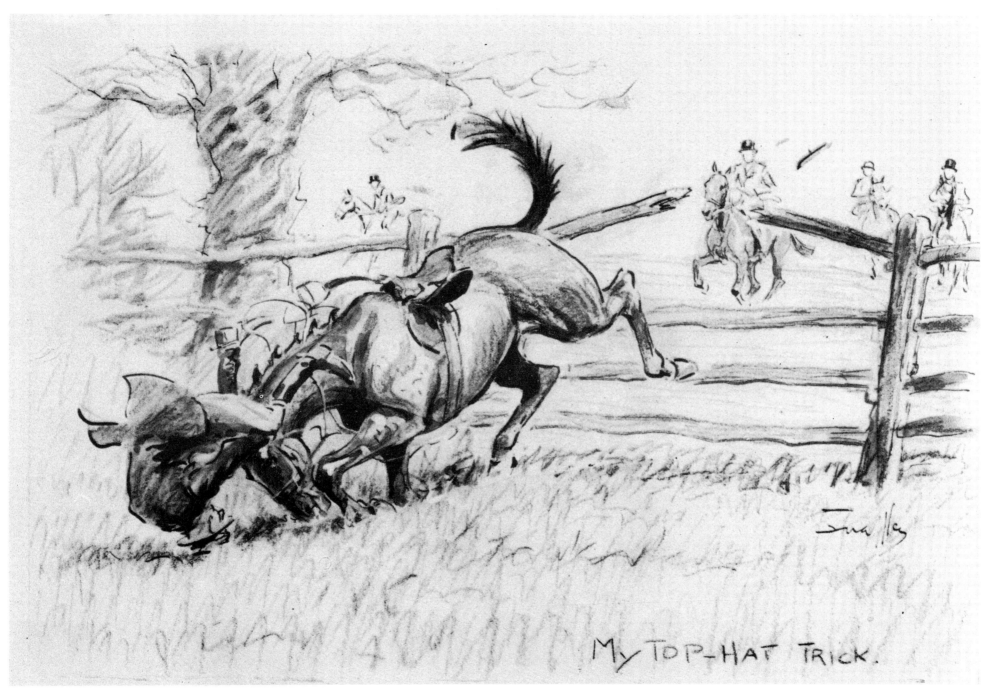

My TOP-HAT TRICK.

– before a fall.

Major Junks

John Jorrocks Esq. M.F.H.
"Tell me a man's a foxhunter and I loves 'im at once"

Surtees, along with Somerville and Ross and Kipling, was to be a constant
inspiration to Snaffles who regularly quoted and misquoted them when
captioning prints; he painted John Jorrocks more regularly than any other
real or mythical character.

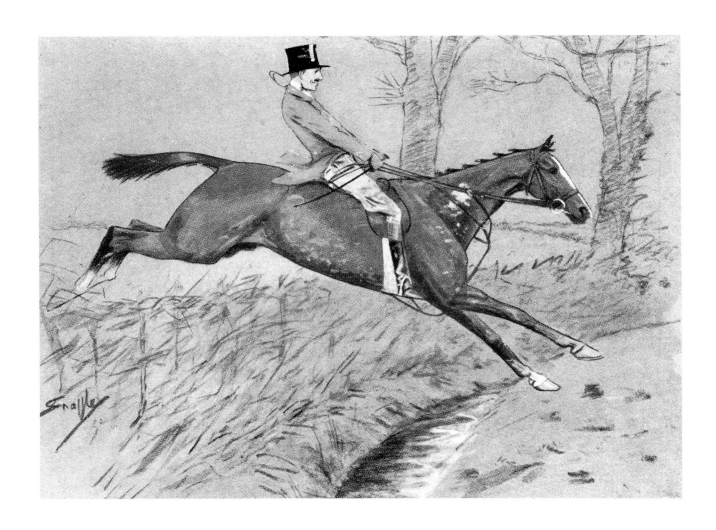

This Christmas card, executed by Snaffles in 1912,
typifies his 'High Leicestershire' style.

and this in turn resulted in the self-portrait entitled 'Twee-Twee' in imitation of his alleged upper-crust accent. It exemplifies one of Snaffles' more endearing traits: the way he could always laugh at himself, so that in his autobiographical sketches or stories he never makes himself out to be a hero. He was never, in fact, a polished horseman or a tremendous thruster to hounds but, as someone who knew him well in Ireland later said of him, 'He saw a hunt as well as the next man, and he was prepared to get up on anything that he was offered.' Most importantly for his work and intentions as an artist, everything he saw that went on in a hunt he stored in that amazingly retentive memory of his. On the whole, his attitude to riding to hounds was the sensible one, well summed up in the quotation from Surtees, 'Happy are they who hunt to please themselves and not to astonish others', which Snaffles first used in a full-page illustration of hard riders jumping timber while others assemble at a gate. This appeared in *The Illustrated Sporting and Dramatic News* of 12th January 1912. Later he employed it, slightly altered, as a caption to one of his most successful post-war prints, Snaffles used the same caption time after time with different images and this is confusing for writer and reader alike. Over a fifty year period his three main areas of work were illustrations for magazines, production of prints from original watercolours, and illustrations for his own six books and a similar number for other authors. Where possible in this book, attempts have been made to differentiate in the text which type of work is referred to.

By 1912 he was selling more and more of his work and prints and by then he had moved to Oakham in Rutland and based himself there. It was at Oakham that he met Aldin once more, for Aldin was hunting with the Cottesmore, staying at Barleythorpe and, as his biographer notes, 'often in the company of Captain Frank Forester, Master of the Quorn, Lord Annally, The Earl of Westmoreland, Lord Chaplin and Lord Molyneux'. Snaffles was moving in much less exalted circles but, as usual, was making friends and having fun. He was fortunate in that he had met and become friendly with 'Doc' Gibson, a leading veterinary surgeon of the area. The Gibsons were well-to-do and kept open house in the manner of those spacious pre-war days. As Snaffles' cottage was close to the substantial family home of the Gibsons, he was a frequent visitor and soon became a great favourite with the whole family, especially with Mrs Gibson who took a motherly interest in him, and John Gibson, one of the sons, proved to be a special friend. They went to the Leicestershire Yeomanry camps together while 'Doc' Gibson was so impressed by his keenness and interest in everything and by his sketches, that when he had a spare horse he would lend it to Snaffles for a day with hounds.

Snaffles, as it happened, had brought his own horses with him. One was his beloved Connie, but he had also acquired another. This was The Colonel, a striking thoroughbred chestnut bought cheaply out of a racing stable because he made a noise. By reason of his appearance, he was christened Flash Harry by his new owner.

Full of pride in his smart purchase, Snaffles bought a top hat to match his horse's looks and sallied forth to the opening meet of the Cottesmore determined to show them all the way. With this in view as soon as hounds found

and started to run he set sail for some stiff post and rails. Alas for his hopes and expectations! Flash Harry remembered his hurdling days and took off several strides too soon. He hit the top rail and smashed it, sending Snaffles head-first into his new top hat. He illustrated this incident in '*Osses and Obstacles*. 'From that day onwards,' he wrote when recalling the incident, 'I have always been content to go a-hunting in a ratcatching bowler which more becomes a fox-hunter in the station of life to which I have been called'. And, he added at a later date, the pockets of a rat-catcher coat were better suited to carrying the sketchbook which always accompanied him out hunting, though he seldom used it, certainly never when people were watching him.

On one unforgettable day, 'a friend', almost certainly 'Doc' Gibson, mounted him on a true Leicestershire blood mare 'for a hunt on the Melton side of the Cottesmore country... when young Tom Isaacs carried the horn and galloped everyone to a standstill'. 'It was then,' he recorded nostalgically nearly forty years later, 'a glimpse of Paradise – anyway it was the sort of place I would have Paradise to be in those days. Miles of glorious pasture, intersected by timber and stake and bound fences stretching away to the far horizon with never a thought of wire, wheat or slippery tarred roads, and every yard of it rideable.'

From that day came a full page in *The Illustrated Sporting and Dramatic News*, the centrepiece of which is entitled 'Forrard On (the Branston side)', 30th March 1912, with the Cottesmore field in full cry, and vignettes of the characters of the past and present hunt surrounding it.

Thereafter is a gap of several months before his next publication. Perhaps he went abroad to Belgium and France, or perhaps it was in this period he made a suspected pre-First World War trip to India (see Chapter 2), or he may have been in hospital. During one of his summer visits to the Leicestershire Yeomanry corps camp he had a bad fall. Details of the year and the injury he suffered are not known, although in later years he referred to it from time to time. It is believed that a horse rolled on him and that this fall was sufficient to take him off the active list and end his Yeomanry days. It has been suggested that it was an inguinal hernia since he does not appear to have been completely incapacitated, or at least not for long. However, we do know that he was at the 1914 Leicestershire Yeomanry Camp as he tells us in one of his books that he saw there the Grand National Winner, Sunloch, ridden by his owner/breeder W.J. Smith. But whether Snaffles was present as a member of the Yeomanry or as a guest is unknown.

Whatever it was that happened to Snaffles in these months to end his Yeomanry days, on the 21st September 1912, there appeared in *The Illustrated Sporting and Dramatic News*, the very first of his Indian pictures entitled 'Sport in the Shiny', its centrepiece being 'The Sport of Rajahs', a polo scene. Around this were vignettes of other Indian occasions including one of a sport he was to make, as an artist, peculiarly his own – pigsticking. Another of these vignettes, 'A Bobbery Pack' was elaborated into a whole page and published in *Fores' Notes and Sketches*. *The Illustrated Sporting and Dramatic News* were sufficiently impressed by the authenticity of these to employ him the following month to illustrate a story of an Indian race meeting, 'A

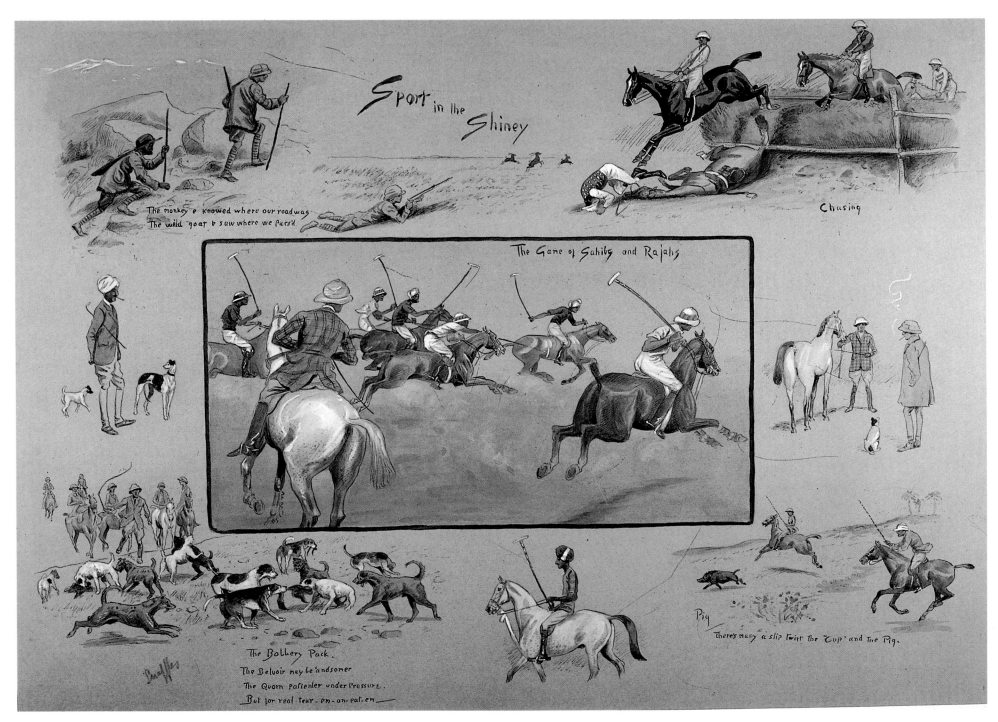

It is debatable if this print was executed before Snaffles visited the Indian subcontinent. The authors feel that, in fact, he managed to go there prior to the First World War, contrary to the generally accepted theory that he did not visit India before the 1920s.

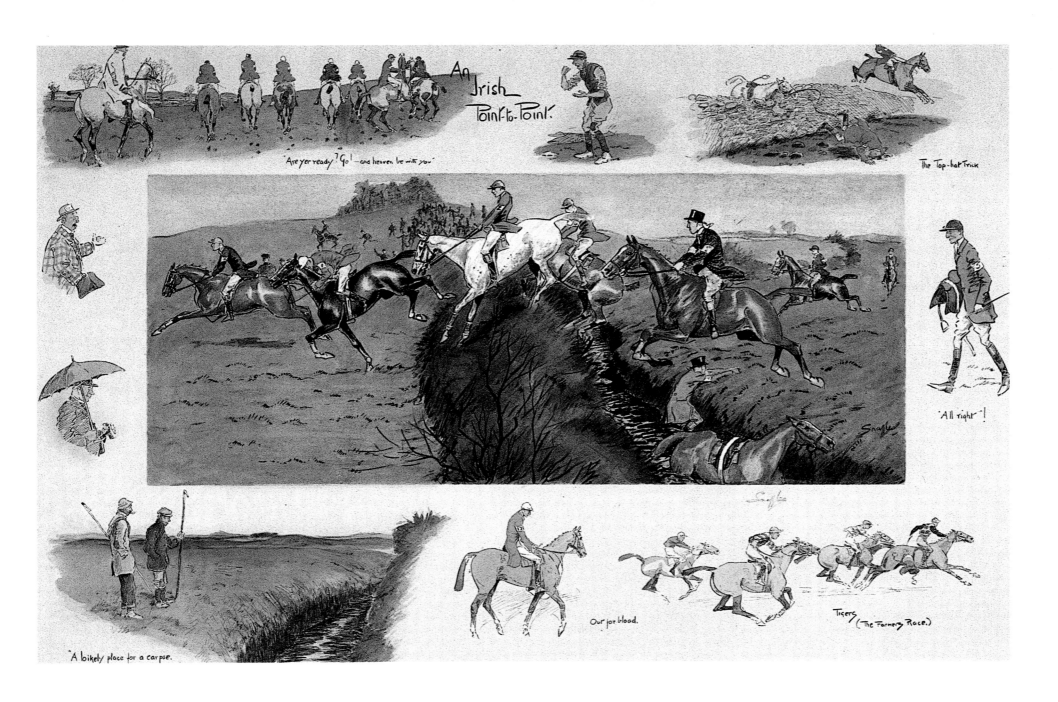

An Irish Point-to-Point.

'Are yer ready? Go!' — and heaven be with you.

The Top-hat Trick

'All right'!

'A loikely place for a carpse.'

Out for blood.

Tigers (The Farmers' Race.)

Once again there is a theory that he did not visit Ireland before executing this print. However in this instance the authors have absolutely no doubt that he was there prior to the First World War where he saw the Meath Hounds hunting and visited the races at Punchestown.

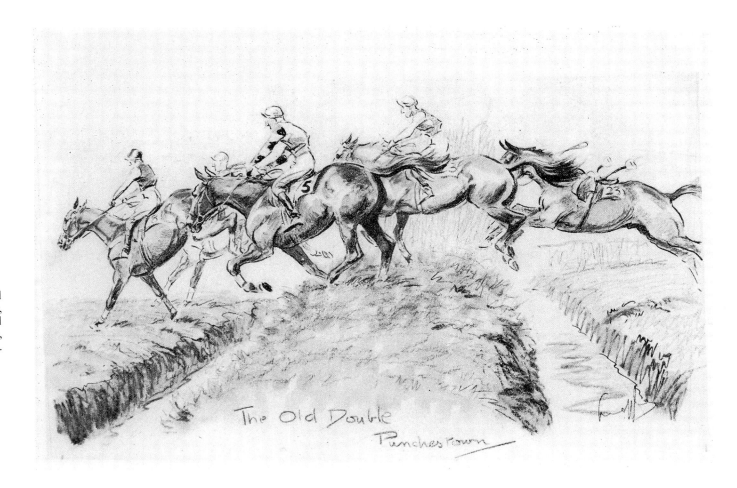

Snaffles first visited Ireland and its great racecourse, Punchestown, the Emerald Isle's answer to Aintree, in 1913.

The Old Double
Punchestown

Forced Hand' by a Major Symonds. Shortly afterwards he was commissioned to paint 'An Officer of 124th Baluchistan Infantry' for which Major H.V.C. Lynch-Staunton, then Adjutant, was the model. Major Lynch-Staunton was later given the option of purchasing the original for £10, so it would appear that Snaffles' prices were increasing with his status as an artist.

The following spring saw his first visit to Ireland where he recorded his impressions of an Irish point-to-point in his accustomed manner of a centre-piece with vignettes, sketching the big double as Punchestown and the Meath Hounds jumping a bank. It would seem that Snaffles was following the hunt on foot when he made these impressions, for the historian of the Meath Hounds can find no record of his ever having hunted with them. With the exception of 'The Big Double' these two sketches became the basis of prints which were published by Fores. There are, incidentally, two versions of 'An Irish Point-to-Point' and these are the rarest of Snaffles' major prints, and the most valuable.

Snaffles' relationship with Fores was fairly informal. Sometimes they acted solely as sales agents; at other times as publishers too. No differentiation has

been made between the two in this book.

By the time the next hunting season was over he had completed a long series of 'Hunting Types' for *The Illustrated Sporting and Dramatic News*. All of these show the influence of Aldin and many of them, notably 'Cutting it Out for 'Em, he was to elaborate into formal prints later on. This particular one shows a lady, side-saddle, jumping timber in front of a fashionable field, for which Mrs. Florence Mather-Jackson, who was well known for doing just that, was the model. He was still in the Shires and signed off that April with a full page, 'The Past Season with the Cottesmore'. It was to be the past season indeed and the last season of all for many of those whom he depicted.

War was coming; the world he had been born into, lived in and which he unrepentantly looked back to with rose-coloured spectacles all his life, was about to die taking with it the cream of those he had seen crossing the flying countries. Amongst them Tom Isaacs, who had given him that memorable hunt across High Leicestershire; nor was his closest friend, John Gibson, to return. Soon he, too, was to be caught up in the storm.

In spite of side-saddle,
habit, and other impedimenta,
Grandma shoved along
with the best of them.

The Hustler
"Gurralong!!" There are three
couple of hounds on the scent

Meltonian Types – Pre 1914

From the autumn of 1911 to the spring of 1914 Snaffles sent many illustrations
recording the hunting life of the shires to periodicals such as *The Illustrated
Sporting and Dramatic News.*

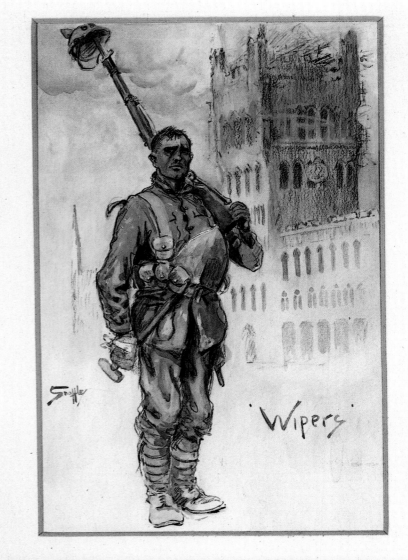

'Wipers' had an instant appeal to the public when it was issued in 1915. Of all Snaffles' First World War prints it was produced in the largest numbers and is still much sought. This is a watercolour on which the print was based.

The Great War

In many respects, as a freelance sporting artist, Snaffles was fortunate in the times into which he was born. The instant camera had not yet superseded the artist in portraying action and catching the moment of suspense whether hunting, racing, or in battle. There were, too, a number of magazines – *The Tatler, The Illustrated Sporting and Dramatic News, The Bystander* and *The Graphic* to name but a few – all of which gave space to the freelancer and all of which were eager for work which would depict with appeal and authority the doings of the sporting set.

Gilbert Holiday, another artist who was to become identified with the Royal Artillery, already had a contract to contribute a weekly page to *The Graphic* and on the outbreak of war, whether through his influence or not, Snaffles was eagerly snapped up by that paper to join the team headed by Holiday as 'one of our artists in France'. Lionel Edwards, Cecil Aldin and G.D. Armour, together with the sporting poet, W.H. Ogilvie, all older men, ran or worked at Remount Depots.

It may be wondered why, with his adventurous, questing and patriotic spirit, Snaffles did not join one of the fighting services. In fact, like Holiday, he was over-age as thirty was at that time the age limit for enlistment and the rule was strictly applied. There was never any question of his physical courage and soon he was in the thick of it.

The first of his sketches appeared in *The Graphic* on 7th November 1914. This was a despatch rider 'Uhlan Dodging' and was signed 'Snaffles' although it is franked underneath as 'Drawn by Charles Payne'. The majority of his sketches were signed 'C.J.P.', although one or two of them were signed 'Charlie J. Payne'. In fact during his year with *The Graphic* neither he nor his sub-editors appear to have decided exactly how to credit him. They alternated between 'Drawn by Charles J. Payne', 'Drawn by Charlie J. Payne, known as Snaffles' or 'Sketches by C.J. Payne, one of our artists in France'. The drawings he did for *The Illustrated Sporting and Dramatic News* at this time, however, were all signed 'Snaffles'.

'Wipers', his picture of a wounded soldier in front of the Cloth Hall at Ypres with a German pickelhaube on his bayonet, which was held to embody the defiant spirit of the Old Contemptibles, became the first of his successful war-time prints and increased his reputation.

The Snaffles of May 1915 was very much changed as an individual and as an artist from the C. Payne who had left the Royal Garrison Artillery in May 1905 as an Acting Bombardier. Suddenly in the first six months of the war, Snaffles' work was to mature and his technique to advance quite remarkably. In fact one could say, to use a contemporary expression, there was a quantum leap forward in the quality of his work.

Clearly, for Snaffles, working under the pressure of copy deadlines was exactly what his technique needed. Like so many self-taught artists, Snaffles had previously been unable or loath to compose, paint and finish a painting quickly and methodically. He liked to change and transpose. Whether this was a manifestation of his basic artistic insecurity or the direct result of not having had any artistic tuition after leaving school, is not for us to judge. Perhaps one of the most important skills any art school can teach a young person with genuine artistic talent, which undoubtedly Snaffles had in abundance, is the ability to design, execute and then leave the paintings alone. It was the shortage of time in late 1914 and early 1915 which taught Snaffles this.

Certainly in 1915 he was everywhere, drawing indefatigably with the French, the Scots, the Canadians, the Anzacs and the Indians, but he never forgot the Gunners. The Artillery provided some of the most memorable of his war-time sketches which were duly turned into equally famous prints. Perhaps the most emotive of all these was his large print 'The Guns! Thank God! The Guns!' showing a Field Artillery battery galloping into action past exhausted and wounded troops. This appeared first not in *The Graphic* but in *The Illustrated Sporting and Dramatic News* for whom he was still doing freelance work and amidst it all he did not overlook his own branch, the less glamorous 'heavies' as many were wont to do. 'Do you say you sweat with the field guns, by God, you must lather with us!' was how he entitled, truly enough, his picture of a gun team hauling a sixty-pounder through the mud. The fact that the quotation from Kipling related not to the R.G.A. but to the Mountain Artillery, 'The Screw Guns', would have carried little weight with Snaffles. He always had a cavalier attitude to accuracy of quotation or ascription, especially where his idol, Kipling, whom he freely adapted, was concerned, and Kipling, who loved men of action and enthusiasm, apparently never objected.

In the 'Artillery' pictures Snaffles' photographic eye served him well, for every detail of harness is accurate down to the last buckle, as indeed are all the uniforms and equipment in his war-time and 'Gunner' pictures ever afterwards. Many have studied them, casting over them a discerning and critical eye in an effort to find an error or a fault, but his work has withstood the test of time.

He was now producing sketches thick and fast for both *The Graphic* and *The Illustrated Sporting and Dramatic News*. These sketches show a new confidence and a stronger and bolder use of line. He was mainly using pencil or pen and ink for his sketches which gave them a new strength and vigour, and any fussiness which had been particularly noticeable in his work in the two years prior to the war had vanished. Clearly he had to rework these

REMOUNTS

"May you find in those far lands,
"Kindly hearts and horse-men's hands."

(Will Ogilvy)

rough sketches considerably before they were suitable for publication as prints. However, his sales of prints from 1915 onwards grew annually.

In 1915 he also made his first attempt at writing. An article on German prisoners of war was published in *The Tatler* and he found time to visit the Condé Museum at Chantilly to view the Meissonier picture 'Devant le Charge' which, in his opinion, was 'by far the greatest masterpiece any equine artist has painted'.

Snaffles' view of the war was the romantic one prevailing at the time, which did not begin to die until the mud, failure and futility of the Somme battles of 1916 killed it forever. He depicted the world of the professional soldier doing the job for which he had been trained and doing it well; making light of hardship and regarding the whole thing as something in the nature of a hunt with, as Mr Jorrocks might have said, more than seventy-five per cent of the danger. In fact, one of his first sketches from the front bore the heading: 'The Light Heart of the British Soldier'. He saw and stressed this side of the battle because its full grimness had not yet struck home, and because that was his way. Since he was a romantic at heart, he glamorised war for consumption by the public – as indeed was expected of him. It was only much later in the war that his world of romantic heroism disappeared to be replaced by the cynicism and bitterness of such authors as Siegfried Sassoon in print and, in paint, Orpen who, as his biographer tells, portrayed his soldiers 'shell-shocked, blinded by glare, exhausted by warfare, ravaged by lice, shamed by defeat...', but, by the time of Sassoon and Orpen, Snaffles had long left France.

As 1915 drew on, the original team of artists at *The Graphic* was beginning to split up. Gilbert Holiday, with whom Snaffles had formed another of his sporting and artistic friendships and who had narrowly escaped being shot as a spy when sketching behind the French lines, had returned home to persuade the authorities to commission him into the Field Artillery, and Snaffles followed him. He, too, was longing for more active employment and besides, he was in love.

On 8th November 1915, at Exmouth in the county of Devon, Charlie Johnson Payne was married to Lucy Georgina Lewin. Snaffles ever afterwards maintained that marrying Lucy was the best thing he ever did and he was right. Lucy Lewin's father, then living in retirement at Exmouth, had been a sailor, a sea-captain who had owned his own trading ship in which Lucy had been born off the coast of New South Wales twenty-seven years before. Snaffles had met her when on leave from France, had been charmed by her and they had fallen in love.

At first sight the marriage may well have seemed to Snaffles' friends a strange one and the pair ill-assorted since Lucy shared none of her husband's interests, sporting or otherwise. She was petite, charming and attractive to all, but underneath a gentle exterior was a will of iron. She took Snaffles over, managed and mothered him, controlled his fecklessness and, more importantly, his finances, encouraged him in his work and stabilised his life. The marriage, a happy union of opposites, lasted until the end of his long life, Lucy surviving him to an even greater age.

Early in 1917, apparently still rejected by the Army as unfit for Army Service but determined to get back into the war, Snaffles enlisted in the Royal Naval Air Service as a mechanic. His reasons for doing so are obscure and he never enlarged upon them, but it would seem that he thirsted for more active employment and no other branch of the three services was open to him. In many ways, Snaffles, throughout his life, retained his natural schoolboy enthusiasm in everything and, odd as it may seem for someone who in many ways was openly a nineteenth-century character, more akin to Jorrocks and James Pigg than the internal combustion engine, Snaffles was however, intrigued by engines and it was perhaps his skill in tinkering with fairly primitive petrol and diesel ones that tipped the balance and persuaded the Royal Naval Air Service to accept him. He was posted to the Isle of Grain and took part in rescuing crashed seaplanes from the Thames Estuary and Channel. This did not prevent him from drawing and painting, and his earliest pictures of warships, flying boats and seaplanes stem from this period. They particularly demonstrate how quickly he had matured in the first two years of the war, and also reveal a surprising artistic ability, showing how easily he was able now to cover the whole of his canvas with sea and sky, where previously the main characters, rather than the background, had been of prime importance.

His work was also in demand elsewhere. The picture 'Hit!', showing a wounded soldier in the wire, was originally commissioned in 1916 to form the cover of a souvenir programme for the charity performance at His Majesty's Theatre of Sir W.S. Gilbert's *Pygmalion and Galatea* arranged in aid of The Princess Club Hospital for Wounded Soldiers.

The more famous war print 'The Gunner. Good Hunting! old Sportsman', depicting an Artillery officer in a British Warm standing beside his eighteen-pounder smoking his pipe and looking up at a Royal Flying Corps fighter crossing the lines, also dates from that year. Drawn from memory, while he was with the Royal Naval Air Service, it, too, was made into a print which now hangs on the walls of many a Gunner mess and in the home of many an ex-Gunner. Along with the print 'Wipers', copies were produced in very considerable numbers. 'The Gunner' is probably the most popular of all his war prints (and the names of those who claim to be the original of that officer are legion). Lionel Edwards, for one, considered 'That Far, Far Away Echo' with its use of the 'dream sequence' as the officer in the mud of the trenches thinks back to his days with hounds, to be his finest work to come out of that war.

These pictures and others attracted the attention of his seniors and he was not to be left in obscurity for long. He had just attained the distinction of being advanced to 'Leading M.M.', which is the equivalent of an Army corporal, when he was summoned to the Admiralty. To use his own words, 'I immediately gathered up my kit-bag, put my hammock over my shoulder and reported'. Not knowing what was wanted of him, he was shown into a room occupied by three bemedalled and brass-ringed officers. The subsequent interview was short and, as he remembered it, consisted of three sentences. 'You paint, don't you?', the senior and most beringed of the three barked at him. Standing stiffly to attention Snaffles replied that he did – a bit. 'Very

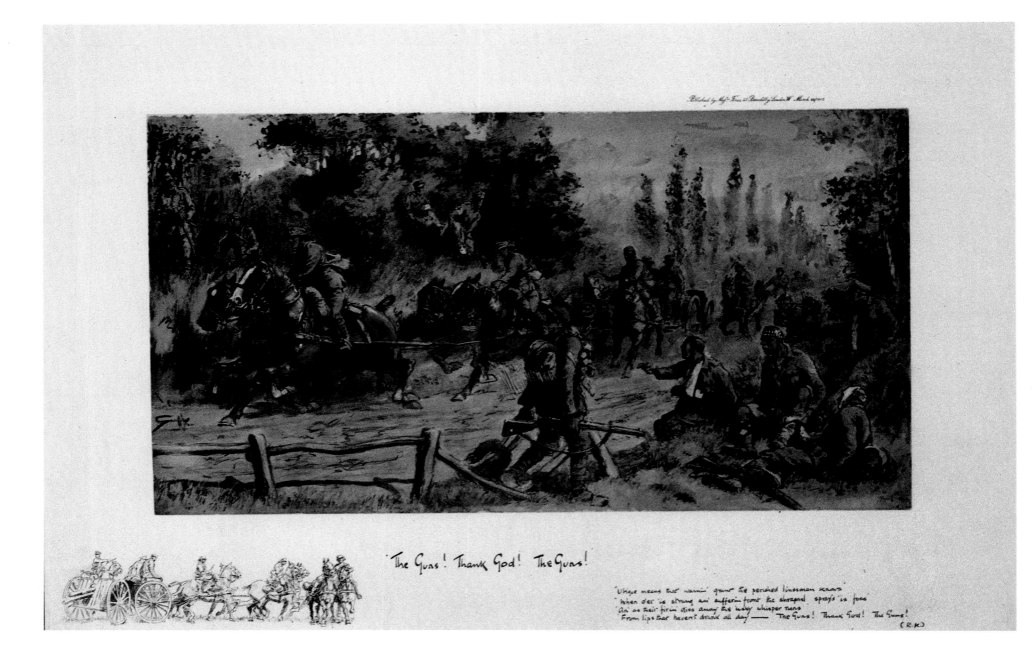

'The Guns! Thank God! The Guns!'

This print very much demonstrates Snaffles' view of war which was the
romantic one prevailing in 1914/15. He has glamorised what in reality would
have been a grim scene, particularly by clever use of the caption and the
spirited dash of the gun team.

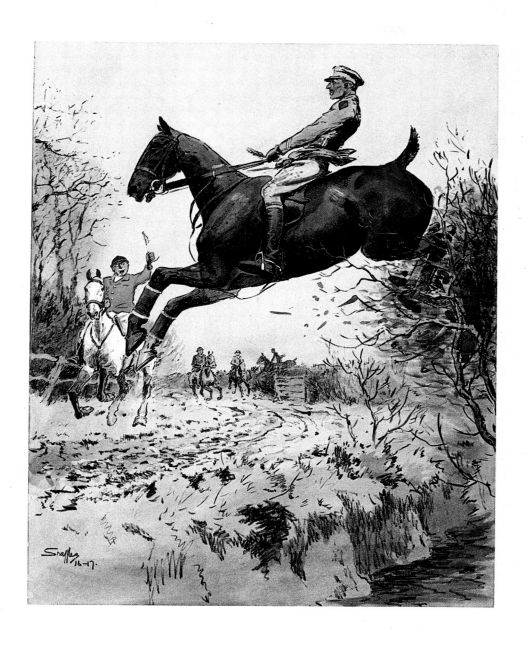

"Blighty" — 'and only five-and-twenty per cent. of the danger.'

Although this print will be recognised instantly by many readers as Snaffles' work, it is in fact very scarce if not rare. Once again Snaffles is stressing the light heart of the British soldier in time of war.

well', was the response, 'You're a Lieutenant now. Go along to Gieves and fit yourself out with an officer's uniform.'

On 8th September 1917 he was gazetted Temporary Lieutenant R.N.V.R. and posted to H.M.S. *President* which was the Department of Naval Equipment. Once there, he was sent to serve under Norman Wilkinson, one of the all-time great fishing artists, and then an official war artist. He was designing 'dazzle' which was an early experimental method of camouflaging ships by painting them in stripes, or other designs, in an attempt to confuse the aim of the U-boat captains who were then decimating Britain's merchant fleet.

Norman Wilkinson was a pioneer of camouflage in general and of dazzle in particular. Snaffles wrote of him: 'By great good fortune there happened to be, serving in the Auxiliary Patrol, a lieutenant who was not only a sailor, but a professional artist. With his combined knowledge of seamanship and the subtleties and distorted values of mass colour in juxtaposition, he took the line of baffling the submarine captain in manoeuvring his craft to bring his sights on to the target's vitals.' It was Norman Wilkinson who initiated Snaffles into the technicalities of the work.

First they had to get him out to sea to gain experience of the conditions in which dazzle was required. He was despatched in a destroyer on the Northern Patrol. He also did time in armed trawlers and minesweepers and came to know the discomforts and hardship, as well as the excitement and companionship which come to those who serve in small ships. He compared patrolling in a destroyer to 'riding a super horse over a super country of great jade green fences. The analogy is an apt one – provided the wind is under her tail', and he drew one of his stirring sea sketches to illustrate this. That he knew only too well the other side of the coin, he showed in a drawing of a seasick passenger aboard H.M.S. *Antelope*, franked by yet another of his adapted quotations, this time taken from Somerville and Ross, 'Those who go down to the sea in destroyers, just see hell.'* He saw some action too, when one of the armed trawlers he was in opened fire on a suspected periscope though no hit was claimed.

Back at base, the work fascinated him and he became so interested in the theory and practice of camouflage in general, that he studied it as applied to wild animals and birds. Later on when he visited India, he used the knowledge he had gained to provide background for some of his most effective animal paintings.

He endured seasickness, cramped quarters, the biting Arctic cold and some danger from the weather, mines and submarines, but he loved every minute of it. The Navy became one of his great enthusiasms almost equalling those others which dominated his life – the Gunners, fox-hunting and racing, and – later – pigsticking. Many years afterwards he was to encourage the young William Chatterton Dickson to enter Dartmouth, saying the Navy was the only life for a man, and he presented him with an original painting of a destroyer buffeting its way through heavy seas as a tangible token of that

The Lodger

'Them as go down to the sea in destroyers just see Hell.'

encouragement and of his own happy and romantic memories.

In the period 1918–1922, Snaffles produced a number of naval prints, very atypical of all his other work except for the remarques which often have a hunting background. These are little known except by the most avid of Snaffles' collectors.

*What Somerville and Ross actually said was: 'Those that go down to the sea in ships see the works of the Lord, but those that go down to the sea in cutters see hell.'

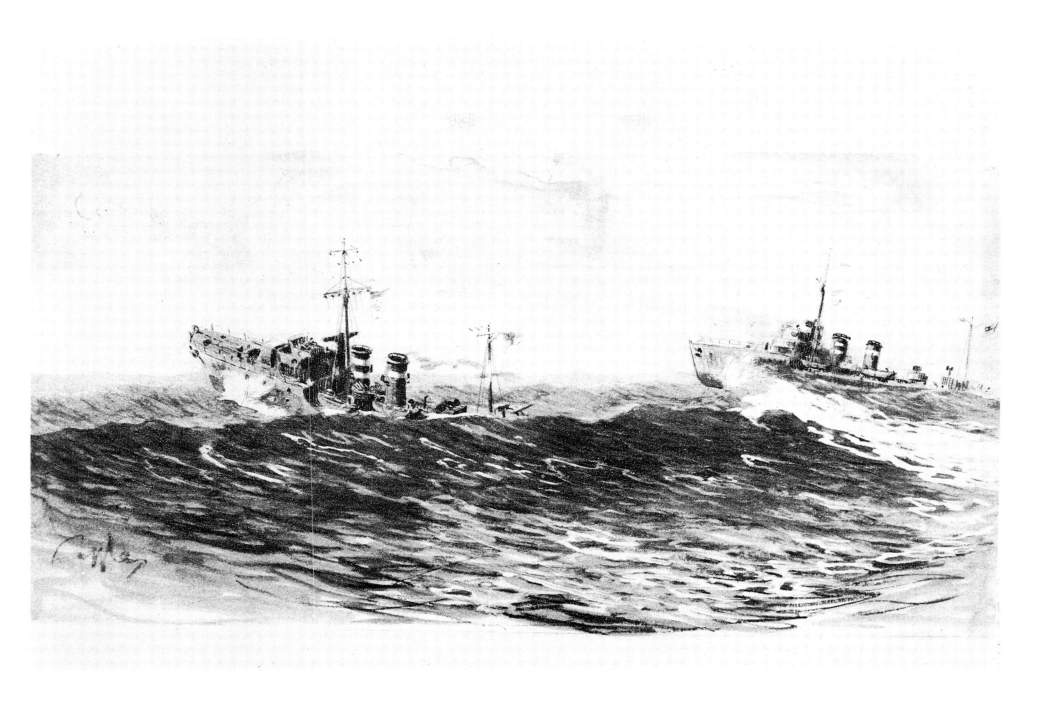

Destroyers

JOCK (K.I)

THE CANADIAN

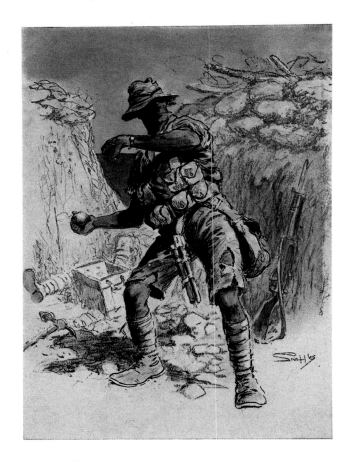

'ANZAC'

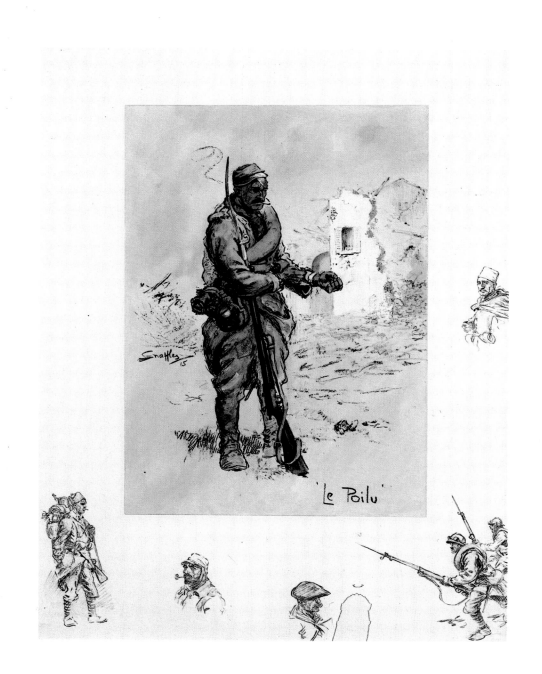

'Le Poilu'

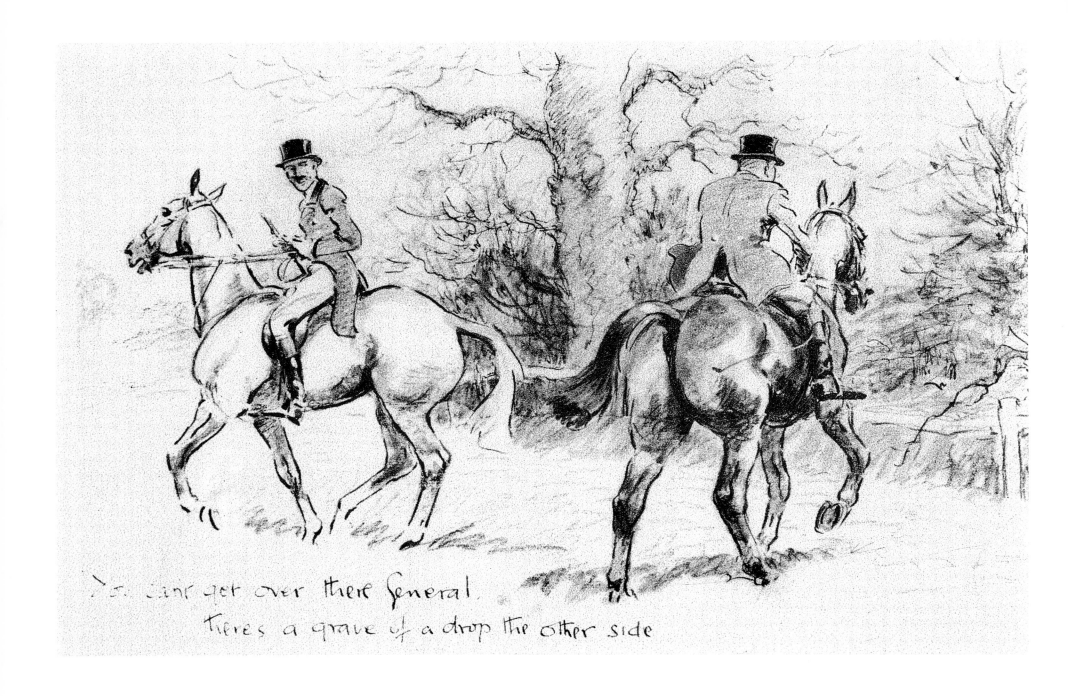

'You can't get over there General
There's a grave of a drop on the other side.'

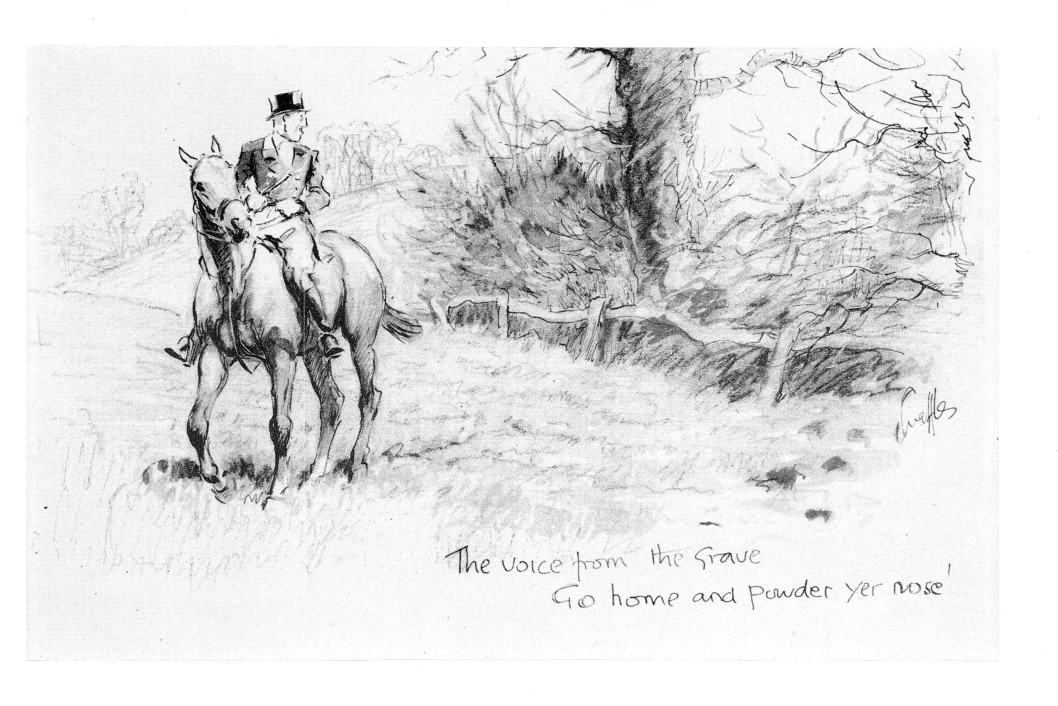

The voice from the grave
'Go home and powder yer nose.'

The Sea Hawk

'The Sea Hawk' was one of the most heavily hand-coloured of Snaffles' prints and was almost certainly produced by the artist himself in a series of variant editions in small numbers.

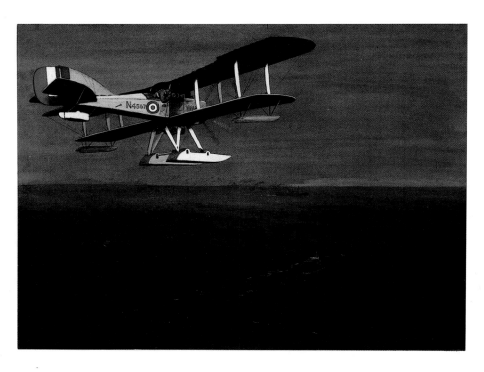

Seagulls

The ships in 'Seagulls' are composites, a practice Snaffles adopted in many of his hunting scenes. They do not represent any individual ship so more work by art historians must be undertaken to unravel the mysteries of these little known prints.

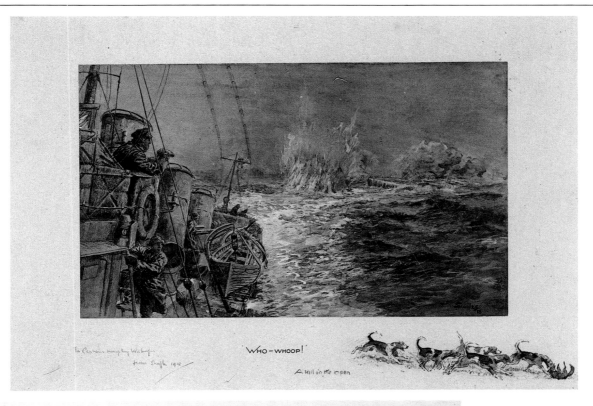

WHO-WHOOP!

A kill in the open

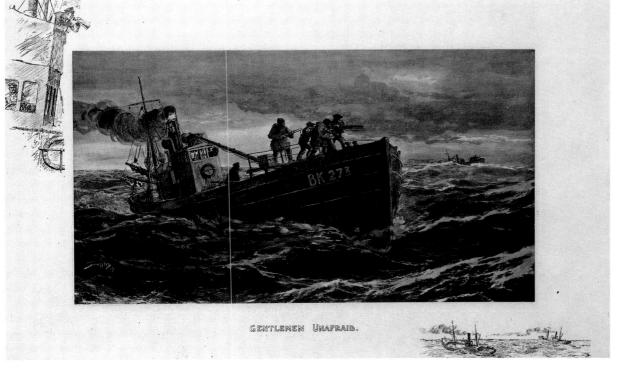

GENTLEMEN UNAFRAID.

Only slightly better known than Snaffles'
air force prints are his naval prints of the
Great War. Once again, much work is needed
by art historians before full identification
and publication dates are established.

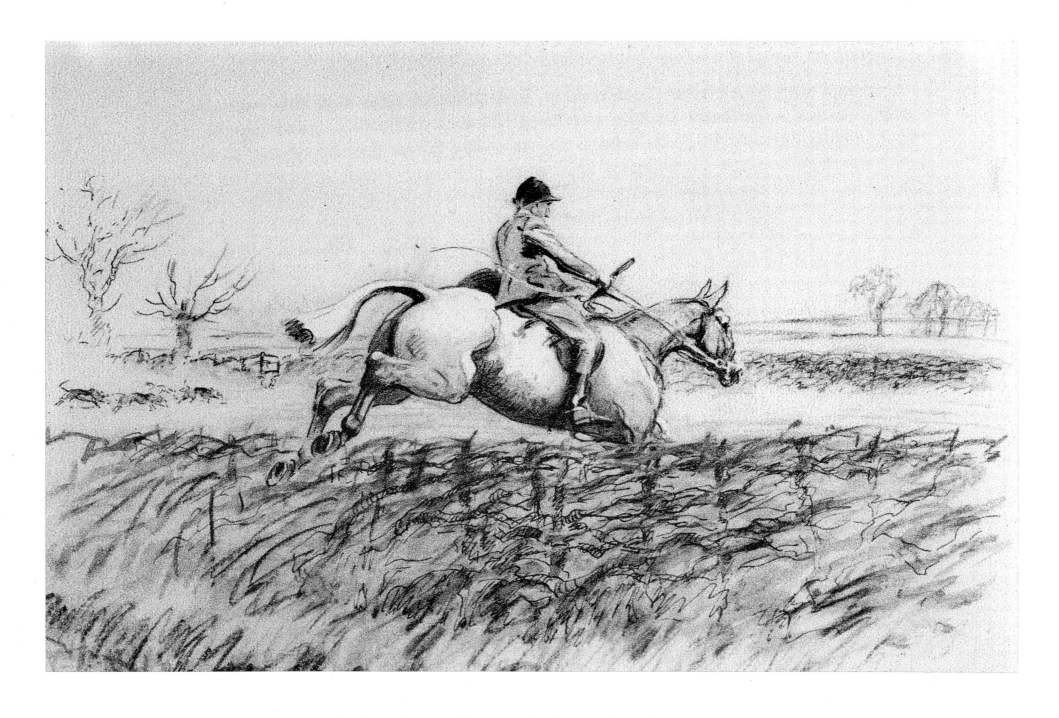

Tom Isaacs (above) was Huntsman of the Cottesmore before the First World
War. Although killed in the conflict he was clearly the model Snaffles used
for many of his post-war prints and drawings.

The Twenties – and Fame

"That'll larn 'em." Snaffles

Farmers' Dinner

November 7th, 1925

Master—
Major E. G. W. W. HARRISON
Royal Artillery

Secretary—
Major L. S. LLOYD
3/6th Dragoon Guards

Menus illustrated by Snaffles were much in demand
for hunt and regimental dinners throughout the years
between the wars.

Back to civilian life once more, Snaffles and Lucy took up residence at Windlesham in Surrey. Along with Gilbert Holiday's, Snaffles' work was included in *The Royal Artillery War Commemoration Book*, known as 'The Gunners' Bible', which was published in 1920. His drawings and prints were by now being eagerly subscribed to and sought after. In 1920, together with Norman Wilkinson, he was awarded the Order of the Crown of Belgium, though he was afterwards to say he had not the slightest idea how this decoration came about.

It was clear that the days of penny-pinching and struggle were over, as his contributions to various magazines in the war and his prints had greatly increased his fame and admirers. No longer were his prints a 'cottage industry', with Snaffles and his sisters working hard to hand-colour them. From 1916 onwards the majority were printed at Bemrose's famous Derby works, then one of Europe's leading Fine Art Printers, and sold in considerable numbers. The first two were multi-plate prints, 'Landing his Wager' and 'A Fire Eater'.

Everyone then was anxious to get back to normality. Racing and hunting were taken up much where they had left off, though sadly all too many of the old familiar sporting faces were missing. Snaffles put on his hunting boots again and rode once more to hounds, resuming his peregrinations across the hunting countries, sketching as he went, and it was during those early days of the twenties that he made the most enduring and influential of his sporting friendships and produced his most famous pair of prints, 'The Finest View in Europe' and 'The Worst View in Europe'.

Major Taffy Walwyn was a Horse Gunner who had survived a tough war from its very outset. It was his battery which had sent the first shells of that war into the advancing Germans at Mons. A superb horseman and race-rider himself – he won the Grand Military Gold Cup three times in the years when it was a highly competitive steeplechase – he was always interested in the higher subtleties of equitation. Towards the end of the war he pointed out to the War Office that there was a Cavalry training school at Netheravon and an Artillery one at Aldershot and that it was ridiculous that the two should be separate. He proposed that there should be a central riding school for both arms and that he should be made the chief instructor. He must have had a persuasive turn of speech for he was only a Major at the time, although his war record – he had a DSO and an MC – would have stood him in good stead. The War Office consented and he was despatched to set up the school at Weedon and design the courses of instruction.

Exactly how and where Walwyn and Snaffles first met is not clear, though it was probably hunting with the Garth, but meet in those early days after the war they did and, it appears, immediately struck up a lasting friendship. 'He was', Walwyn's daughter, Mrs Jean Holt, now famous herself as an equestrian sculptress, recalls, 'just the sort of keen, sporty little man my father liked'. Snaffles visited Walwyn at Weedon and stayed with him sketching the officers being schooled over the fences Walwyn had designed. One of these, a kind of Badminton Horse Trials, Irish Bank and Coffin rolled into one, known as 'The Valley of the Shadow', particularly took his fancy and he drew

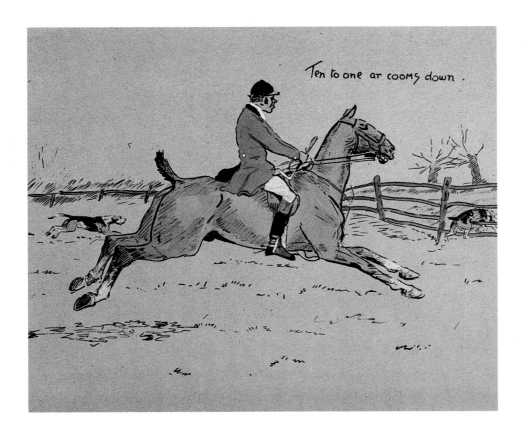

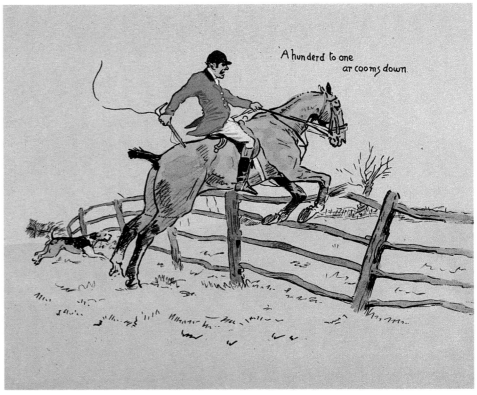

Landing his wager

This charming set of small prints, although published towards the end, or just after the First World War, was conceived and the original drawings executed by Snaffles prior to the war. At the same time, or perhaps a year later, another multi-plate set of prints was executed. In this instance there were three images as opposed to four and showed a heavyweight foxhunter negotiating a post and rails by having the rails removed till his horse can walk over. Snaffles amusingly entitled the set 'A Fire Eater'.

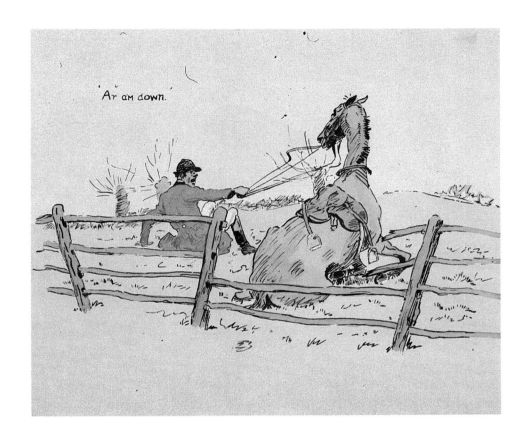

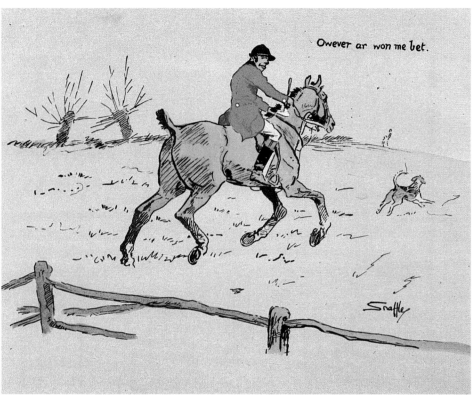

Styles In Navigation (1)

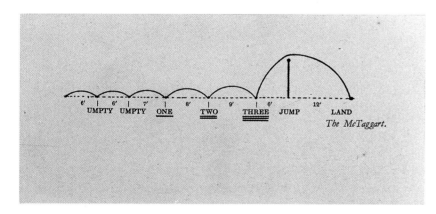

UMPTY UMPTY <u>ONE</u> <u>TWO</u> <u>THREE</u> JUMP LAND

The McTaggart.

Snaffles, by temperament and background, would undoubtedly have favoured the ash plant answer to problems. However, his great friend and patron, Taffy Walwyn, was a prime mover, along with Lieut-Colonel MFC McTaggart DSO, in a more scientific approach to riding.

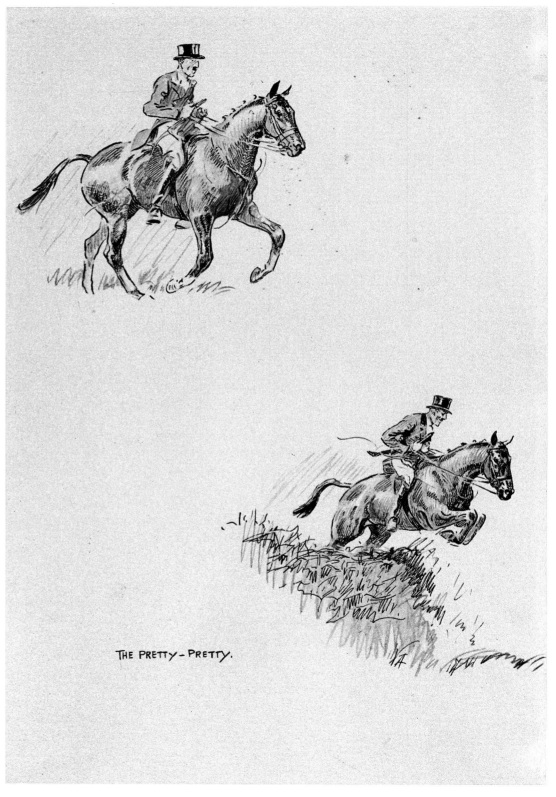

THE PRETTY - PRETTY.

Styles in Navigation (2)

'Give me a snaffle bridle and an ash plant,
and to hell with the book.' *Lieut-General Sir 'Jaques' Harman.*

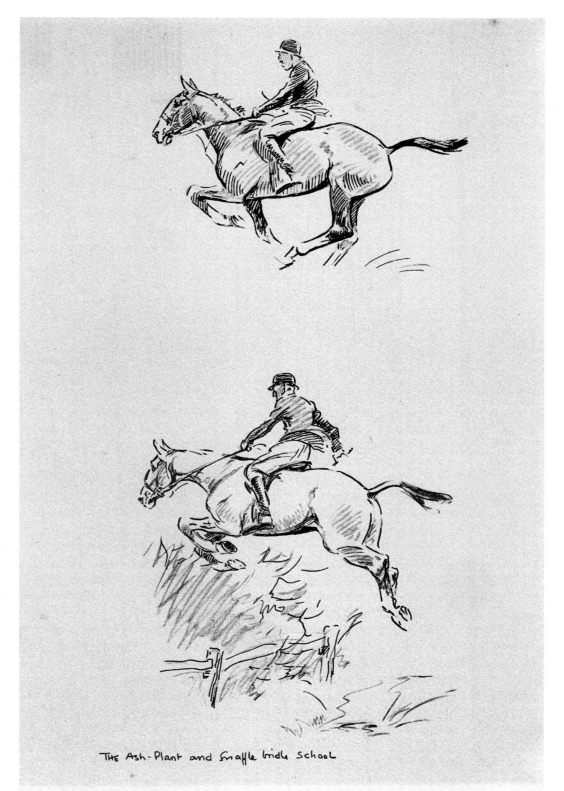

THE Ash-Plant and snaffle bridle school

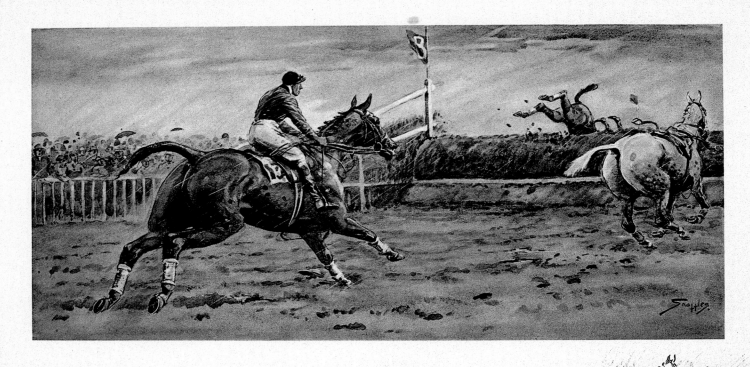

THE WORST VIEW IN EUROPE

"Oh Murther!' The dhrink died out of me and the wrong side of Bechers."

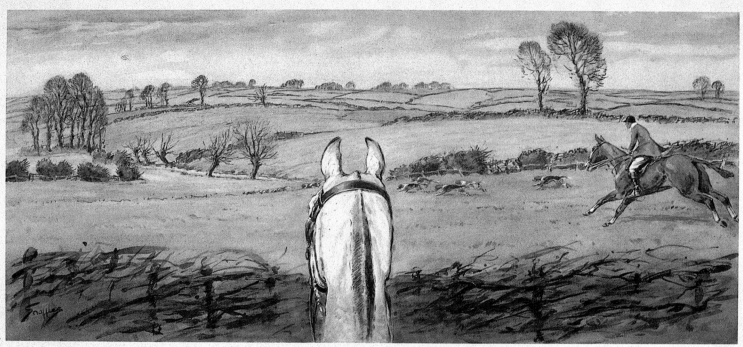

THE FINEST VIEW IN EUROPE

c1926

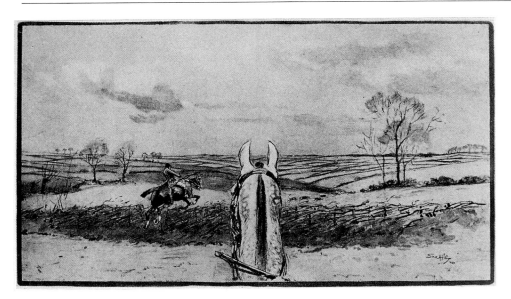

c1920

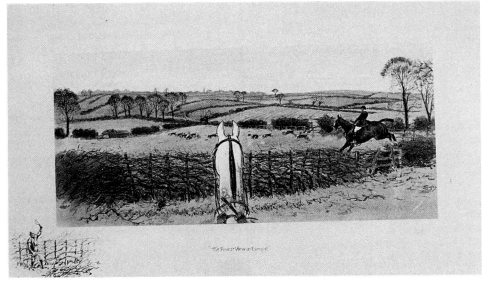

c1921

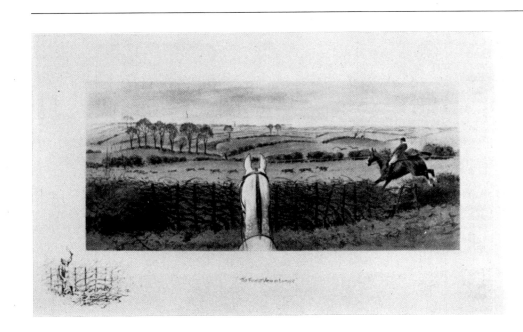

c1924

a picture of riders taking it on with varying degrees of success. This, together with vignettes of instruction over obstacles, was published in *The Illustrated Sporting and Dramatic News* in February 1921, Snaffles himself writing beneath it: 'The old military seat is now obsolete... During the latter part of the course students are let loose with the Grafton and Pytchley...After a blank day at Shuckbrough the Prince of Wales made up for it by helping himself to most of these fences before returning to town.'

There is no record of Snaffles 'helping himself to most of these fences', but Walwyn did, on occasion, mount him out hunting. One day he gave him a hunt with the Pytchley on his good horse Rifle Brigade. They had a memorable run across the cream of Northamptonshire and from that day stems 'The Finest View in Europe', the picture that turned Snaffles from being a run-of-the-mill sporting and military artist into a minor celebrity.

'The best known sporting picture of the present century' was how Lady Clive, who is one of the writing Pakenhams, described it when she was compiling her pictorial history of the leisured classes, *The Day of Reckoning*, in the sixties. 'It seems', she went on to say, 'to be a law of nature that when you find one Snaffles in a house you always find several and that their owners when telling you about them should become quite lyrical.' Nevertheless and oddly enough, the exact origin of his famous picture remains unclear, and when Lady Clive wrote to Snaffles for permission to reproduce it in her book he himself appears to have been confused as to its origins. This is not perhaps so surprising since he was by this time in 1963, in his eightieth year and most of his records had been lost in the war.

He wrote as follows:

'Sept 9. 63

Dear Lady Clive,

Thank you for sending me the photo of 'The Finest View' – it is very good and should reproduce in black and white quite well. I have touched up the highlights which will help the reproduction.

It may interest those who know the picture to know the history of it.

The inspiration came to me during a glorious day with the Pytchley when my friend and patron, Taffy Walwyn, was an instructor at Weedon & mounted me on his famous Rifle Brigade and to quote the authors of 'The Irish R.M.' it was just 'Smelling Heaven', for neither barbed wire or tractors had invaded this fox-hunting Elysium in those days.

Old Arthur Nightingall suggested I did a companion to this Finest View in Europe, and told me how in 1901 he won the National on Grudon with two inches of snow on the ground which worried him and his trainer. However, they sent the stable lad into Aintree to get some butter which they rubbed into the frogs of Grudon's feet, which by the way saved the situation and with the aid of a strong peg of whiskey got round safely and won the race. But he told me that by the time they got to 'Bechers' the drink had died out of him and he was the wrong side of 'Bechers'. And this inspired me to draw 'The Worst View in Europe'.

Yrs,
Snaffles

N.B. Those who possess copies of my first painting published pre 1914 will notice that the rider's hands are shown in the foreground, and that in the later impression the hands are omitted – also less of the horse's neck is shown. The answer to this is simple, and quite of interest to horsemen and women. During the period that I depicted the hands and reins in the foreground we sat back at our fences, and the idea was to drive our horse at the obstacle. Of course the hands and reins would then be in the picture. But with the introduction of the forward seat most of us were converted to this form of navigation and consequently the perspective was slightly altered. So the nearest object which came into view was the horse's neck and ears.

This explanation will, I trust, clear up arguments amongst those interested in the subject.

S.'

The trouble about the information contained in this letter is that instead of clearing up the provenance of 'The Finest View' it makes it more obscure for, as mentioned earlier, Snaffles' memory had betrayed him. Rifle Brigade, who had been on loan to the Prince of Wales to ride in point-to-points, did not exist pre-1914, nor did Weedon, and the friendship with Taffy Walwyn did not commence until after the Great War. Either the occasion was quite different and the hunt he recalled was another day on another horse, or, as seems more likely, the run from which the picture sprang was immediately *after* the First World War. Certainly its first publication in a magazine and, it is now submitted, in any form, appeared in *The Illustrated Sporting and Dramatic News* on 27th November 1920, signed 'Snaffles. 20.' Stylistically, too, the print is more in accordance with his work immediately after the war as the background is more detailed and shows greater depth of perspective than any pre-war work. Snaffles, as has been said, often made different versions of his sketches and prints, working and re-working them. At times the print would vary greatly from the original sketch and often, as indeed in this case in suggested order of date, from print to print. The last of these prints, it will be noted, differs almost entirely in detail from the first, although the effect remains the same, thanks mainly to the caption. It shows the huntsman, having cleared the fence, galloping on behind his hounds and there is a brook in the middle distance which did not appear before. The trees in the middle distance of the first two versions of the print have been moved to the left, and the centre of the print now shows a clear view to the horizon, perhaps some three miles away. The whole effect is entirely different, as the viewer's eye now follows the huntsman and the hounds to the far distance. The viewer, if a hunting person, can imagine the hounds heading over the horizon while in the earlier editions the effect stopped in the middle distance with the trees.

In January 1921, shortly after the publication of 'The Finest View', there appeared in *The Illustrated Sporting and Dramatic News* the first of a splendid series of full-page pictures entitled 'Foxcatchers'. They ran to over a dozen in all and each of them bears that touch of life and humour either of phrase or situation – or both – that was in all Snaffles' work. The vignette beneath one showing the driving finish of a point-to-point between two good amateurs has caught the moment, the action and the spirit in a way that has never been bettered. Lionel Edwards once gave it as his opinion that racing was a branch of sport which seemed to defeat artists. It did not defeat Snaffles; some of his racing pictures drawn during the twenties and thirties are amongst the finest he ever did. Never was the adjective 'sporting' applied more truly to an artist than to him.

The series 'Foxcatchers' together with The Finest and Worst Views attracted wide attention. His reputation soared and his fame was secure. He was welcomed to all sporting occasions – hunting, racing, polo and indeed shooting, though he always maintained that he was 'a third-rate shot'. So far as can be ascertained, he never owned another horse, nor did he need to, so anxious were people to mount him and to see him out with their hounds.

Success did not spoil Snaffles; he always remained a private man, refusing to push himself, and detesting anything in the nature of what he called 'brag'.

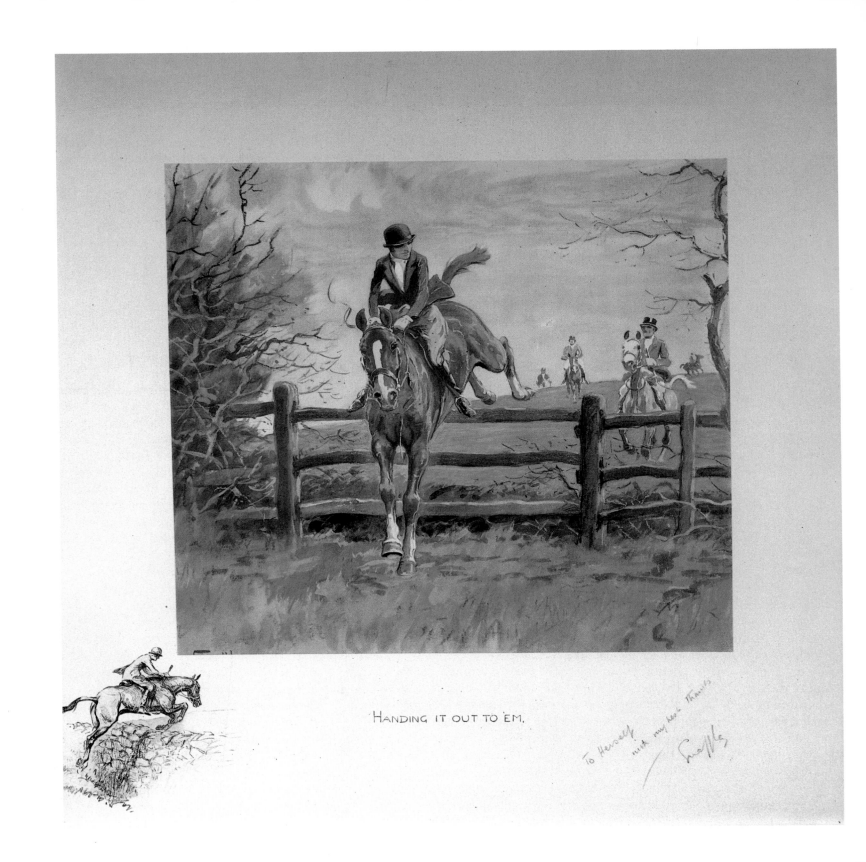

HANDING IT OUT TO 'EM.

To Herself with my best Thanks

He told a friend that he regarded the talent he had been born with as a wonderful gift from the gods, which enabled him to do what he loved doing – riding horses and painting them in the company of those who shared the same interests and whom he liked to be with. The tributes of those who knew him both then and later as his fame and reputation grew, are glowing. 'He was a dear little man', one Gunner friend with whom he hunted with the Royal Artillery (Woolwich) Drag said of him, 'so modest and self-effacing despite his fame'. Another wrote of him, perhaps the tribute he would have liked best, had he known of it: 'He had clear blue eyes and if you had not known, had the look of a retired Admiral who had spent his life scanning the horizon'. He had, too, in abundance, the elusive quality of charm and, like most of those possessed of it, the ability to inspire affection in those for whom he cared. Wherever he went he made friends and, what is more, he kept them, though it has to be said that he could be moody in company that did not interest him or which he found incompatible, and he had his share of artistic temperament which sometimes surfaced.

It was in the early twenties that he formed the habit of going every year to the Grand National whose running provided a fertile field for his brush. He has left it on record that he saw 'twenty odd' Nationals from the old stand at the Canal Turn, the County Stand or down the field. One of his equine heroes became 'Sergeant Murphy' who was fourth in 1922 and won the following year at the age of thirteen carrying 11 stone 3 pounds. He painted him in a stirring picture, 'Just as Old as He Feels', jumping the Canal Turn in 1922, and used him as a model for 'Ba Goom Canna that Owd Chestnut 'Oss Joomp!' at Bechers the year he won under Captain Tuppy Bennett. Both these appeared in *The Illustrated Sporting and Dramatic News*, on 29th March 1924 and 20th March 1926, respectively.

In those days the trip to the National was an annual pilgrimage for sporting people and parties were made up to travel by train to it. Mrs Norah Pearson, then Miss Norah Roy and a noted point-to-point rider, now the mother-in-law of Fred Winter, remembers travelling in one such party when both Lionel Edwards and Snaffles were amongst its members. On the return journey, Edwards was busy sketching and she remembers Snaffles watching him enviously and saying: 'You have nearly finished your picture. It will take me a year.' Snaffles liked Edwards and admired his work, an admiration which did not extend to Munnings whose paintings he regarded as being over-stylised and 'chocolate boxy'. In conversation he once told Edwards of his habit of mentally 'snap-shooting' incidents and storing them in his memory until the time came when he could commit them to paper, and he went on to say that this had become such an obsession with him when hunting or watching a race that for some minutes afterwards he went into a kind of trance of concentration, becoming oblivious to all around him. This trance-like quality of memory explains why many of his companions at sporting events were astonished to see that he never produced a sketchbook at the time and yet reproduced the scene or the incident with absolute authority and accuracy.

His close friendship with Aldin continued during those years and another mutual friend recalls how, on hacking home from a day with the Garth when she had lost her way, she came upon Snaffles and Aldin, also hacking home and deep in discussion. They gave her directions and resumed their talk on the problems of their profession. Both were then at the height of their powers and it would have been interesting to have learnt what difficulties of light, shade and composition were under discussion, but their paths led in different directions and she had to leave them.

Although Snaffles always denigrated himself when it came to portraiture, saying 'I am not a portrait painter, I leave that to Munnings and his like', he could, in fact, catch a likeness when he wanted to as he showed in the portrait of Aldin jumping a fence in a point-to-point. This he presented to Aldin inscribed: 'Out for a jolly (South Berks) to C.A. from Snaffles'. Aldin's attitude to point-to-point riding was the old-fashioned sporting one, well expressed in his book of reminiscences, *Time I was Dead*: 'Each year until I was well over fifty, I had a joy ride or two in our local point-to-points....I never troubled much over the 'pot' – it did not hang out in front of my horse's head like the proverbial carrot in front of the donkey, and to tell the honest truth I never cared much whether I won or lost provided we all had some fun going round the course and I had a comfortable ride.' In the painting, apart from the true facial likeness, Snaffles has caught this attitude exactly. He must have watched Aldin jumping a fence and impressed it on his mind.

Mrs Pearson, too, recalls Snaffles' methods when she was the subject of 'Handing it out to 'em' where a young lady pounds a hard riding field at a stiff fence. Riding a horse of Taffy Walwyn's called Viking II, on which he had won the Royal Artillery Gold Cup, and which Snaffles had borrowed for the occasion, she went to Tweseldown Racecourse and there jumped a fence time and again until Snaffles satisfied himself he had accurately memorised the style and the action of horse and rider.

As he had said in one of his letters to Lady Clive, Taffy Walwyn besides becoming a firm friend was his 'patron' who introduced him to many of his fellow officers, friends and acquaintances, mounted him on occasion and put work in his way. Sometimes they would discuss captions to the pictures together, but work and commissions, including his first commission to illustrate a book, were in any event coming thick and fast in those heady days of increasing fame and success during the early and middle twenties.

In 1927, Constable published Geoffrey Brooke's *Horse Lovers* which was illustrated by Snaffles with a colour frontispiece and thirty-two black and white drawings. On the whole, the small size of the reproductions of his drawings did not do his style justice, although the colour frontispiece is of interest. It clearly shows the influence of the great sporting artistic teacher, Lucy Kemp Welch, and one must wonder if Snaffles had not sought her advice on his illustrations for this book. They may have met in France during the First World War as she was with the Gunners as an official war artist then.

By the late twenties, Snaffles had finally developed his own distinctive style as an artist and one notices less and less frequently the influence of other artists on his work. During the years 1928 to 1943 he was to produce a succession of great prints and it is in this fifteen year period that many people consider he produced his best work, although some people find his more primi-

White Cottage was almost certainly built by Snaffles
and Lucy to their own design.

tive and perhaps more lively hand-coloured prints of the 1908–1914 era more attractive – they are certainly rarer. In the years 1908–1914 it must be remembered that his print making was very much a 'cottage industry', whereas by the late twenties his work had a good following amongst the sporting and military set and prints were being produced in considerable numbers.

In 1925 he and Lucy moved to White Cottage, One Tree Hill Road, Guildford, which was to be their home and base until 1940. As can be seen from photographs it was not a cottage, but a substantial house, probably built by Snaffles and Lucy, as it had fine views over the rolling countryside. Certainly they were the first occupants. Exactly how the wherewithal was found to pay for it is unknown. Maybe this was a result of Snaffles' work, or

perhaps Lucy had come into some money on the death of her father or mother, who at one time had been comfortably off. More likely, the money came from a combination of Snaffles' earnings and an inheritance of Lucy's.

Here Snaffles had his studio, and above the garden gate there was – and still is – a metal representation in miniature of James Pigg, Jorrocks' incorrigible and unstoppable huntsman, holding his hat aloft and halloaing a fox away. Unauthorised entrance to the studio was strictly guarded against by Lucy, for Snaffles, once at work, was both reclusive and secretive; even close friends were barred from entry without special dispensation. It was here that those 'moments of obsession' began to flow from his memory into his hand and brush; and here were produced, with increasing confidence, maturity

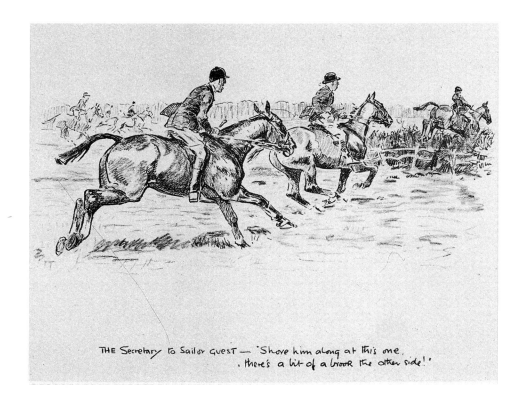

THE Secretary to Sailor Guest — 'Shove him along at this one,
there's a bit of a brook the other side!'

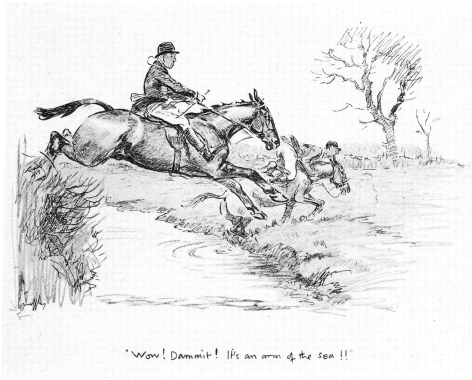

"Wow! Dammit! It's an arm of the sea!!"

The Staff College Drag was regularly attended by Snaffles, as he lived within
a few miles of Camberley, and a frequent subject for both prints and
illustrations.

and marketability, some of his most famous sporting paintings, helped by the peace and tranquillity brought about by Lucy's calming influence, protection and astute financial management.

'The Grand National 1925. Valentine's second time round', showing Double Chance, the winner, lying third to Silvo and Fly Mask, followed by 'The Canal Turn of 1926' with, to quote Snaffles himself, 'the racehorses eliminated and the foxhunters making a race of it', both came from the studio in Guildford. The picture, 'Prepare to receive Cavalry', of soldier riders taking the Arborfield Brook in a point-to-point, and 'The Staff College (Camberley) Drag' with its vignette of 'Tiny' Ironside, the future C.I.G.S. and Field Marshal, smashing his twenty stone through some solid timber, also belong to that period, as does his second and better 'Happy are they who hunt for their own pleasure'. These demonstrate Snaffles' ability to catch with exactitude the seat and style of a rider, be he foxhunter or steeplechase jockey. F.B. (Fred) Rees, the leading rider of his generation, is clearly unmistakable on Silvo in 'The Grand National', as is Jack Anthony on Old Tay Bridge. It was during

this period, too, that the device of interlocking snaffles was impressed on the margin of his signed prints.

Snaffles was never one to confine himself for long to one place, milieu or subject. Traces of the young nomad were in him still and behind the shy and retiring façade which he presented to the world lay a thrusting spirit, eager for exploration and to see and experience new scenes, sights, people and places. As he said himself: 'Having arrived at the age when most foxhunters think twice about leaving the ground, the idea struck me that the winter months could be pleasantly spent cantering about India's sunny plains. This would be a pleasant diversion with no moments of unpleasant indecision and, moreover, give me no end of scope for my brushes and pencil.'

In fact, as regards age and the implied reflection on his nerve, Snaffles as usual did himself an injustice. He was only forty-three and, as will be seen, there was plenty of galloping and jumping and 'moments of unpleasant indecision' left in him still. Taffy Walwyn was now stationed in India and that was another major attraction for making the journey.

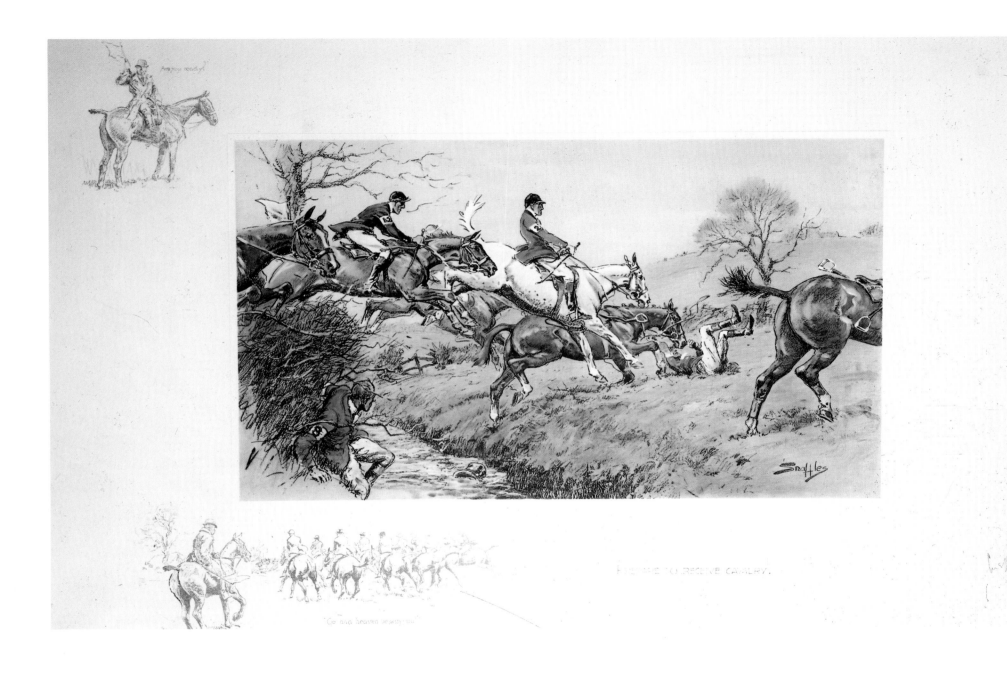

Military point-to-points and steeplechases, especially those held at Sandown,
were regularly attended by Snaffles and provided a favourite subject to
paint. The title 'Prepare to receive Cavalry' is particularly apt, as the
Arborfield Brook claims at least two victims.

THE R.A. HARRIERS

Hold hard you qualifiers
Dammit! Give 'em a chance

India

So in 1927 Snaffles and Lucy sailed to India via Malta and the Suez Canal, and met up with Taffy Walwyn who was one of the few soldiers who did not enjoy India. This was chiefly because he was stationed at Sialkot which was not in a sporting area for there was no pigsticking and no 'shikar', to use Snaffles' own expression when writing of it. 'Shikar' to sporting India meant field sports – hunting, shooting of every sort and, of course, pigsticking. Snaffles was always anxious to identify himself with the country he was in and to pick up the dialect which, as a good listener and with his ear for a phrase, he did supremely well. During his talks with Walwyn he picked up much of the argot including the universal, 'Qui-Hai' or call for 'waiter' which, as he explained in a note to one of his pictures 'has become the sobriquet of all sahibs who reside in the country'.

From his stay with Walwyn, too, came the inspiration for another remarque of his highly successful print, 'Merry England', which shows a top-hatted, red-coated member of the field, a happy smile on his face, galloping on a grey horse through the rain, while a lady riding side-saddle clears timber behind him. The original title was 'Merry England and worth a guinea a minute', and the remarque showed a fox jumping a dyke, but when it was re-issued in 1928, the print was re-titled 'Merry England and worth a lakh a minute' and the remarque was changed to show an officer (Taffy Walwyn) resting in the Indian heat in a chair with his feet up.

Walwyn passed Snaffles on and, as usual, he fell among friends, his modesty, lack of pushiness and genuine interest in their activities making him welcome everywhere he went. His travels took him throughout sporting India, then a paradise for the sportsman. It was still very much Kipling's India of the Raj, unchallenged in its permanency, confidence and authority; there were still sahibs and servants, polo and shooting, clubs and messes where the Army, especially the Cavalry and Gunners with whom Snaffles mostly mixed, reigned socially supreme and thought of little but sport.

Snaffles also spent a considerable time with one of the most famous Indian Cavalry Regiments, the Scinde Horse, and many of the sketches which were to appear in his later books of Indian Cavalry were made when he was staying with them. His particular friend was Major F. Townsend to whom he presented a sketch whilst staying with him. It is perhaps worth noting that Snaffles' technique when doing caricatures of officers developed little, if at all,

"Gooshot sahib!"

The dog in this drawing is Wong, of whom Snaffles was to write and illustrate a short biography. He was to draw him again, twenty years later, in his book *Four Legged Friends and Acquaintances*.

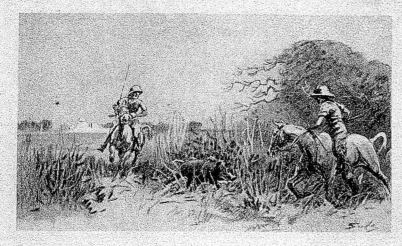
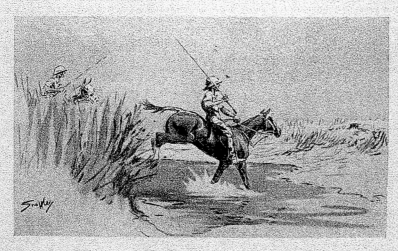
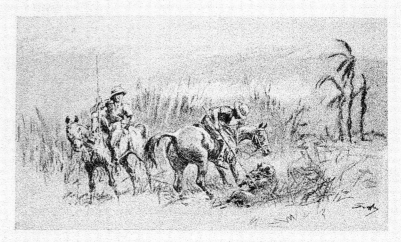

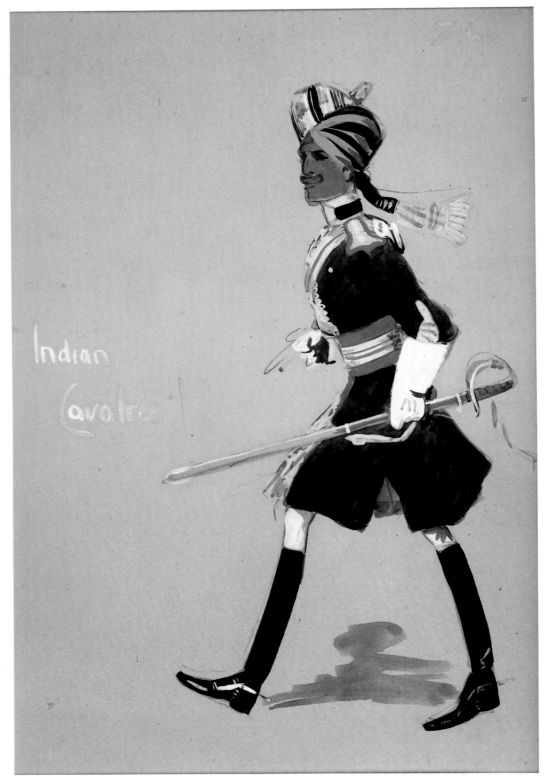

Indian
Cavalry

This watercolour of an officer in the Scinde Horse was executed by Snaffles on his first pre-war visit to India and given to Major F Townsend. It is worth noting that Snaffles' style of caricature painting had not really developed much since 1908/9 (see page 18).

GETTING CANTANKEROUS

Undoubtedly Snaffles was the best artist this century to portray pigsticking.
No other artist has matched the quantity and quality of his work.

after 1911, and it would be impossible to date a few of his pictures unless one knew their provenance.

He travelled throughout Northern India, up the Khyber, to Lahore 'Kim's city', to Peshawar, Muttra and Meerut. Captain Scott-Cockburn, at that time the doyen of hoghunters who had won the Kadir Cup three times on his superb horse, Carclew, wrote: 'Since we first heard Snaffles was to visit us in India, we have looked forward to the results of the visit.' They were not to be disappointed, for Snaffles, as he told a friend, found India an even more fascinating place to work than he had expected; the light was so sharp that the contrast had especial appeal. He threw himself eagerly into every facet of its sport and soldiering and has left behind him an unique and nostalgic record of what it was all like in those last halcyon days of the British Raj in India. In fact his prints and books about India are of considerable historic interest nowadays and, with the exception of Lionel Edwards who did considerably less work in India, his pictorial records of pigsticking are the best ever produced and are still widely used to illustrate books and articles on the subject.

Wherever he went he would sketch. His stay with the Scinde Horse yielded a picture of them galloping past in review order, and at Meerut there was another sketch of his beloved Horse Gunners 'spreading themselves at a gallop', the Brigadier at their head, sword at the carry, 'riding a finish'. From the Landi Khotal at the top of the Khyber Pass, he drew the Mountain Gunner struggling through a narrow defile, 'Sniffin' the morning cool, I walks in my old brown gaiters along o' my old brown mule'. He got the quotation right this time, and indeed in all the sketches he made, there was this Kiplingesque avidity to be correct in every detail from the last bolt on the screw gun to the final fold of the turban on a Scinde sowar or the twirl of an Afridi beard.

This attention to detail became almost an obsession. After attending one formal function he wrote to Captain Geoffrey Alexander of The Central India Horse (who was on the Viceroy's staff and with whom he had become friendly through agreeing to make a sketch of Captain Alexander's good polo pony, Corner Boy):

'I wonder if you would do a little job for me. When we arrived at the Ball the other night the Indian Officer who received us Salaamed & I only replied with a salaame. I find he was entitled to a Salaam Sahib. I should hate to hurt his feelings so if you see him would you explain that it was my ignorance and apologise for me.'

This letter was written from Peshawar where he was staying with Major Victor Wakely, Whipper-in to the Peshawar Vale Hounds, and he added a paragraph: 'This is a great place – had a great hunt yesterday – had to swim for my life though. I came adrift when crossing a river.'

The Peshawar Vale Hunt met at six o' clock in the morning to pursue jackal over a stiff country of banks, ditches and rivers into one of which Snaffles had taken his ducking. Another follower had thrown him the shaft of a hunting whip while holding its thong, in an effort to tow him to safety. 'It's all right.

72

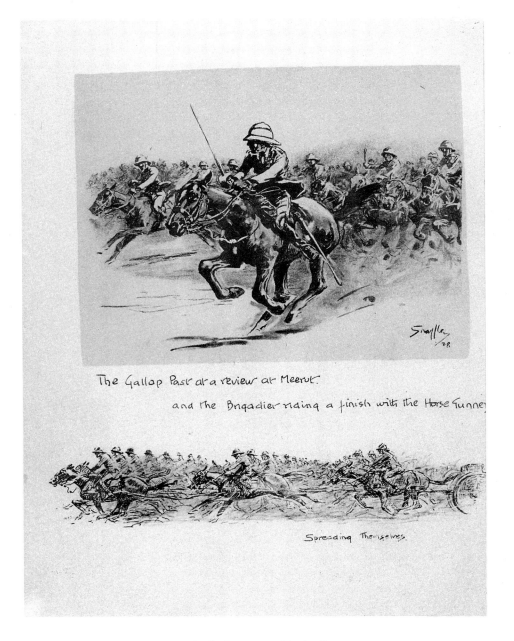

The Gallop Past at a review at Meerut. and the Brigadier riding a finish with the Horse Gunner

Spreading Themselves.

No-one who had not served in the Gunners could have done these pictures. They are pictures of Gunners, for Gunners, by a Gunner.

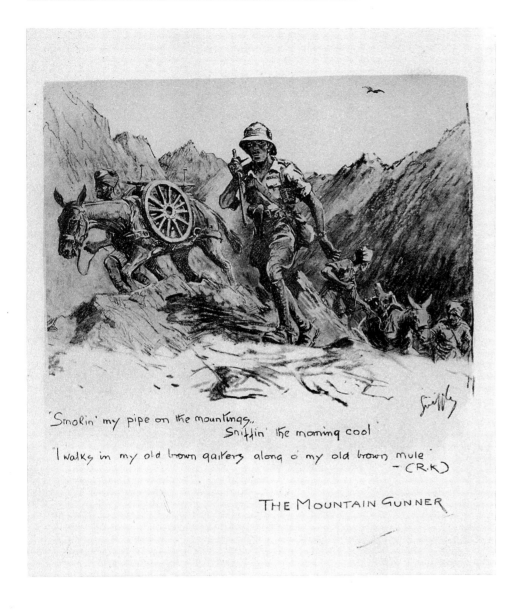

'Smokin' my pipe on the mountings,
Sniffin' the morning cool'
'I walks in my old brown gaiters along o' my old brown mule'
— (R.K)

THE MOUNTAIN GUNNER

This drawing, executed near the Khyber Pass
in 1928, remains a firm favourite and is much
sought after by present-day Gunners.

I'll come ashore under my own steam' had been the typical spirited Snaffles reply – no wonder they loved him!

Mostly with the PVH he was mounted by Colonel Kerans, DSO, an Irishman from Birr, County Offaly. Colonel Kerans remarked to him that the 'Banks and Yawners' of the PVH country were not unlike those of Limerick and Meath. With that retentive memory of his, Snaffles stored this remark away and when he came to produce his print of the 'Peshawar Vale' showing the field crossing one of the big doubles, he added the caption, 'Begad! This would stop them Meath fellers'. The print was published by Fores as a 'Signed Artist's Proof in four colour process at £2.2.0.'. The rider in the foreground in the print being Colonel Kerans who Snaffles often addressed when writing to him as 'The Gent in the Black Coat' or just 'Dear Birr', the latter of course being Colonel Kerans' home town. In fact now, more and more, painting and caption were becoming contrapuntal, the one lending force and vigour to the other.

But it was above all the sport of pigsticking which excited Snaffles' imagination and stirred his pencil and brush. Largely forgotten now in the U.K., save for the memories of the dwindling band who took part in it pre-1947, pigsticking was the pursuit of the wild boar over a rough and dangerous country which demanded sureness of foot from the horse and strength of nerve from its rider. It has never been better described than by Major General Elliott in his *Field Sports in India*:

'The sport of hog-hunting, or pigsticking as it was later called, consists of the finding and pursuit of the wild boar by mounted sportsmen armed with a spear. After being chased, often for a mile or more, the boar becomes tired and annoyed and charges the hunter and, after a short or long battle, is killed, usually by a spear driven through his heart. This bare statement quite fails to account for the spell it cast over those who took part in it. Foxhunting is said to be the King of Sports and the Sport of Kings, but anyone who has ever ridden after and killed a boar is certain that pigsticking is the finest sport of them all.'

'On, on, on!', was the pigsticker's creed and their motto the chorus that was sung in their messes or over their campfires:

'Over the valley, over the level,
Through the dark jungle ride like the devil
There's a nullah in front but a boar as well,
So damn the nullah and ride like hell.'

These were sentiments which had instant appeal for Snaffles but one look at the country over which pigsticking took place convinced him that this would be no 'pleasant canter over India's sunny plains'. However, during an evening in the mess at Muttra when port and more indigenous drinks circulated freely, he consented to ride after pig the next morning. He awoke in the shaky dawn with growing apprehension. 'My initiation', he says, 'was just a

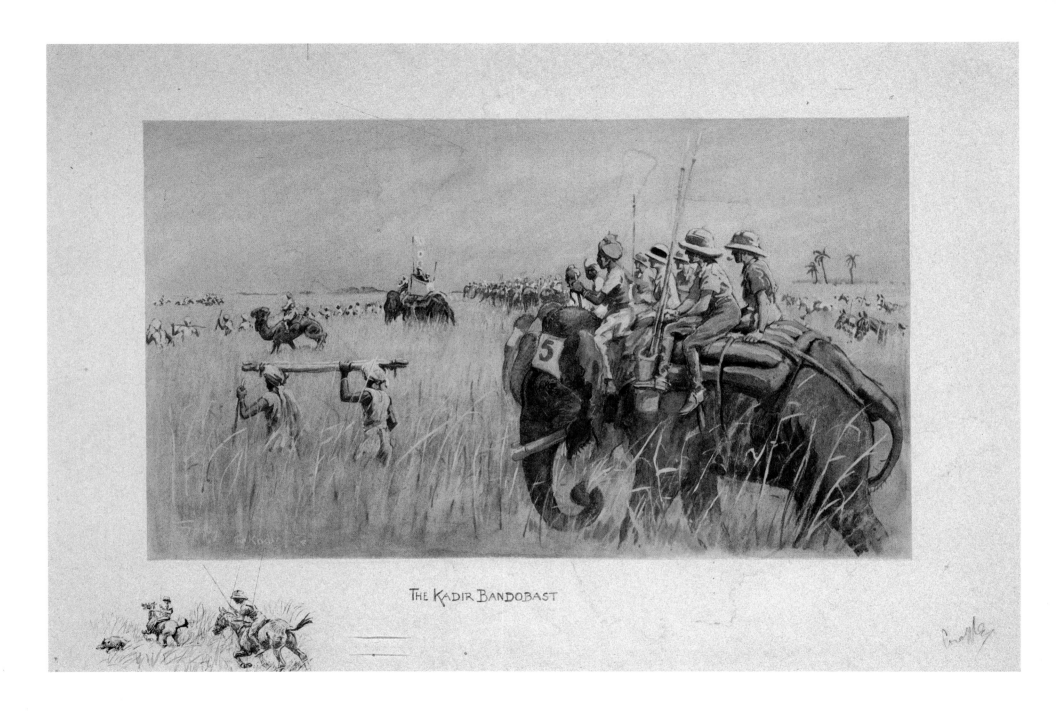

THE KADIR BANDOBAST

One of the most spectacular prints of pigsticking ever produced. It gives
some idea of the vast organisation behind the running of the Kadir Cup.

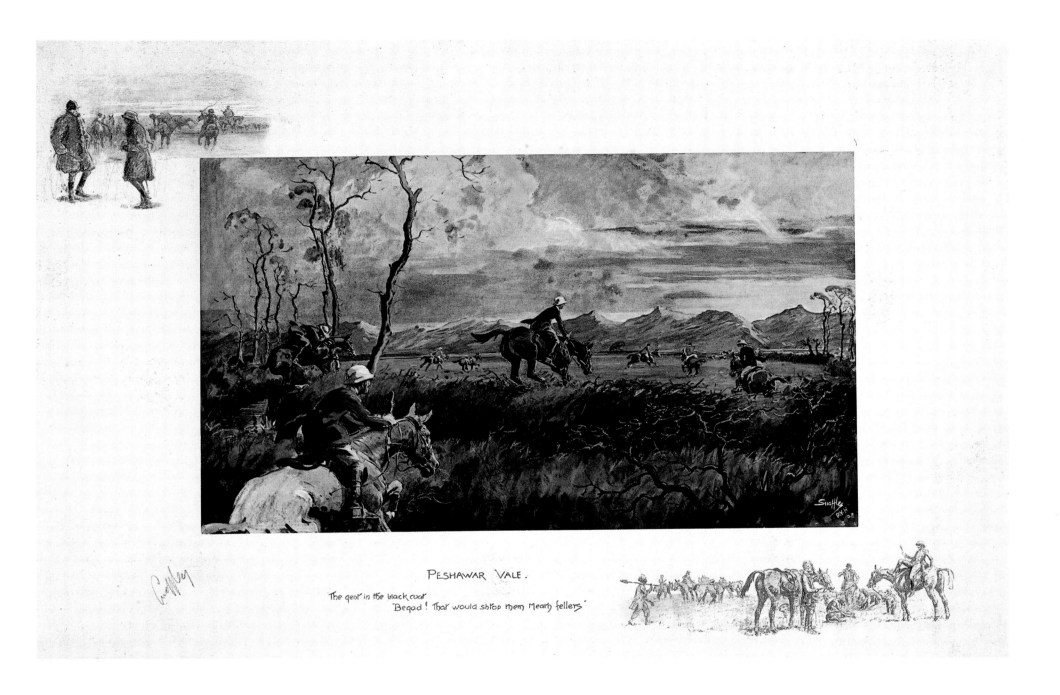

PESHAWAR VALE.

The gent in the black coat
'Begad! That would shtop them Meath fellers'

The rider in the black coat and white topee negotiating the bank was
Colonel Kerans who became a close personal friend with whom Snaffles
later stayed in Birr.

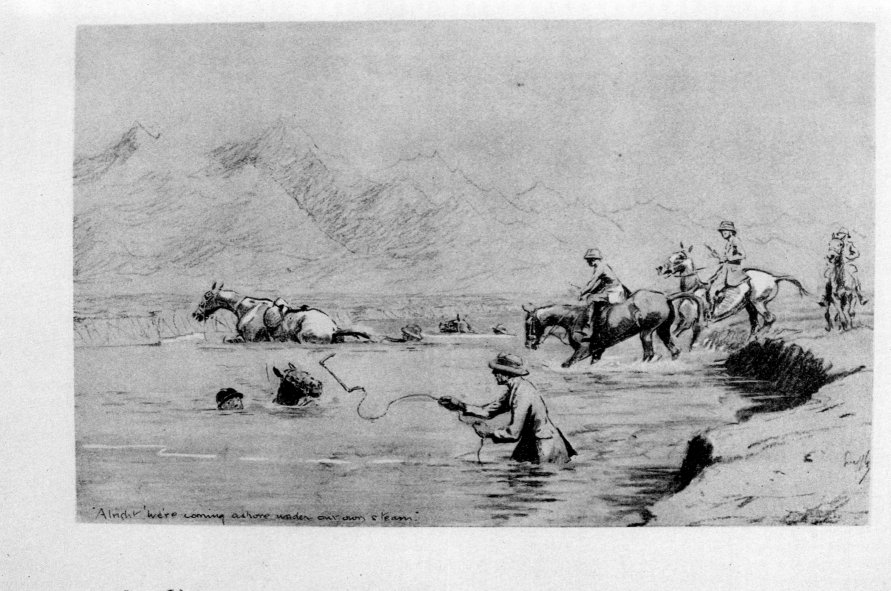

'Alright we're coming ashore under our own steam.'

The Sha-Alam Regarra.

Snaffles having to swim ashore when hunting with the PVH. Later he was to help illustrate a book on the hunt's history.

27

RECORD OF 1ST SPEARS.

Mr. Akroyd Hunt, R. A.	..	49	Capt. Ruttledge, Poona Horse	2
Capt. Catto, 4th Q. O. Hussars		17	Capt. Richards, R.A.	50
Mr. Clarke, R.A.		12	Mr. Rice, R.A.	9
Mr. Chapman, R.A. ..		4	Col. Sarson, R.A.	1
Mr. Colchestor, R.A. ..		17	Mr. Sheppard, R.H.A. ..	3
Mr. Clements, 4th. Q. O. Hussars		4	Maj. Scott, R.A.	4
Mr. Ford, 5th Inniskilling Dragoon			Capt. Scott Cockburn, 4th. Q. O.	
Guards		3	Hussars	20
Mr. Gee, R.A.		22	Mr. Templer, R. A.	13
Mr. Gage, 4th Q. O. Hussars		2	Maj. Wallace, R.A.	29
Mr. Guille, R.H.A. ..		5	Capt. Warden, R. H. A. ..	18
Mr. Hill, R.A.		20	Capt. Waller, R.A.	7
Mr. Hayes, R.A.		3	Mr. Wetherfield, R. A. ..	20
Maj. MacFarlane, R.A. ..		3	Muttra Cup Spears	29
Maj. Marriott, R.A.V.C. ..		1		
Mr. Parr		44	Total ..	412
Mr. Payne		1		

BAG OF BOAR BY MONTHS.

November 1927	6	Maholi		9
December ,,	32	Chota Kosi		7
January 1928	8	Aurangabad Nullahs		7
February ,,	29	Muttra Islands		6
March ,,	38	Delhi Road		5
April ,,	82	Barahra		5
May ,,	75	Barsana		4
June ,,	119	Rahera		4
July ,,	23	Radha Kund		3
					Aring Grass		3
	Total	..		412	Rawal Nullahs		3
					Mahaban		2
					Bad Nullahs		2
					Brindaban Road		2

JUNGLES IN WHICH PIG WERE KILLED.

					Jait	2
					Tarsi Bagh	2
Sultanpur	73	Karhela	2
Panigaon	48	Noh Jhil	1
Jahangirpur	28	Sahar	1
Bijoli	25	Brindaban Nullahs	1
Garaya	25	Ganeshra	1
Majhoi	25	Madhuri Kund	1
Koela	21		
Seikshai	21	Total ..	412
Sakraya	17		
Samoli	15	H. McA. RICHARDS, CAPT.,	
Jaisingpur	15	J. A. AKROYD-HUNT,	
Kokila Ban	15	*Joint Honorary Secretaries,*	
Ral	11	*Muttra Tent Club*	

A page from *The Hoghunters' Annual vol 2 1929.*

nightmare. In the first place I had spent a hilarious evening overnight, my spear felt dashed awkward and heavy, and altogether I was overcome by an acute attack of nostalgia for a Garth Monday, and would have exchanged this sort of thing for the biggest obstruction they could hand out.' His fears were not allayed by his introduction to his mount, Aaron: 'There's your horse, old man. He's blind in one eye but can catch a pig.' But with his spear 'heavy as a boathook – new hat like a bushel basket' he climbed on and when the order 'to ride' after a warrantable pig was given and Aaron took charge, he found his heart going with them. He recorded his further series of adventures and misadventures in a brilliant series of little sketches and caricatures which were published in, amongst other places, *The Hoghunters' Annual.* Despite his disavowals of any ability he was in the end awarded 'first spear' which meant that he was the first of the heat to draw blood. And it must have given him enormous pleasure to find in the same annual under RECORD OF 1ST SPEARS of the Muttra Tent Club, his name recorded thus: 'Mr. Payne. 1.'

There were more adventures after pig, many incidents of which were faithfully recorded in his memory and his sketchbooks. One of them nearly led to a disaster. So intent was he in watching the other spears that he rode slap on top of an old boar who was lying in some rushes asleep. The boar, enraged, charged. It was only the experience and agility of Aaron that saved him, he said, from needing a new pair of breeches and possibly some stitches. It may have been this incident which led him to record in an article in *The Tatler* on his return home: 'My reflections are that pigsticking is a grand game for single young subalterns and Government officials who get free doctoring...'

But he was vastly excited by it all. The danger, the fun, the camaraderie over the campfires at night all appealed to his romantic spirit. He always detested showiness of any sort and here was sport stripped to its bare essentials against an adversary who could maim or even kill. Those who regarded sporting occasions as an excuse for dressing up had, from his earliest days, been objects of satire for his pen. 'The spooney who hunts for the ride out and the ride home' had been caricatured by him before the war, as had 'The devil of a feller – on the Flat' immediately after it. There could be none of that in pursuit of pig. You rode hard 'with a loose rein and a light heart' or stayed at home. There could be no seeking after smartness of turnout either – 'the more patches the more pig and the harder the hoghunter'. It all added up to his two tenets of equestrian sport which he so well illustrated in his prints 'The gent in ratcatcher', which is inscribed with the words from Jorrocks 'I have my man cleaning my 'osses not my breeches', and ' 'Andsome is – wot 'andsome does'. These tenets, it may be added, tallied exactly with the creed of the hoghunter and gained him recognition as a kindred spirit by such 'Qui Hais' as Captain Scott-Cockburn and K.J. Catto.

The days passed quickly. Besides recording his memories and sketches for the book of his Indian experiences that he was determined to produce, he went shooting snipe on the marshes with a beloved mongrel, Wong, which he had acquired and whose 'autobiography' he was later to write and he watched inter-regimental polo, and observed the memsahibs on the maidan

Competitors and spectators at the Kadir Cup 1928. Snaffles is in the centre
of the second row, the only man in the picture wearing a tie.

at Delhi. But the season was coming to an end and to its culmination, the Kadir Cup, the Grand National of pigsticking and he moved on to Meerut where the Tent Club organised the great event.

The Kadir Cup had originated in 1867 as a race, assuming in 1874 the form which lasted to its ending with the demise of the Raj. It was run off in heats, the 'first spear' being the winner of each heat and so on to the final which took place on the third day. This was followed by two races, a lightweight and a heavyweight over a fearsome hog-hunting country which usually resulted in grief and casualties. Spectators watched from the backs of elephants provided in 1928 by the Rajah of Rainpur.

Snaffles' pigsticking experience and abilities were not such as to permit him to take part but he was there to watch every heat and to store up every incident in his mind. He appears fifth from the left in the second row of the photograph of 'Competitors and Spectators'.

He had already sent back a series of pigsticking sketches to *The Illustrated Sporting and Dramatic News* which had attracted considerable interest and now he drew his 'The Finest View in Asia', based on 'The Finest View in Europe' and adapted to the Meerut country and to pig. It was duly published as a double-page spread in the magazine and subsequently as a print but it is not one of his most successful pictures for it lacks the colour and spontaneity

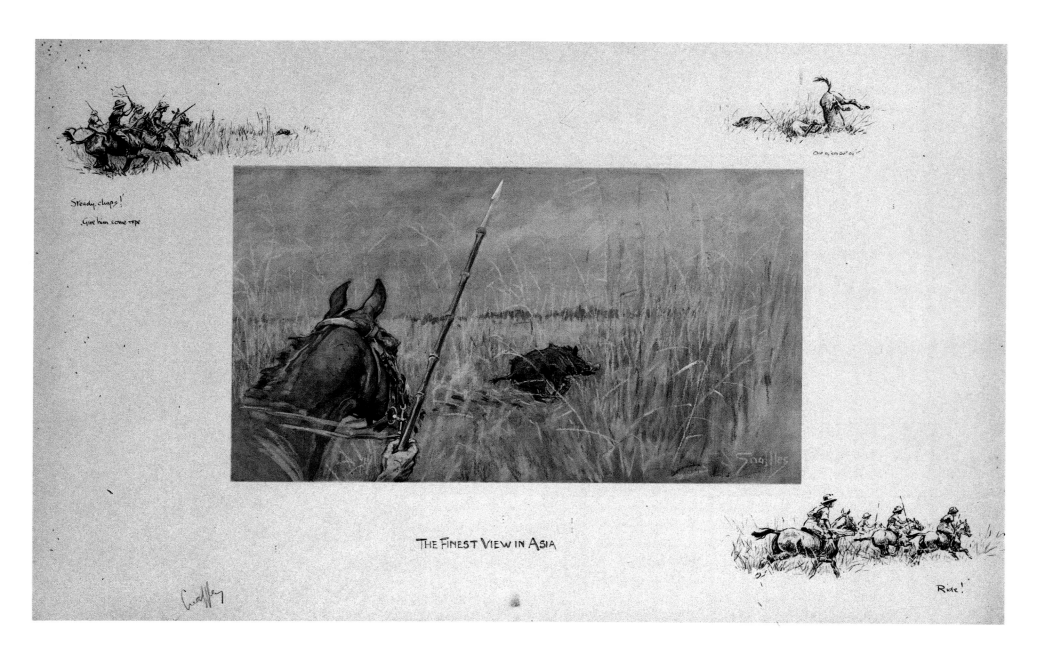

Steady, chaps!

Give him some rope

Out o' em out o'

THE FINEST VIEW IN ASIA

Ride!

Those who were bitten with the pigsticking bug regarded it as the finest
sport in the world, as not only was it very exciting but extremely dangerous.

of the earlier hunting prints and the background is left vague. Even the sub-editor of the magazine, writing the script beneath its reproduction, was moved to say: 'Perhaps the art critics will fault the drawing of the left hand foreground of this picture'.

But one thing neither the art critics nor anyone else could fault in this or any other of his pigsticking pictures was his accuracy of detail. One of those who took part in the sport has written: 'As a pig-sticker myself, I find it impossible to find any fault in horse, horseman, seat, spear or terrain or the hog himself!' No mean tribute to Snaffles' powers of observation and recall.

After the Kadir came the dinner where everyone forgot danger, triumph and disappointment and let themselves go. The old songs were sung and toasts were given. After the Loyal Toast came that to the gamest of the game – their quarry. It brought everyone to their feet. Following the recital of the verse already quoted – 'Over the valley, over the level' – its proposer spoke the lines:

> 'Gentlemen I won't detain you a minute,
> I hope every glass has something in it
> Are your glasses charged...?
> Mr Vice, the Boar!'

The shikaris (ghillies) were brought in and toasted, even the hathi (elephant) came into the celebrations which lasted until dawn. Snaffles attended the dinner and long afterwards drew a sketch of the entry of the elephant, confessing as he did so: 'My drawing of this hilarious occasion may seem somewhat hazy, for my eye and hand were anything but steady by the time old Hathi arrived to salaam to the Kadir wallahs in response to their toast to the elephants.'

And then it was time to arrange his sketchbooks, gather up his belongings and set off on the journey home. Lucy had accompanied him in all these forays but as always had kept quietly in the background. Now she attended to the tickets and the packing and all the details necessary to arrange the return journey by P. & O. The one thing she instructed Snaffles to do was to look after his gun, which was valuable as it had been made by a leading London gunsmith. But Snaffles was working up to the very last, sketching, recording, wrapped in his memories and oblivious of what was going on around him. He still, too, retained much of the fecklessness of his youth and indifference to worldly possessions. When the liner sailed Lucy asked him: 'Where is the gun, Snaff?' She was met by a blank stare – he had forgotten it.

That Indian trip proved a gold mine for Snaffles, both artistically and financially, and introduced his work to a still wider public. The sketches and pictures in *The Illustrated Sporting and Dramatic News* were so widely praised and attracted so much interest and attention that an exhibition of them was arranged to take place at The Sporting Gallery in Covent Garden; articles on the Kadir Cup and the P.V.H. were written for him to illustrate; and he was invited to create a special design for the menu card of the Hog-hunters' Dinner held at the Savoy with H.R.H. The Prince of Wales as the guest of honour, and Lieutenant General Sir Robert Baden-Powell (founder

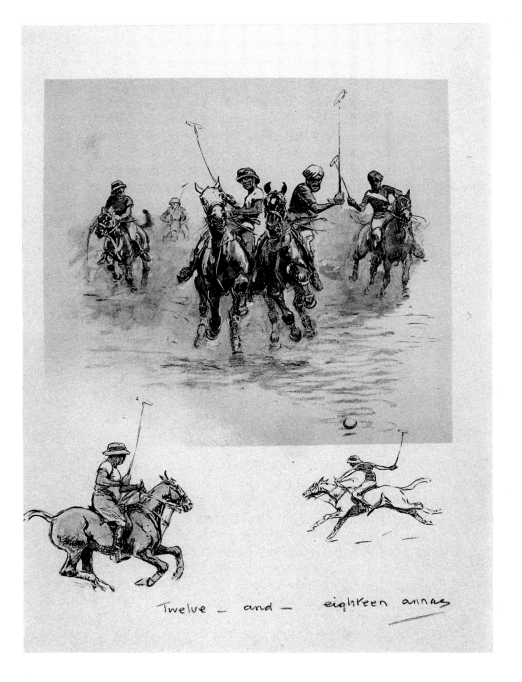

Twelve — and — eighteen annas

Snaffles was one of the few artists who has really been able to portray polo well. He ranks as one of the best international artists of the sport of all time.

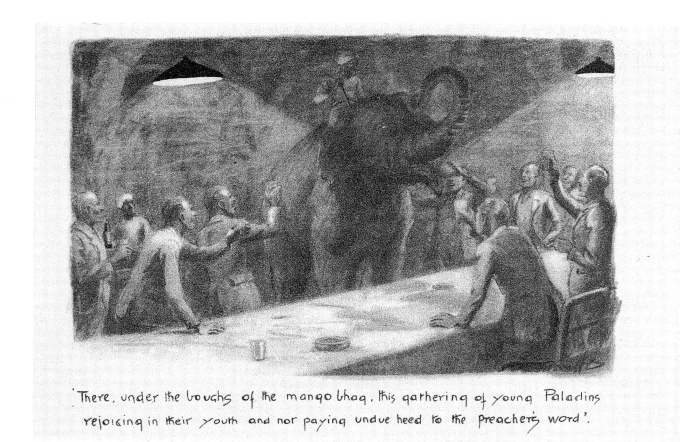

'There, under the boughs of the mango bhaq, this gathering of young Paladins rejoicing in their youth and nor paying undue heed to the preacher's word'.

It would be interesting to know if Snaffles got the idea for this drawing from Lionel Edwards' very similar illustration for Kipling's book, *The Maltese Cat*; or vice versa.

of The Boy Scout Movement and a previous winner of the Kadir) in the Chair. This design, referred to as 'by the famous artist Snaffles' was reported as earning 'the grateful thanks of all of us, for it was a most excellent one of a "warrantable" boar just making ready to charge'. Fores produced a number of prints of pigsticking including a set of four (see Appendix A numbers 101–4) which sold at eight guineas the set, and a profusion of his sketches appeared in *The Hoghunters' Annual* which alone was an endorsement of their authenticity. When *My Sketchbook in the Shiny*, dedicated to 'The good chaps at Muttra and Meerut and the Master and Whips of the P.V.H.', appeared in 1933, it was an immediate success and ensured that his work would last far beyond ephemeral magazine publication. He had come a long way from an enlistment in the ranks of the R.G.A. and sleeping in an officer's stables.

Nor did he forget his first loves of hunting and racing. *Mr. Jorrocks' Calendar*, with an illustrated quotation from Surtees for every month of the year – 'The whole is enclosed in a brown hog-grained leather case measuring 8½ × 11 inches. Price 20s post free' – was published soon after his arrival back

from India in 1928. It demonstrated for all to see that he could capture the characters of Jorrocks and James Pigg far better than any of the other moderns who had attempted it and as well as, if not indeed better, even than John Leech. It also gave another instance of the versatility of his talent.

There was a new equine hero, too, in Mr Jock Whitney's Easter Hero, the tearaway chestnut who had won two Gold Cups and, despite having spread a plate, almost won a National under the crippling burden of 12 stone 7 pounds. Snaffles painted him in full colour jumping the Canal Turn in 1929 alongside Gregalach, the eventual winner, to whom he was giving no less than 21 pounds which appeared in *The Illustrated Sporting and Dramatic News* on 22nd March 1930. It was the sort of heroic failure to instantly appeal to him and Easter Hero went immediately into his private pantheon of unforgettable equine champions alongside Sergeant Murphy and one or two others who were to join them later on.

Then, in 1930, came an invitation from Colonel Kerans to visit him at Birr, where he was spending a long leave, and to hunt in Ireland.

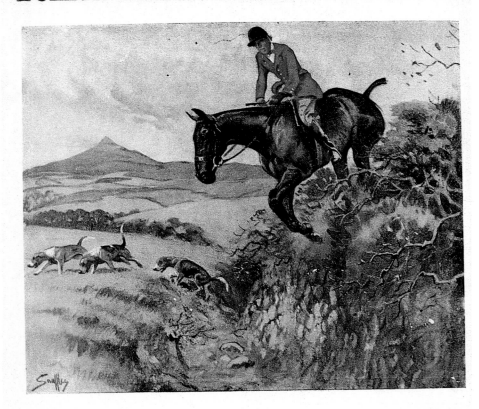

By
M. J. FARRELL
& SNAFFLES

First published by Collins in 1933.

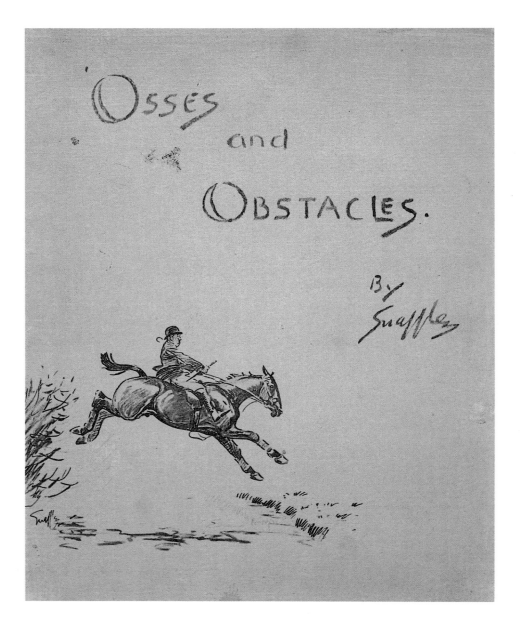

First published by Collins in 1935.

These Snaffles dust jackets are not shown to scale. For example *More Bandobast* and *'Osses and Obstacles* are each at least twice the size of *Mixed Bagmen*, however they illustrate Snaffles' work for this medium.

First published by Collins in 1936.

MIXED BAGMEN

J.K.STANFORD

Illustrated by Snaffles

First published by Herbert Jenkins in 1947.

Ireland and Red Letter Days

Snaffles' avowed intention of travelling to Ireland was to have a hunt with the famous Galway Blazers across their stone walls, of which he had heard so much. Arrangements were duly made and his first day turned out to be an eventful one. Since no hirelings were available at the time, there was some difficulty in mounting him and eventually Colonel Kerans asked Major Waller, who was in the East Galway country, if he could help. The Wallers had a spare horse, a point-to-pointer who was an undefeatable jumper but, having been raced, he liked to get on and took a fair hold. However, they agreed to take him along for Snaffles, although at the meet they warned him that he was unlikely to need the spurs he was wearing.

The meet was at Dunsandle, the home of the Master of the Blazers, Mr Bowes Daly. The hounds found almost immediately and raced away on a screaming scent. Mounted on a headstrong point-to-pointer crossing a strange country over the Galway walls – which he had never seen before – Snaffles had his hands full, and confessed afterwards that he was 'entirely over-horsed'. It did not stop him enjoying himself or observing all that went on. As hounds flew across an undulating country with a range of blue mountains in the distance and walls every few yards – or so it seemed to the stranger – the scene before him impressed itself on his eye and took shape in his mind.

The hunt continued for a further twenty minutes without a check but when they did pause there was no sign of Snaffles. His hosts were in some anxiety as to what had happened to him, but eventually he cast up, rather forlorn and slightly breathless. So struck had he been, he explained, with the instant recognition of a pattern for a picture that he had pulled up and, away from the hunt, taken his sketchbook from his jacket and set about recording it. When he put his sketchbook away he found himself alone – lost in a strange country. Somehow he had to find the field again, so he set out. As he quickly realised, and commented on in print, there are no gates in the Galway walls so he had to jump that point-to-pointer over them in cold blood. At least once he parted company and was lucky enough to have his mount caught and returned by a grinning country boy. It made a good story and lost nothing in the telling. Much good Irish Whiskey and a memorable Irish hunting tea at Dunsandle restored his spirits which in any event were hard to dampen for long and he set out to be driven back to Birr by Mrs Marjorie Waller. But the day was far from over.

As they drove along the winding roads towards Birr they passed a field from which came the sound of donkeys braying. Immediately he heard them, Snaffles asked Mrs Waller to stop the car. He jumped out and ran to the side of the road where he could watch them. There were two, standing together, ears cocked, contemplating some movement in the next field. He stood for some moments surveying the scene and the background and, on returning to the car, told Mrs Waller that they had given him an idea for a painting.

On arrival at Birr he was told that the Blazers' Hunt Ball was to be held that night at the Wallers' house and that he was expected to join the party and attend it. His bathwater was cold and he was aching from his exertions but good food and drink enabled him to join in the jollifications which went on far into the following morning. On their way back to Birr, when avoiding loose horses, the car in which he was travelling skidded and overturned. 'It was', he said writing a few years later in *Red Letter Days* underneath a sketch of the overturned car and its occupants, 'the end of a perfect day in East Galway!'

The following morning he asked Mrs Waller to drive him back to the field where he had seen the donkeys. Again he stood in silence for a time, absorbing background, colour and atmosphere. Back in the car, he told her he was satisfied, and she was struck by the fact that at no time on either occasion had he taken a note or made a sketch, but such was the genesis of 'The Informers'.

The other picture, 'The Biggest walls in the counthry was in it', an illustration of the Blazers' field in full cry, owes its origins to his hunt of the previous day, when he abandoned the chase to sketch it. It was published originally in *The Illustrated Sporting and Dramatic News* of 28th February 1931 and was a double-page four-colour spread and then entitled: 'More and more walls. Dammit there are more walls than fields!' Subsequently it was issued as a print with the altered title given above and its remarque of a large gentleman, 'Old Johnnie Smyth', pushing at the loose stones of the walls with his boot before taking it on. The riders in the immediate foreground are Major Waller, and his wife who is in the act of jumping.

It is worth noting how exactly Snaffles has caught them. Mrs Waller's eyesight was not good and her husband would always look back as he landed to see that she was all right. In the picture, Snaffles has portrayed this gesture as the Major turns in his saddle to watch his wife safely over. The other riders are identifiable too, among them Henry Smyth on the grey who had lost his cap earlier in the hunt, Brigadier Dominick Browne who is taking the wall in the middle distance, and Diana Daly riding side-saddle, as was Mrs Waller. The 'gent in ratcatcher' in the left of the picture is Snaffles himself riding for the brook. In his usual self-deprecating way he let it be known that he had ridden like a fool and landed like a lunatic, slap in the brook, but this, as we have seen, was not the case. He missed the hunt because he stopped to sketch and he included himself riding hard for a fall as a piece of artistic licence which in fact added to the composition of the picture. Having mastered the techniques he acquired in the twenties, he was to become more and more interested in composition during the first few years of the 1930s.

This four-colour double-page spread of the Galway Blazers was the last of

THE END
of a Perfect Day in East Galway

The captions Snaffles used for his illustrations in *Red Letter Days* were simply magical, particularly the one here and those reproduced on pages 88 and 89.

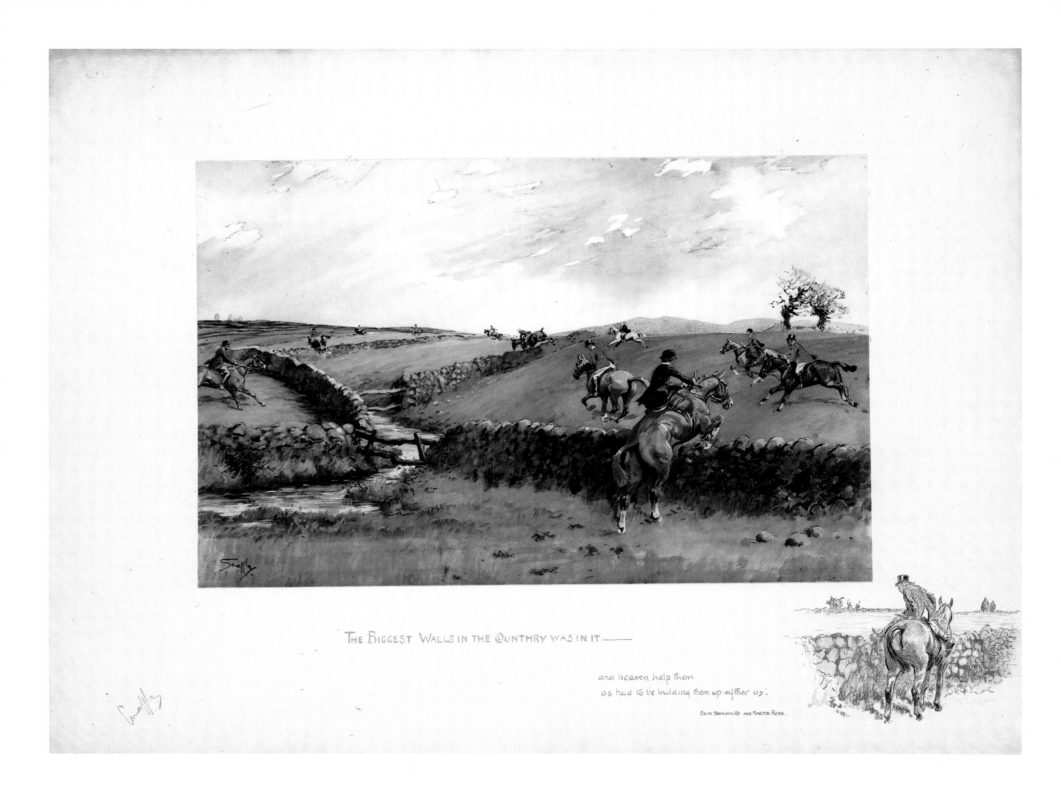

THE BIGGEST WALLS IN THE COUNTHRY WAS IN IT——

and heaven help them
as had to be building them up afther us.

EDITH SOMERVILLE AND MARTIN ROSS.

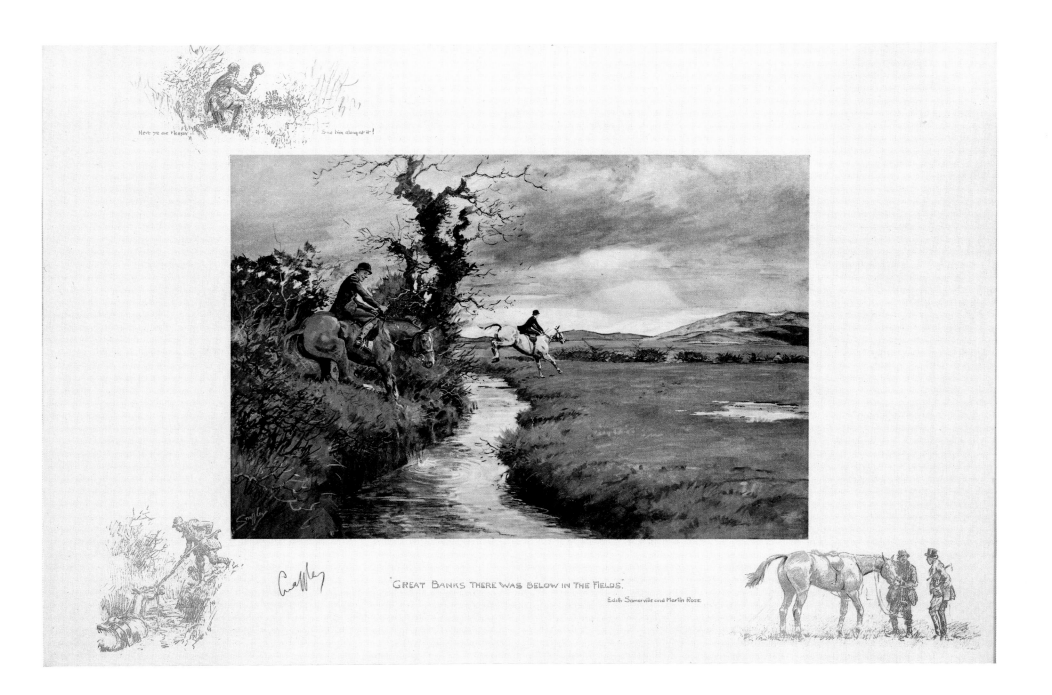

Here ye are Major Snd hm alang at it!

"GREAT BANKS THERE WAS BELOW IN THE FIELDS."

Edith Somerville and Martin Ross.

'Where a crow can go, he can go.'

his contributions to *The Illustrated Sporting and Dramatic News*, except for illustrations for an article on pigsticking. Henceforth, with the exception of a few contributions to *Punch*, he ceased work altogether for magazines, concentrating instead on original paintings, the best of which were in turn made into prints by Fores.

On that visit, much as he had in India, Snaffles found sport in Ireland occupying a corner in his heart, and he was a constant visitor during the next few years, sometimes alone, sometimes accompanied by Lucy. He did not confine himself to the hunting season but would come over in the summer, often to the Dublin Horse Show which he sketched and then he would drive about the countryside talking to all whom he met, his ear acute to pick up a phrase or an idiom which would give him an idea for a picture or provide a caption for one that was already in his mind.

Edith Somerville, whose books, we know, were some of his favourite reading, has described how she and her cousin, Martin Ross would listen everywhere, at meets, fairs or in railway carriages, to the cadence of the speech of the countryside and take surreptitious notes of it for their stories. Following in their footsteps, Snaffles pursued much the same course in his search for a caption. With his retentive memory he had no need for a notebook which would have given the game away and perhaps turned the spontaneity into stage Irishry. And what captions they were that he garnered: 'Where a crow can go he can go' and 'This horse would make a liar of St. Paul!' are only two which he was to use so effectively later on in the book *Red Letter Days*.

The following hunting season he was back in Ireland again, this time staying with the Hudson-Kinahans at Clohamon House, Bunclody, County

'This horse'd make a liar o' Saint Paul!'

Wexford. Colonel George Hudson-Kinahan, who had met Snaffles in India, had taken the Island Hounds on his retirement and invited Snaffles to stay and hunt with them. The Island is a bank country, in the north of County Wexford, which could not be better described than it was by Molly Keane in that wonderful evocation of sporting Ireland between the wars, *Red Letter Days*, the book she wrote under her pen-name of that time, 'M.J. Farrell', in collaboration with Snaffles: 'Wexford is the real paradise for those foxhunters who want the blood and bones of the thing, those bred to love sport rather than to follow fashion. A wild sort of country. Hardly a strand of wire. Not a great deal of plough and what there is rides light.' It was just the sort of country to appeal to Snaffles and once again he found himself among friends and 'tasted paradise'.

The Hudson-Kinahans mounted him on The Doctor, a patent safety over the tall narrow Island banks, many of them stone-faced which take a deal of jumping. He described The Doctor in a caption to the frontispiece of *Red Letter Days*: 'the brightest equine star in County Wexford is an old cocktailed horse with a big knee and a wide eye'. The Doctor carried Snaffles without fault or faltering over the roughest places of which there were many and Snaffles portrayed him with affection and gratitude. The horse also appeared on the dustwrapper of the book.

Red Letter Days came from that season in County Wexford. Molly Keane wrote the text and Snaffles provided the illustrations. Between them they produced an unforgettable picture of a place and time when such sport was shown as will never come again. It was a period of recession in the Irish horse trade, and in the chapter 'What matter?', Molly Keane wrote of those hunting people: 'We can't sell the horses so we may as well get some fun out of them.' She saw to it that the fun got into print and Snaffles portrayed it in his pictures.

THE INFORMERS

THE MOON LIGHTER.

'I WOULD BRING SUCH FISHES BACK'

(KINGSLEY)

To A.St.F
fm
Snaffles

91

A Devon and Somerset Balance Sheet.						
	The Visitor			The Aboriginal		
	£	s.	d.	£	s.	d.
Mount	200	0	0	15	0	0
Clothing and saddlery about	100	0	0	2	17	6
Overheads and subscription	150	0	0		—	
	450	0	0	17	17	6

'– and if you are interested in the result, follow the little pictures.'

Not only did Snaffles have an ear for a catching phrase, but this series of drawings demonstrates that he saw a hunt from several angles.

She, too, remembers Snaffles' modesty, his lack of pushiness, his listening ear and above all his photographic eye, 'like a snapshot', she says. She stayed with him at Guildford while they were collaborating on the book and they went together for two days racing at Sandown. Since Snaffles told her that he wanted to watch the seats and the styles of various riders as they tackled their fences, they saw much of the racing from down the course. Like others before her who had accompanied him when he had a subject or a painting in mind, she was struck by the fact that though he had a notebook in his pocket he never opened it. He confided to her that when he was either painting or sketching he intensely disliked having anyone watch him. She accepted that this was the reason she was never invited into his studio, even though he must then have been at work on the illustrations for their book.

This secretiveness may have been a sign of the insecurity he felt about his work owing to his lack of formal art education, or it may have derived from the modest opinion of himself resulting from his early struggles. Whatever

the case, there was no need for him to worry since this was the period when he was producing his very best work. His reputation was on the crest of a wave and his income more than sufficient for their lifestyle, which was modest, compared to that of the other leading equestrian artists of the day such as Sir Alfred Munnings, Cecil Aldin or Lionel Edwards. After World War I, Snaffles never owned a horse and did not have the expense of a large private stable as the other three artists did. Nor, as in Cecil Aldin's case, did he spend considerable sums of money supporting a pack of foxhounds. He told a friend that *My Sketchbook in the Shiny* had paid all the expenses of his trip to India and left a handsome profit over and above so that he could take all the time he wanted with his pictures. In fact his book and print sales helped him become increasingly a man of leisure; he spent more and more time racing, shooting and attending polo matches and horse shows and, of course, one must never forget that not only was he a keen fox-hunting man, but followed beagles, otterhounds and staghounds on a regular basis. By the late

 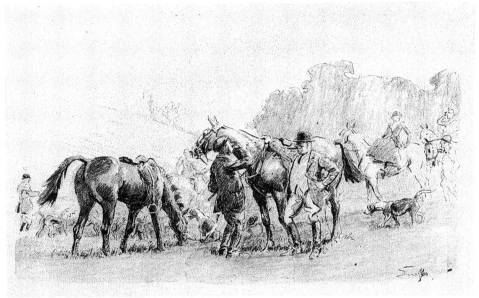

twenties Snaffles had developed his own distinctive style of painting and technique and the visists to Ireland combined with entire financial security and growing public acclaim were to produce a golden ten year period from about 1930 when his greatest prints were produced.

The result was that his paintings, and the prints made from them, were more colourful, the detail was painted in much finer texture and, above all else, the composition was more carefully thought out. We saw in the period 1920 to 1926 how Snaffles worked on the composition of 'The Finest View in Europe'. Certainly the print of 'The Biggest Walls' was a major advance in composition for Snaffles. No longer did he find it necessary to have the action taking place in the foreground or the central character or characters dominating the scene, as he had done, except with his Naval and Air Force prints, up to 1920. A good example of his increased confidence in composition is the print 'Happy are they who hunt for their own pleasure and not to astonish others' where the action is not in the foreground and no one figure dominates

the print. In 'The Biggest Walls' the action is all in the middle or far distance starting with Mrs Waller jumping away from the viewer and continuing into the far distance via a series of horses; the real action, the running hounds is out of sight, but any foxhunter knows exactly what is happening.

When Snaffles sat down to produce a companion piece to 'Biggest Walls' he was to produce another fine print of Irish Hunting, 'The Great Banks There Were Below in the Fields'. This print illustrates well his methods of working and the great attention he was paying in the early thirties to composition. It also demonstrates that he was now a complete artist and had mastered virtually every technique that an equestrian or sporting artist needed.

The first version or, perhaps one should say, the idea, appeared in *Red Letter Days* as a picture of a lady riding side-saddle on a grey horse, landing well out over a bank and ditch against a background of heather and hills, but, as he told Mrs Waller, the finished print was a composite. When he came to look again at the picture in *Red Letter Days* he decided to elaborate on it and

remembered a fence in the Ormond country, a big double, that he thought could well be fitted into a hunting scene.

Firstly he drew the large bank with its formidable ditch towards the left-hand side of the paper he was working on. This mirrors the wall and stream found in approximately the same place in 'Biggest Walls'. He then placed a rough rider on a young horse dithering on the edge of the ditch towards the left-hand side of the painting. The rough rider once again approximately mirrors Snaffles riding at the wall and stream in 'Biggest Walls'. In 'Biggest Walls' one can well imagine Snaffles having a horrendous fall into the stream while in 'Great Banks' one imagines the rough rider ending up in the stream because of the clever use of remarques. The lady on the grey whom he had seen going so well with the Island Hounds and who was, in fact, Mrs Janey Ryan of Edermine, was no longer allowed to dominate the scene as had happened in the sketch in *Red Letter Days*, but was moved to the near middle distance and to the centre of the painting. The viewer's eye now naturally runs left to right, i.e. from the rough rider at the left of the picture to the grey in the middle and across to the right-hand edge of the print where Snaffles added, in the smallest size possible, a pink coat negotiating a fence in the near distance. Once again, as in 'Biggest Walls', the viewer knows where the hounds are running. It is finally worth noting that in both cases Snaffles had used a grey horse to lead the viewer's eye across the painting. In 'Biggest Walls' it was Hugh Smythe riding and in 'Great Banks' Janey Ryan.

This print also demonstrates clearly how many of Snaffles' works were, in the final analysis, composites. This in turn accounts for the fact that so many people claim to be the models for, or know the scene of, his prints.

In their final form as prints 'Biggest Walls' and 'Great Banks' are probably two of the most effective of all Snaffles' hunting prints, and along with 'The Finest View in Europe' and 'The Worst View in Europe' are amongst his most sought-after works. These pictures all demonstrate as a mature artist not only his technical ability, which was by now excellent, but his ability to produce images that are loved by successive generations of sportsmen the world over, regardless of whether they have ever hunted in Galway, the Island country or Ormond. The caricaturist of the early days – whose lines were similar to those of H.M. Bateman – had vanished save in his pencil-sketched remarques which were more freely drawn and less stylised.

When he was with his friends in the Island country they tried to persuade him to become a fisherman, since the River Slaney which flowed below Clohamon was then a famous salmon river. He did not take to it at all but he did produce a fishing picture, 'A Slaney Fish', for *Red Letter Days* which again he altered and worked on before it became the print 'I would bring such fishes back' (Kingsley) showing a fisherman playing a salmon below a Bridge over the Slaney.

How hard he worked and the trouble he took to satisfy himself with both detail and composition is illustrated by the story of the painting of Captain (as he was then) Alexander's Corner Boy, already referred to. A year after he had first seen the pony he was writing to its owner: 'Hope you won't think I have forgotten all about the sketch of Corner Boy – I've been up to my hocks

94

Corner Boy

This picture shows the former polo pony Corner Boy in his old age dreaming of glories past, as Snaffles said, 'long ago and far away'.

Many of Snaffles' Christmas cards were based on successful prints or illustrations. This grey horse first appeared in 'Osses and Obstacles published in 1935 under the title 'Sheer Wizardry', when he had a docked tail and was carrying the huntsman rather than a top-hatted follower. Incidentally this Christmas card was by far the largest he produced and was really a print, measuring approx 10″ square.

in work but hope to get it off my chest within the next mail or so.' The next mail was a long time coming. No less than six years later, in December 1934, he wrote again: 'The Corner Boy picture is finished – dashed long time I've been about it. Now it is finished several of my pals have persuaded me to print it as it makes rather a pretty subject and so I have decided to do this and call it "On Pinsin". If you still want the original for the C.I.H. it will be here when you are on leave.' It seems, even then he was not happy about it and more work had to go into it. Over a year later he was writing again: 'I should very much like you to have the original but it has taken me such an age to do I could not bring myself to part with it for an ordinary amount – however if a rich bloke does not come along and tempt me by the time you retire I shall probably forget the sweat and agony I have put into it and will take a less optimistic view of its value...' Three more years went by and then, meeting Snaffles watching polo at Hurlingham, Major Alexander asked him about the picture and was told that it was finished at last and was in Fores Gallery in Piccadilly. Next day Major Alexander hurried along to Fores and asked to see it, to be told he was just in time, it had been sold to America for a large sum. The rich 'bloke' had indeed come along – and they were in the act of packaging it for export.

So Corner Boy's owner never even had a print of his pony; all he had was a sketch from a photograph of him playing polo, sent to him to check details; and it appears no prints were ever made of On Pinsin or at least none have survived. It was not until nearly another twenty years had elapsed that Snaffles from memory produced a colour picture of Corner Boy in retirement dreaming of his polo playing days, which appeared in *Four Legged Friends and Acquaintances*. In the end, Colonel Alexander, as he is now, commented, 'I never got the picture and I think I might have had a photograph of it!' Despite all Lucy could do, Snaffles' artistic temperament, of which he had his fair share, and his unbusinesslike habits could occasionally be infuriating.

He returned to Ireland to see the Wallers once again and to visit the Hudson-Kinahans at Clohamon. He was generous as ever with his gifts of prints and pictures and Mrs Waller remembers how, on his subsequent visits, he would take from their frames the prints he had given them and touch them up where he thought they required it. She also remembers how she had to chivvy him over his slowness in producing the sketches of her children on their ponies which he had promised her.

When he reached the Island country the point-to-point season was in full swing and he was asked to join Colonel Hudson-Kinahan as a judge at their point-to-point. In those days cobs' races were a feature of all meetings. These races produced a large entry and were vastly popular with the locals. They were hotly contested and were the medium for a considerable volume of spirited betting. The cobs' race was the last on the card and on this occasion the finish was a hectic one, the favourite, who had been heavily backed, fighting it out with an outsider. The two of them passed the post locked together.

Unfortunately, neither of the judges had been paying the attention they should have to the vital matter of placing the horses. Colonel Hudson-Kina-han, who was inclined to vagueness at the best of times, had left the decision

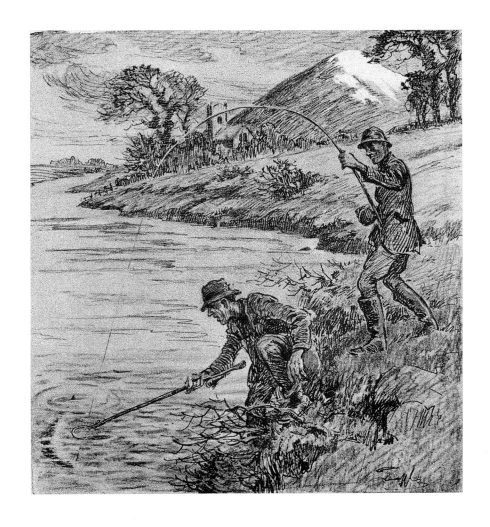

A Whale of a Fish

In the days when Snaffles was living in Wexford, working on *Red Letter Days*, the Slaney was one of the great salmon rivers of Europe.

to Snaffles and Snaffles, as he freely confessed, had been so enthralled by the scene that he had gone into one of his trances while memorising it. Neither of them had the faintest idea which horse had passed the post first. But a decision had to be made; they plunged – and gave it against the favourite.

The crowd, on the favourite to a man, were convinced that their fancy had won. In a moment, too, they had persuaded themselves that the visiting Englishman had a bet on the one he had named as the winner. There was uproar. A mob of infuriated countrymen advanced on the weighing tent, brandishing ashplants and baying for Snaffles' blood. It was an ugly situation which looked like getting worse when, fortunately for Snaffles, a priest intervened. He spirited him away through a gap in the canvas in the back of the tent, brought him to his car and drove him to Clohamon.

Snaffles – and who can blame him – was visibly shaken, and the sequel to his verdict with its implications of crowd violence etched itself far more firmly in his memory than the actual finish which had precipitated the whole thing. Along with the episode of riding over the boar already described, he used this incident to illustrate the difficulties those trances brought him into and he recounted the incident not only to friends, without revealing himself as protagonist, but he also mentions it in one of the fragmentary autobiographical essays that made up the text of his book *A Half Century of Memories* which was published in 1949.

Although this was his last visit to hunt in Ireland, he never forgot his friends in the Island country or in Galway. He gave Mr Bowes Daly an original painting of himself and his hounds in exchange for a terrier and pre-

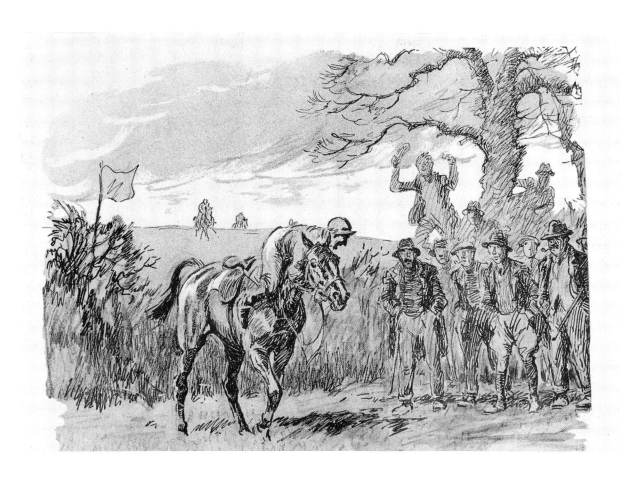

'They were on the favourite to a man'

sented Mrs Waller with the paintings of her children. Every Christmas all those he had known in those hunting countries and with whom he had shared the fun and the fears and the frolics, would receive personalised cards bearing affectionate greetings and memories of happy days.

These Christmas cards, which he and Lucy sent out every year, became a feature of his work. They were normally printed in black and white and then carefully hand-coloured by Snaffles himself. Sometimes they were just a plain piece of card with a long handwritten message from him and/or Lucy on the back, and sometimes they were in a more conventional form. Possibly, Snaffles first started to make them as a kind of advertisement to remind patrons or potential patrons of his work and later on they were often sent to people instead of a sketch. They were normally based on a successful illustration for

one of his books, or on a print such as 'Merry England'.

Another feature of his work is the small number of rough sketches that survived – his work tends to be fully finished or not to exist. Whether Snaffles destroyed most of his working sketches himself, or they were destroyed in the Second World War is unknown, but it is probable that as he disliked doing little sketches and giving them away, he developed his Christmas cards in lieu. In fact they have been of the greatest possible help to the authors when writing this book because they were so attractive that many of his friends kept them every year. It is from them that much of the information for this book has been gleaned.

Collectors consider this Christmas card to be one of Snaffles' most pleasing.
He has certainly caught the scene brilliantly.

Snaffles has inscribed this 1929 Christmas
card with the words 'Happy Christmas and
may you chip in for the good things of 1930'.

This lovely Christmas card is based on one of
Snaffles' most popular prints 'Merry
England' which was first published in 1927.
However for Christmas he has set the scene
in a snow storm rather than heavy rain.

'Co-ops'

Although Snaffles spent a considerable amount of time shooting, alas he produced no prints of this sport. Most of the drawings he did of shooting, except in India and Ireland, were done in a five year period, 1947–52.

'The Individualist'

Just as in 'Styles in Navigation' (see pages 56 and 57) Snaffles' loyalties were
tested when it came to deciding whether he preferred the style of his smarter
friends or patrons to that of the individualist.

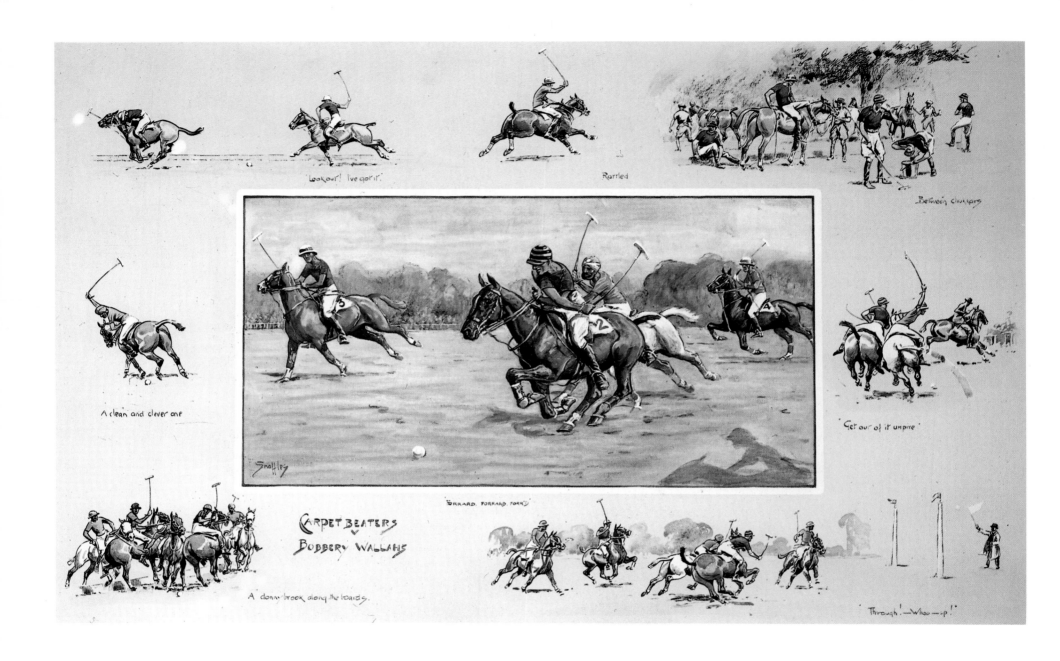

'Lookout! I've got it.'

Rattled

Between chukkars

A clean and clever one

Get out of it umpire

CARPET BEATERS
v
BOBBERY WALLAHS

FORRARD. FORRARD. FORR'D.

A donny-brook along the boards.

Through! —Whoa—up!

Although Snaffles only produced three prints of polo he was a frequent
visitor to polo matches at the London clubs and in the Aldershot area as
well, of course, as on his trips to India.

'The Barren Rocks of Aden'

A Second Trip to India

More Bandobast (Bandobast = arrangements; organisation), published in 1936 was the product of Snaffles' second post-war Indian tour in late 1934 and early 1935. Stopping first in Aden, he drew the 'concrete gunners' guarding the fortress for coaling the Empire's ships and protecting her trade routes. With typical attention to detail he pointed out in the caption to one colour plate: 'To disarm the sticklers for military detail, the Gunner Badge is deliberately placed on the right hand side of the helmet to add to the colour effect' and 'the contours of the coastline are generalised so that a gun position may not be revealed to my country's possible enemies'. Proceeding on to Somaliland he stayed with the Somali Camel Corps, rode with them and hunted warthog, 'the next best thing' to pigsticking.

In India once more, this time further south and based on Secunderabad, he went out with the Ootacamund Hounds and compared the country to Exmoor, noting that 'no obstructions occur which might necessitate a horse leaving the ground seriously'. He went wildfowling for teal and grey lag geese and visited the Equitation School at Saugor whose methods he was able to compare with those of Taffy Walwyn's at Weedon.

On Snaffles' previous visit to India, after the final of the Kadir Cup and the running of the two races after it, everyone insisted on his joining them in another ride after pig and he was mounted on one of the finest horses, Manifest, who was later to win two Kadir Cups.

During the chase he mishandled his spear by holding it across his body in thick thorn, a frequent novice's mistake he was told afterwards. This resulted in each end of the spear catching in the thorn and he was 'absalomed' – lifted out of the saddle and deposited on the hard ground. Shaken, he remounted, broke a leather and, out of control, nearly landed himself amongst 'a cohort of pigs'. Finally, with difficulty, he managed to pull up and gave up the hunt, with his mind made up 'that if St. George himself offered me a ride on his dragon-sticker I would decline and in future watch this pigsticking business from the back of an elephant'.

In *My Sketchbook in the Shiny* he illustrated his nasty experience of absaloming. Snaffles never minded doing self-portraits and often showed himself to comic disadvantage especially in his books where many pages are devoted to self-portraiture. However, throughout his life he thoroughly dis-

Absolam'd

SPREADING THEMSELVES

The title 'spreading themselves' is one of Snaffles' favourites and was
normally used when depicting his beloved Gunners at the gallop.

liked posing for photographs and was seldom photographed except when it was unavoidable in a group scene.

So when he was at Saugor he intended to go pigsticking as a spectator rather than as a participant. Since there were no elephants available, the equitation officers mounted him on a small grey Arab called Grey Sprite. At first Grey Sprite proved the ideal hack; however, when a boar broke back across the line, Grey Sprite, as Snaffles describes in one of his books, was after him like a long dog and he had an even more perilous ride than before which he describes in hilarious detail. When one considers that he was then in his fiftieth year and had never been regarded as a physically strong man, one can only marvel at and admire his spirit and hardiness.

He went into the jungle, too, painting, shooting and studying camouflage as applied to the wild. His intense interest in the latter led to an unpleasantly close encounter with a tiger, so intent was he on examining how the beast's stripes blended with its background, relating what he saw to his war-time experiences with dazzle.

It had been his intention to wind up the trip with a visit to Meerut for the Kadir but, as he wrote to Major Alexander from S.S. Ranjuna at Bombay, in yet another letter about Corner Boy: 'I had arranged to see the Kadir and go home in *The Viceroy* but as they altered the date of the former to the date on which this ship sails we decided to come home in this packet and see the National – if we stayed for the Kadir we could not get a ship till the end of April. I have managed to get hold of some grand material especially in the jungles around Gug (Jubbalpure) and Saugor.'

He returned home to be greeted by the news that his old friend Cecil Aldin, who had been in bad health for some time, had died while he was away. But perhaps an even greater shock was the sudden death of Rudyard Kipling the next year. Snaffles had at last been able to arrange a meeting with him. It was to take place at Brown's Hotel in January 1936, but a few days earlier Kipling was rushed to the Middlesex Hospital with an internal haemorrhage. He died on 18th January, the very day on which they were due to meet. So Snaffles never did meet in the flesh the man whom he admired above all others in the literary world and whose works had been to him throughout his life both an inspiration and a joy.

More Bandobast increased his reputation, his pocket and his public. An exhibition of his pictures from this book and from his second trip to India was held and attracted wide attention. It included watercolour landscapes at which he appears to have tried his hand for the first time. Several of these were also included in the book and it must be admitted that they do not rank with his best work or anywhere near it. This was not his forte, as he was no landscape painter, having neither the temperament nor the training. Snaffles seems to have realised this himself, for it does not appear that prints were ever made or marketed from these watercolours.

This was soon followed in 1937 by the death from pneumonia of another friend, fellow-Gunner and brother-in-arms, Gilbert Holiday, who had been confined to a wheelchair after a bad fall with the Woolwich Drag two years before. Though he had continued with great gallantry to struggle through

pain and discomfort to work to the end, Holiday's injury had curtailed his production and his widow had been left badly off. To help her as well as to create a tribute to his memory, his friends in the Regiment, headed by Brigadier Lyndon Bolton, organised the publication of a book of his paintings and sketches to be called *Horses and Soldiers*. Snaffles' assistance was asked, which he gladly agreed to give. He advised on the arrangement of the plates and discussed captions with Brigadier Bolton, some of which he thought up and drafted himself. He also contributed a gracious appreciation of the artist and his work in which he revealed that they had discussed together the problems confronting the portrayer of horses in action which ended:

More Bandobast saw Snaffles illustrating
books with simple scenic watercolours.

'We'll all go riding on a rainbow.'

Snaffles found hunting with the Ootacamund Hounds similar to hunting on Exmoor.

'A morning's ghoom with a sketch book
near Muttra'

On Snaffles' second post-war trip to India
he became more interested in the scenery,
flora and fauna than on his first trip when
sport of all types had been his main
preoccupation.

'And now his pencils, chalks and palette have been put away, his seat on the Canal Turn Stand has been taken by another, the riders of the Woolwich Drag have a bowler hat the less popping over the fences in front of them, and all that is left is a warm corner in the hearts of his old friends. Vale.'

There is no doubt that he was now, more than ever, a celebrity. Collins, under the guidance of Billy, later Sir William Collins, a sportsman himself, were now publishing his books and putting all the weight of their powerful marketing organisation behind them; *The Hoghunters' Annual* was referring to him as 'the great sporting artist': the sales of his prints were considerable.

Though he remained essentially the modest man he had always been, mixing with no coterie and exercising no wiles to push either himself or his work, he could not avoid being affected to some extent by his growing fame. Like many of those of his temperament he did suffer, if ever so slightly, from a T.E. Lawrence – like tendency to back into the limelight. A dealer who knew him well recalls that when he came to the gallery he expected a certain amount of deference and enjoyed instant recognition by a stranger, together with praise and admiration for his work. This was only a minor facet of his character, for success truly did not spoil him. Had it even begun to do so Lucy would have intervened.

Lucy has been aptly described by a Gunner friend as his 'guiding star'. By now she was his manager, relieving him of all financial worries, and husbanding the considerable sums he was earning. The marriage was childless, and although he never spoke of it this must have brought sorrow to them both, especially to Snaffles for he liked the young and took pains to encourage those who showed promise or shared any of his enthusiasms.

One young officer about to be commissioned into the Indian Army was brought to lunch at the White Cottage by his parents who had met Snaffles in India. On hearing that the young man drew and painted in watercolour, Snaffles immediately expressed interest and engaged him in conversation, as one artist to another, about his methods of working and subject-matter. After lunch he conferred upon this young man the almost unheard-of privilege of taking him into his studio and showing him his work in progress. Then he suddenly went to a drawer, opened it and took out two prints, 'The Finest View' and 'The Wet Nullah', signed them on the mount and gave them to him saying they were a twenty-first birthday present (the fact that he was about to attain that age having been casually mentioned at lunch). These prints now hang on the walls of that officer, today a Lieutenant-Colonel, as a testament, he says, after all these years, to 'the admiration and appreciation of a very young officer towards an accomplished artist and a very charming and generous person'.

He had kept up his friendship with the Walwyn family, too. He gave Peter Walwyn a signed scrapbook in which to keep the sketches and cards with his messages on them which he sent him and drew him on his donkey, presenting him with the initial sketch for the finished picture. When, a little later, he found that Peter's step-sister, Jean, was interested in drawing and sculpting horses, he helped her with the technique he had himself found so difficult to

"I got that one near Meerut, he'd
been Secretary for over six years —
Almost a record"

Snaffles contributed not only accurate but
some highly amusing drawings to *The
Hoghunters' Annual* over a long period.

achieve, drawing sketches with arrows to show the effect of light and shade and how it was obtained.

As neighbours at Guildford, he had the Chatterton Dickson family with whom he formed a lasting friendship. It has been mentioned earlier how he encouraged the young William Chatterton Dickson to join the Navy and he took a tremendous interest in the boy, showing him the beautiful wooden model of his father-in-law's ship which he had in his studio — the young were more easily admitted there, it seems, than adults — and promising him that he would be given it when he grew up. He also talked to the boy about his own days in the Navy, about ships he had served in and officers he had served under, liked and respected, among them 'Humph' Walwyn, later Vice Admiral Sir Humphrey Walwyn, Taffy's elder brother, another of his many friends from all walks of life.

Undoubtedly, there was about Snaffles a certain chameleon-like quality which, far from detracting from it, enhanced his charm and made him immediately acceptable to any company in which he cared to mix — a quality, incidentally, which he shared with his hero, Kipling. A close friend confirms that he had an extraordinary ability to become part of a scene in a very short time as if he had been there all his life. With the Navy, he was the naval officer par excellence; in India the epitome of the 'Qui Hai'; and when he returned from Ireland he might have been, as that same friend recalls, 'straight out of Tipperary'. There was nothing false or affected about this: had there been, none of the closed societies he entered so easily would have tolerated him for a minute; it was simply the natural ability born in him to assume a different skin and to be at home anywhere he wanted to be. And there was always Lucy, quiet and supportive, whose ready tact was able to smooth over the few rough patches created by occasional lapses of temperament.

More Bandobast was the fruit of his last trip abroad, for another war was coming and Snaffles' friends in the services knew it. His work with dazzle in the last one was remembered and he was called in to advise on the camouflaging of aerodrome hangars and other likely targets for enemy bombers. This took up much of his time and his output as an artist decreased. In 1938 an exhibition of British Sporting Trophies organised by *The Field* at the Imperial Institute, Kensington, included a pigsticking wall, the centrepiece of which was his portrait of Scott-Cockburn on Carclew with, beside it, four of his other pigsticking prints. In the following year he contributed to what turned out to be the very last issue of *The Hoghunters' Annual*, a humorous caricature which its editors used as the frontispiece. On it were depicted two boars at their ease, smoking after-dinner cigars, regarding the head of a pigsticker mounted on the wall above crossed spears. One was saying to the other: 'I got that one near Meerut, he'd been secretary for over six years. Almost a record.' Behind them on another wall was a miniature of a boar chasing a 'Qui Hai' who was legging it for cover for all he was worth. The years had not diminished Snaffles' gift for seeing and recording the comic side of sport.

And then, in September 1939, Hitler invaded Poland, Chamberlain declared war on Germany, the 'phoney war' began and, for Snaffles, to quote his beloved Kipling, it was 'back to the army again' — or very nearly so.

Snaffles found the jungle particularly fascinating and tried to rationalise the large cat's camouflage with his experiences of dazzle in the First World War.

MISTER STRIPES

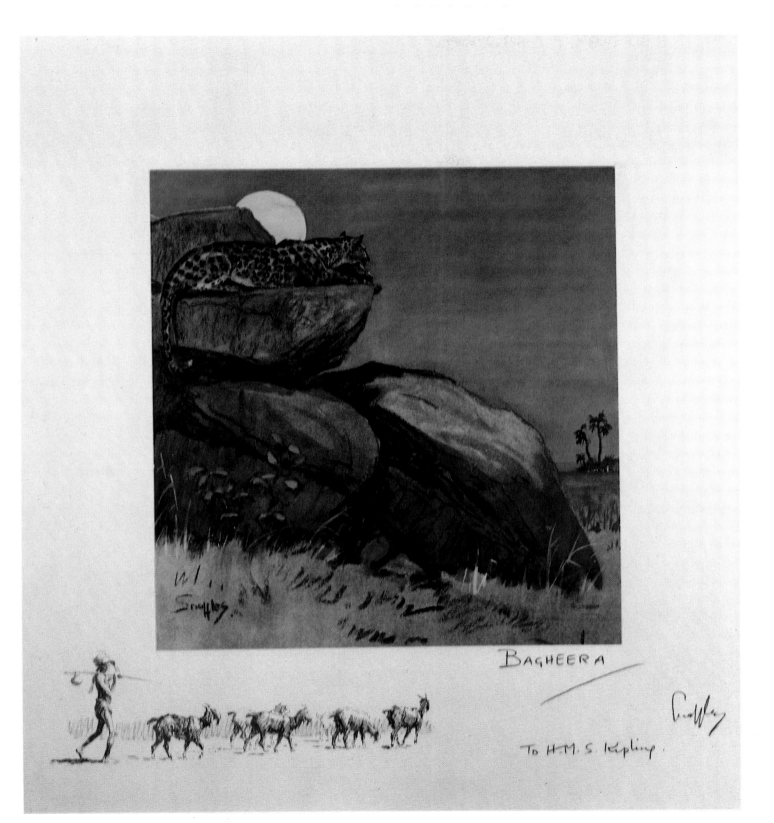

BAGHEERA

To H.M.S. Kipling.

One of the great attractions of India, as well as the marvellous lifestyle, was its close association with his hero, Kipling. Later Snaffles gave inscribed examples of his prints to the destroyer named after the author.

Their Lawful ———

Occasions

"'Tis my delight on a shiney night."

THE REUNION

Although we associate Snaffles' best known work with the rather formal
occasions such as racing at Aintree or Sandown and hunting with the Quorn or
Cottesmore, he loved all country pursuits, fishing perhaps less than others.
This charming series of drawings of a lurcher named Rocket shows the artist's
ability to merge into any sporting situation. Rocket's aquaintance was made
in the taproom of a pub on Dartmoor, during the Second World War.

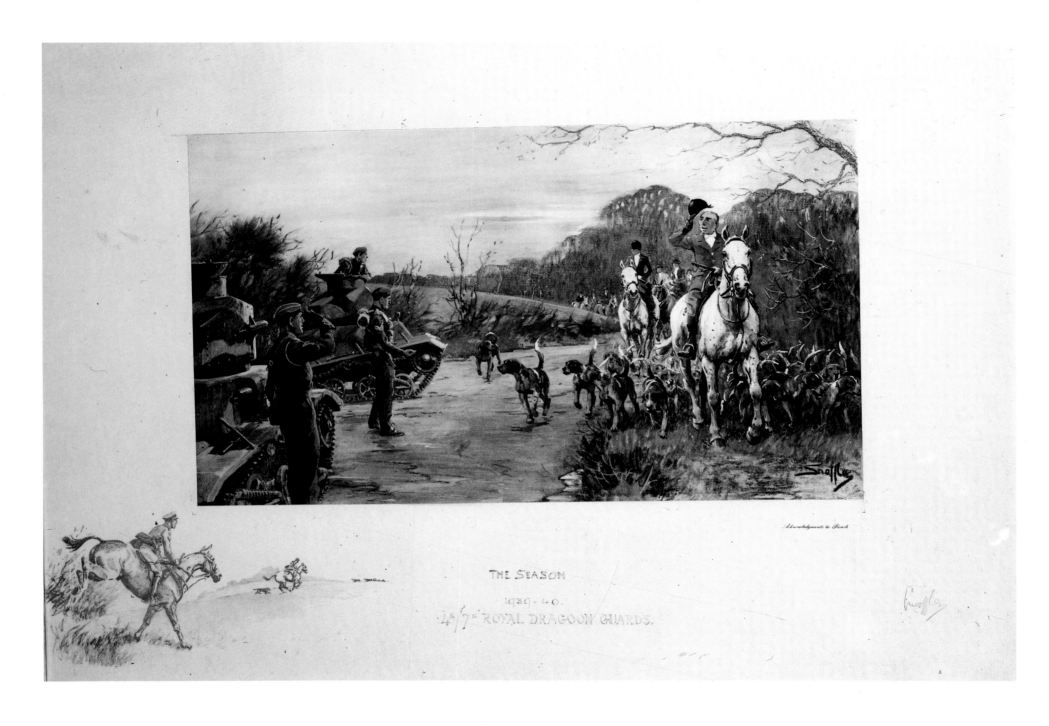

THE SEASON

1939-40.

4ᵗʰ/7ᵗʰ ROYAL DRAGOON GUARDS.

The Season 1939–40

'Pass Friend'

This print was published during the Second World War. It has been
republished in the 1980s with a facsimile signature in place of the original
pencil signature.

The Second World War

The first of Snaffles' war-time drawings, 'The Season 1939–40' appeared in *Punch* in November 1939. Here a troop of light tanks is drawn up at the side of a road. An officer in the nearest tank stands in its turret, saluting a pack of hounds which is passing by led by their huntsman who doffs his cap. While he was working on this drawing Snaffles was not satisfied that he had got the folds of the tunic in the officer's saluting arm just as they should be. The Chatterton Dickson family, as has been said, were then neighbours and friends at Guildford. Unhappy with what he had done Snaffles asked Colonel Chatterton Dickson to come to the studio and pose for him at the salute which he agreed to do. When, immobile, he had held the pose for some fifteen minutes while Snaffles, oblivious to all else, continued to paint, he protested: 'For God's sake, Snaff, haven't you finished yet?' Interrupted, Snaffles looked round in some surprise. 'Oh', he said, 'You still here, are you?' It was another instance of the way he became utterly engrossed and oblivious to all else when at work and one of the few occasions when anyone actually saw him at his easel.

The print in its final form, differs considerably from the illustration, though due acknowledgments are made to *Punch*. The tanks have been reduced in number and moved to the left foreground; the officer, now wearing the scarlet and blue 'fore and aft' forage cap of the 4th/7th Royal Dragoon Guards, has been taken out of the turret and stands in the immediate foreground, saluting the hounds; the whipper-in of the sketch is replaced by a lady riding side-saddle with the followers of the hunt behind her. The whole makes up a more attractive composition than the illustration in the magazine and is, as well, a slice of social history. It also illustrates again Snaffles' methods of altering, working and reworking until he was satisfied with the finished article which could be issued as a print. A series of monthly sketches in *Punch* of military and naval occasions followed; he joined the Home Guard when the threat of invasion loomed and here too his pencil was busy. 'Pass Friend' showed one of his companions on a night patrol beside his horse, an American issue .300 rifle slung on his shoulder, watching a fox steal into a spinney. Alas, Snaffles' health did not stand up to Home Guard duties, he was well over fifty-five, and he had to resign.

Then, during the Battle of Britain, a stick of bombs straddled the White Cottage. Work became difficult and Snaffles and Lucy decided to leave.

Colonel and Mrs Langford, with whom they had stayed in Muttra and often met hunting with the Garth, offered them refuge in their house in Somerset. They packed up, stowed their belongings, which included Snaffles' prints and pictures, in two different warehouses where they hoped they would be safe from bombing, and took up residence with the Langfords.

It was not altogether a happy time. Snaffles was not well; he was suffering from a heavy cold and his temperament was showing. He asked for a spare bedroom with a north light to be used as a studio and a sitting room where he could relax. He spent much of his time in these rooms but despite this and all that Lucy's tact and diplomacy could do, the arrangement did not work out. After about a month the guests moved out, going to live at a farmhouse near Wellington. It is a tribute to both families that, despite the slight difficulties in getting on which had arisen when they lived at close quarters, the friendship did not lapse and they continued to see each other constantly, right to the end of Snaffles' and Lucy's lives. 'They were so charming and nice with it all you could not really fall out with them', Mrs Langford recalls.

The friendship with the Chatterton Dicksons remained stable too. They spent a holiday together near Haytor in Devon where Snaffles and Lucy had moved and where Snaffles was helping with the farm work though his ill health persisted. He sent Peter Walwyn a sketch of the Dartmoor Home Guard. 'Uncle Tom Cobley's Dragoons' he called them, adding: 'They are mounted on Dartmoor ponies. Such handy little chaps. I should very much like to be with them but the doctor won't let me.'

From this period too came his 'farming' prints, the best known of which is the farmer with his team of horses raising his hat to a flight of bombers overhead and saying: 'Forrard on me lads and hit 'em bloody hard.' It is an instance of the susceptibilities of the time that when this came to be issued as a print, the word 'bloody' was excised to be replaced by a dash!

After Wellington Snaffles and Lucy lived for a time at Orcheston St Mary and around 1944 moved to Hill Farm, Winterbourne Stoke, near Shrewton in Wiltshire. Soon after the war they moved to Orchard Cottage, Tisbury, also in Wiltshire, which was to be their home until the end. Snaffles built a studio in the garden and spent much time in it, or watching birds at the nearby Fonthill Lake. Tisbury, by a coincidence which must have appealed to him, had associations with Kipling. John Lockwood Kipling, the poet's father, lived there from the early nineties of the last century until his death. Kipling himself was a frequent visitor to his parents' house and during the writing of *Kim* would bring the manuscript down time and again to discuss its details with his father. This alone must have been one of the many attractions Tisbury held out for him since the poet was never far from his thoughts and the all-pervading love of his poems was with him always. When he heard that a destroyer, H.M.S. *Kipling*, was commissioned he presented a set of his prints to the wardroom and another to her Captain and, after her sinking, he replaced the Captain's set.

This was but one instance of his thoughtfulness and generosity. Where his friends, and particularly their young, were concerned, no trouble was too much for him. Though he had long since ceased to ride or own horses his

and now it's Uncle Tom Cobley's Dragoons

Snaffles spent quite a bit of time on or near Dartmoor during the Second World War. The above drawing is of the Dartmoor Home Guard, mounted on Dartmoor ponies. Snaffles has got the relationship between man and horse quite clearly wrong, as the nearer soldier appears to be riding a nag which is more like a gun horse than a pony.

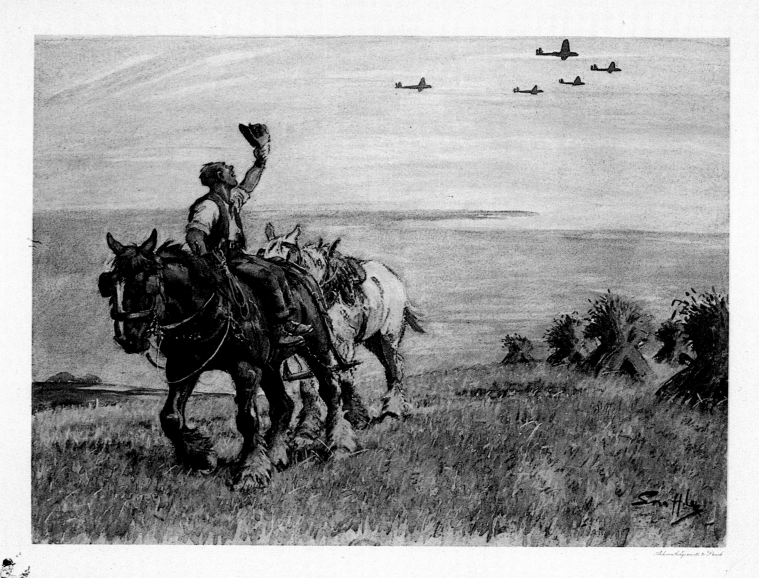

"FORRARD ON ME LADS, AND HIT 'EM 'ARD!"

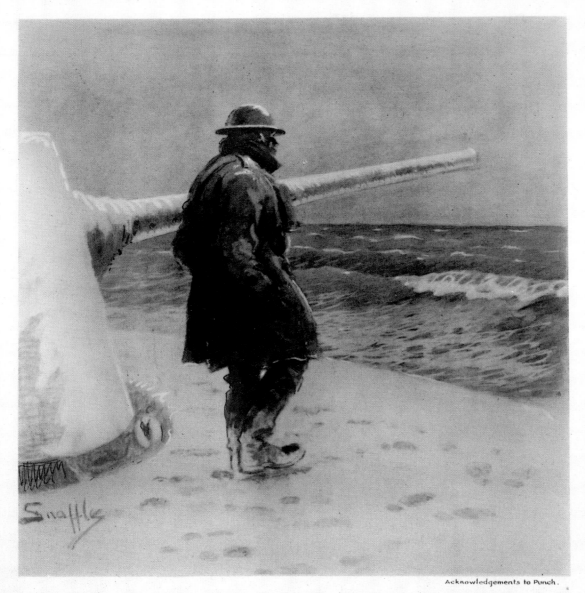

Snaffles

"UBIQUE MEANS ——"

(R.K)

Acknowledgements to Punch.

Snaffles executed this
picture at Dover during the
terrible winter, 1940–41.

Like his close friend Cecil Aldin, Snaffles was keen on encouraging children to ride; although in his latter years he must have been a rather daunting figure until they got to know him.

"WELL! THAT'S PONY CLUBS IS IT?"

Orchard Cottage, Tisbury, where Snaffles spent the last twenty
years of his life, and where his widow Lucy lived for some thirteen
years after his death.

interest in them and those who did, remained as strong as ever. On learning that Gillian Chatterton Dickson had a passion for ponies and riding, that there was little horse-knowledge in the family and that the riding round Guildford was not of much account, he introduced her to the South and West Wilts Pony Club, gave her every encouragement and help, and during the annual camps made a home and base for her at Orchard Cottage. It was when her parents came to collect her from one of these camps that Snaffles and Lucy suggested to them that a house beside them was for sale. The Chatterton Dicksons inspected it, liked it, and bought it, remaining their closest neighbours and friends to the end.

The war years were hard on Snaffles in many ways. His age and health made it virtually impossible for him to fulfil his determination to serve in the Home Guard or on the land. Certainly those years saw a rapid deterioration in his general health but of far greater concern to him was the gradual, but marked, loss of sight. He also felt, terribly, the loss of most of his effects which were destroyed in two separate fires. The first, in the war, was probably the result of enemy action. However, the second, came after the cessation of hostilities and was a terrible blow to him as he lost nearly all his pre-war sketchbooks, original paintings and prints. This fire, which destroyed the warehouse at Taunton, containing his personal belongings, was one of those million-to-one accidents: the building was burnt down during the V.E. Day celebrations, catching fire from a carelessly-thrown firework.

But great though this blow was, and although his health was not good and his eyesight beginning to fail, reassurance came that he was not forgotten because soon after cessation of hostilities in Japan he was asked to contribute to *The Royal Artillery Commemoration Book of the War*; a companion volume to the one produced after the First World War to which Snaffles had contributed. When it was finally published in 1950, amongst his contributions were 'Open Sights' showing the 31st/582 (Maiwand) Battery in action near Gazala, and 'Ubique Means', a painting of a coastal gunner standing beside his gun staring out to sea in a squall of wind and rain. The latter demonstrated how he kept up his loyalty to his own old arm, the 'concrete gunners', the forgotten men of the Royal Regiment.

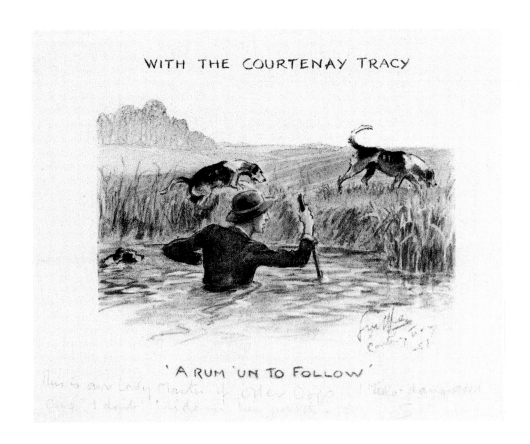

WITH THE COURTENAY TRACY

'A RUM 'UN TO FOLLOW'

EVICTED

Snaffles loved all country pursuits and was
a keen follower of otterhounds for nearly
sixty years. He is being a bit unkind here, as
he has inscribed this Christmas card, 'This
is our Lady Master of Otter Dogs. I take
damn good care I don't ride in her pocket.'

Judy, Biddy and Vixen were Snaffles' three
favourite terriers. They all appeared on his
Christmas cards at one time or another.

"You're a better sight than the Lord Mayor's show."

THE WHEAT IS MY CARE. THE REST IS THE WILL OF GOD

During the war, after his health had made him retire from the Home Guard, Snaffles was involved in farm work. For the first time agricultural activities began to appear in his prints and Christmas cards.

This image was used not only for the above Christmas card, but also for a print which was issued towards the end of the war.

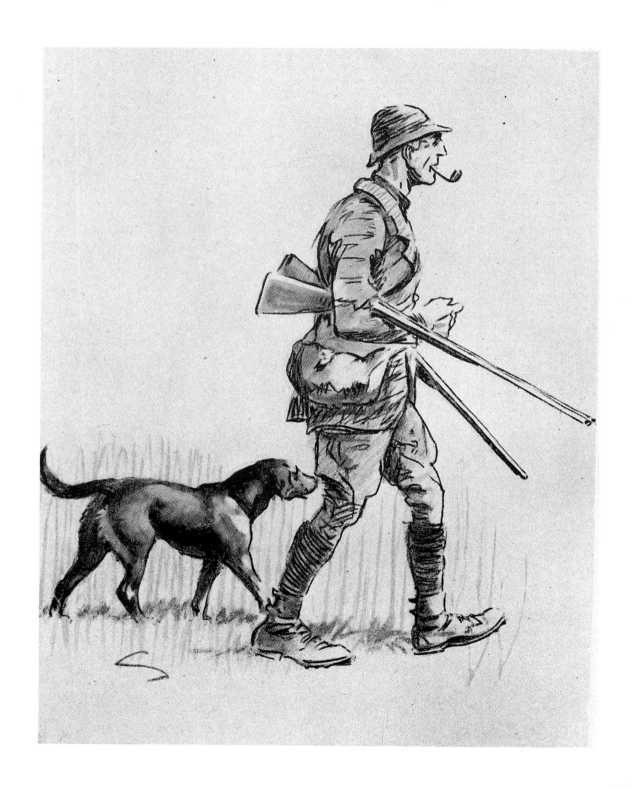

Mixed Bagmen for which this drawing was executed, was published just after the war. It was devoted mainly to shooting and was Snaffles' first major post-war artistic success.

The Last Years

Certainly when peace came Snaffles was feeling his years, but worse still, from the point of view of the sporting artist, it was a time of austerity when anything approaching frivolity or ostentation was out of fashion. A socialist government with a vast majority was in power; field sports were frowned upon as pursuits of the former ruling few, the demand for sporting art was at its nadir and there was paper-rationing coupled with difficulties of production.

As luck would have it, he was asked in 1946 by another friend, J.K. Stanford, the bestselling author of *The Twelfth* to illustrate another of his early books, *Mixed Bagmen*. This dealt largely with shooting and Snaffles' lively illustrations showed that he had not lost his touch and that he could depict that sport as well as horse sports which he also illustrated in the book.

To the end, Snaffles remained an unrepentant Victorian in his attitudes and values; his crusty outlook upon modern life and society did not diminish with the years. He loved the country and the countryside, dogs and horses, the changing season, and he detested urbanisation and mechanisation. His thoughts, as those of ageing men will, were turning more and more to the past when there was galloping grass everywhere in the Shires, when no fence was too big and no horse too bold.

With little demand for prints, and following much press acclaim for his illustrations in *Mixed Bagmen*, Snaffles resolved to set down on paper his recollections of those happy days and to illustrate them. The fruit of these recollections was *A Half Century of Memories* with its sketches and colour plates, most of them humorous, all of them elegiac of a lifetime of sport and the services, lived to the full. 'I've taken my fun where I found it', he recorded on the fly-leaf of the book which was published by Messrs Collins in 1949, and indeed he had.

All Snaffles' life he had been a hero-worshipper; it was one of the attractions of his essentially simple character and he still had his heroes, chief amongst them of course being Rudyard Kipling. 'Some folks, will say', he wrote in *A Half-Century of Memories*, 'that I have ridden very hard in his pockets. But could I have had a better pilot?' and he continued unrepentantly to quote and misquote him whenever occasion arose. Kipling was closely followed by the Walwyns, Taffy and his elder brother, the Admiral; Sir Aubrey St. Clair Ford, the Captain of the *Kipling*; Scott-Cockburn of the

Kadir; Tom Isaacs, huntsman of the Cottesmore in the glorious days before the First World War – 'This meteor which appeared and passed across the constellation of Meltonian stars'; and all those who crossed the County Wexford banks and Galway walls so brilliantly and well.

Also in 1950 Fores published a pair of highly successful prints of point-to-points, 'A sight to take home and dream about' and 'O to be in England now that April is there'. Undoubtedly Snaffles had painted the original centrepieces for these around 1936 and somehow the pair had luckily come through the war unscathed and were to be his swansong as a print-maker, although 'O to be in England' was issued in 1952 with a different remarque and entitled 'O to be in Ireland now that April is there'. Perhaps now is the right time to try to evaluate Snaffles' contribution to twentieth century British equestrian art with his final print coming from the presses.

Although Snaffles never had any formal education in art or, for that matter, exhibited a painting at the Royal Academy or The Royal Institute, he must now be regarded as one of the leading equestrian artists of the first half of the century along with Sir Alfred Munnings, Lionel Edwards, G.D. Armour and Gilbert Holiday, leaving aside Cecil Aldin whose real forte was probably, in truth, dogs rather than horses, although he was a magnificent painter of horses as well.

If an art historian was asked to mount an exhibition of British equestrian art between the two wars, 1918–1939, and he could select one, and only one, artist to represent each major media, most people would agree the selection would be Alfred Munnings as an oil painter, Lionel Edwards as a watercolourist, Gilbert Holiday as the best handler of pastels and Snaffles as the greatest print-maker. Although – with a few exceptions such as the 1932 series of prints ''Osses and Obstacles' which included 'A National Candidate', and 'The Sparrow Catching sort'; and the 1933/4 pair 'Biggest Walls' and 'Great Banks', – Snaffles' original paintings do not bear direct comparison with Munnings and Edwards, but his prints are certainly as good. He normally needed the caption and the remarque to achieve his full effect but for many people his prints represent twentieth century British equestrian art at its best and perhaps he has, some thirty to forty years after his last print was published, a bigger following now than any other British equestrian artist.

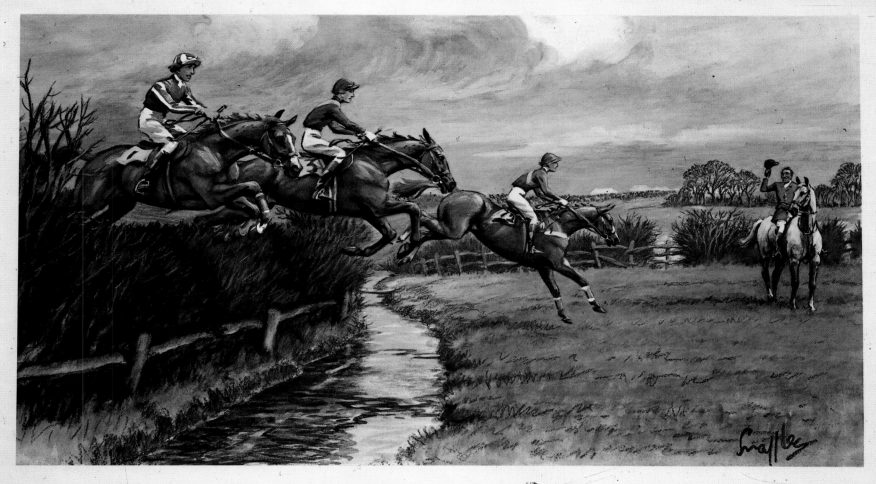

Published by Messrs Fores Ltd. 123 New Bond St. W1

A SIGHT TO TAKE HOME AND DREAM ABOUT —

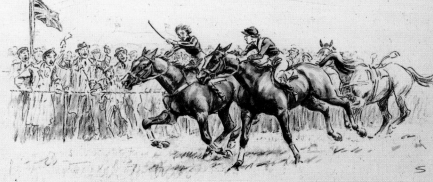

But old JORROCKS would have had it — "They were nasty jealous steeple-chasin' little hussies"

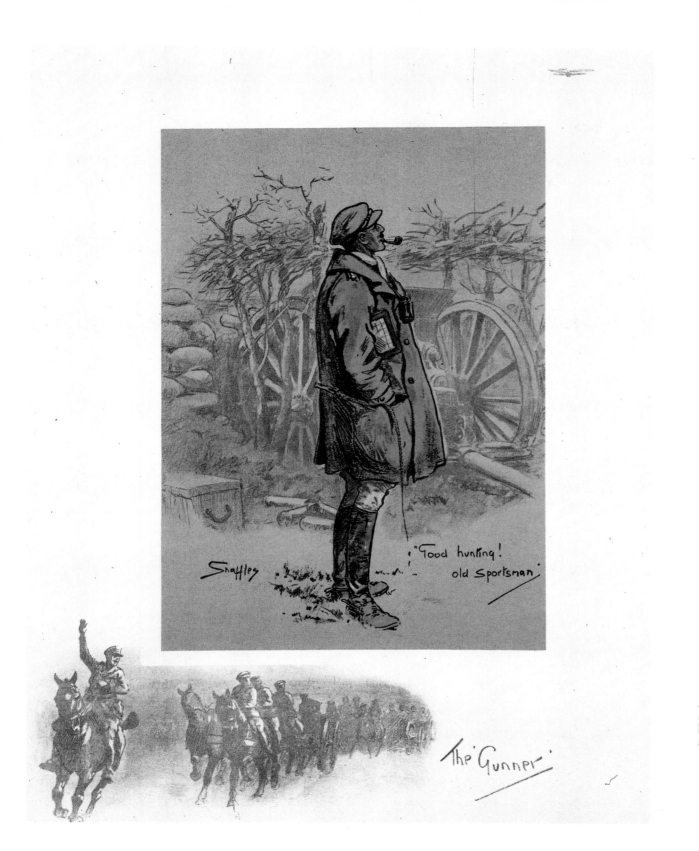

Although first published in 1916 this print has an extraordinary ephemeral quality so that it has become equally sought after by both First and Second World War Gunners.

"lemme go!! I only wanted to kiss the old 'orse!"

An incident, recorded by Snaffles at Ascot in 1934, after Brown
Jack had won his sixth consecutive race.

After the Second World War, there was a new equine hero too – Prince Regent, 'the dream horse', who was another of the National's heroic failures trying to carry 12 stone 5 pounds round Aintree in the mud when he was past his best. He was granted the accolade of appearing in colour as the frontispiece of Snaffles' next book *Four-Legged Friends and Acquaintances* published in 1951. 'Romping over his fences as if they were of no consequence' was the caption he put to it. Snaffles' affection and admiration for those 'long-faced friends' of his who had carried him or whom he had watched in action down the years, never dimmed. Here, besides Prince Regent, was a colour plate of The Doctor with someone remarkably like Colonel Hudson-Kinahan on his back, surmounting a stiff stone-faced bank in the Island country, together with recollections of Sergeant Murphy and Brown Jack and a drawing of Taffy Walwyn clearing a fence in the jumping arena on his well-known show-jumper Stuck Again. Nor had his passion for accuracy deserted him. 'I am saving the original of Daddy on Stuck Again for you', he wrote to

Peter Walwyn. 'Ask him if he has a small snapshot of himself during that period. I will make it more like him.'

Much of the book concerned horses. He dedicated it to those 'long-faced friends', quoting from Somerville and Ross: 'But to stir the soul to a kind of quivering enthusiasm is the peculiar gift of a horse.' At the same time he did not forget the dogs he had owned and loved. Most of these were varminty little terriers, many of them mongrels, all of them imbued with character, courage and affection. 'For me', he wrote in a tailpiece, 'the fields of Paradise would be very lonesome and empty places if I found myself there without a little white dog or two at my heels', and illustrated it with a self-portrait which has been chosen to close the book. No-one loved his dogs better than Snaffles did and no-one knew better than he the desolation the loss of a loved one can cause. The one sketch in the book which is in complete contrast to his usual humorous style shows a terrier writhing in a death agony having been run over by an unheeding and uncaring motorist. Underneath is a cap-

'Skill as Olympia recurs'
'And he gets leave, with luck again'
'Comes Taffy leaping o'er the furze'
'To lead them all on 'Stuck Again.'

(H.M.S)

Just after the war Snaffles executed this
drawing of his patron Taffy Walwyn on the
ex-chaser Stuck Again.

A National Candidate

THE SPARROW-CATCHIN SORT

A HEAD LIKE A LADY——

A FAREWELL LIKE A COOK

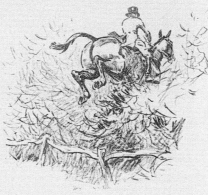

Like 'A National Candidate' this print comes from a 1932 series entitled ' 'Osses and Obstacles' (not to be confused with the book of the same title). They show Snaffles at his very best as a horse artist.

'Brothers and sisters I bid you beware of giving your heart to a dog to tear.'

This is one of the few grim pictures or illustrations Snaffles produced apart
from in wartime.

tion from Kipling: 'Brothers and Sisters I bid you beware of giving your heart
to a dog to tear.'

Over half the book is devoted to dogs, his own and others, and his draw-
ings of them have a charm and softness not seen in any of his other works. His
handling of the chapters, both words and illustrations, on his 'two
sweethearts' Biddy the terrier, ex-Dunsandle, and Vixen, are particularly
touching; and the story of Wong would do justice to Cecil Aldin at his most
amusing. It is easy to see why, some forty or fifty years earlier, Cecil Aldin,
already recognised as a leading sporting artist with a particular affinity for
dogs, should have taken up with Snaffles and advanced him so much in the
pre-First World War days; they must have had much to talk about as regards
horses and sport and also a great common bond in their love of dogs. It is a
pity that more of Snaffles' work on dogs has not survived.

In the early fifties he was approached by his pre-war acquaintance,
Lieutenant-Colonel Mike Ansell, then the driving force behind the British
Horse Society, and Britain's Equestrian Olympic Teams, who asked him for
paintings and he gave him two watercolours of scenes from Surtees which
were made into highly successful Christmas cards in aid of The British Olym-
pic Teams.

Snaffles was now approaching his seventieth year, though there were to be
no further major paintings which would be made into prints, memories
thronged his mind and there was one more book still to come. This was *I've
Heard the Revelly* – Kipling again – which was published in 1953. In it he
once more looked back, searching his photographic memory for incidents
military and sporting; much of it was filled with nostalgia for that past when
there were parade uniforms to set off the swagger, when Horse Gunners wore
'the jacket' with pride and there was 'all the honour and glory that went with
horse soldiering'. The drawing was as firm as ever, humour lurked always in
the background and altogether it was a graceful farewell to almost sixty years
of boot and saddle, spear and spur, and the 'good chaps' he had known all
over the world.

He ceased to drive a car, to the considerable relief of those who used the
roads round Tisbury, for like many of his generation he had no understanding
of and little use for four-wheeled vehicles and was a most erratic driver,
although in his younger days the internal combustion engine, like printing
presses, had a great fascination for him. But he did not, however, entirely
abandon pencil and brush, spending hours beside the Fonthill Lake watching
the birds there, sketching and painting them. He kept up his correspondence

Snaffles was very fond of dogs, especially terriers. It is a pity that so few of his dog drawings survive. Top left is a drawing of Vixen and the other two are of Biddy, an Irish terrier which came from the Blazers Kennels at Dunsandle.

'It was the rain bow gave thee birth
and left thee all her glorious hues'

'THAT BLUE WING'D JUDAS'

(Reynard the Fox).

All these Christmas cards were executed when
Snaffles' eyesight was very poor; nevertheless
they have great charm and were his epitaph as
an artist. They should not be taken as a true
measure of his ability but more the work of a
charming, elderly and ill but gallant, sporting
English gentleman, keeping alive a tradition he
had started fifty or more years before,
producing hand-coloured Christmas cards
until a few days before his death on 30th
December 1967.

THE PATIENT FISHERMAN

'The Blessed Yaffle laughing loud
Foretelling the South-west rain'
(Kingsley)

Xmas 59

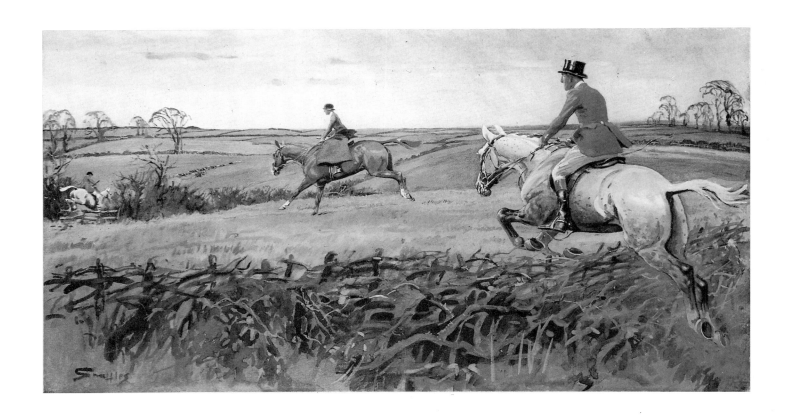

'If there is Paradise on Earth
It is this! It is this!! It is this!!!'

This couplet, inscribed by the Emperor Shah Jahan on the walls of his Hall of
Private Audience in the Mughal Palace at Delhi, is the inspired title of one of
Snaffles' greatest prints. He executed it in 1925 but it represents the three or
four glorious seasons when he lived at Oakham just before the First World War.
The Huntsman on the grey is probably Tom Isaacs who was killed in the Great
War; the scene is as Snaffles would have imagined it, through his rose-tinted
spectacles, without roads or wire cutting into the country.

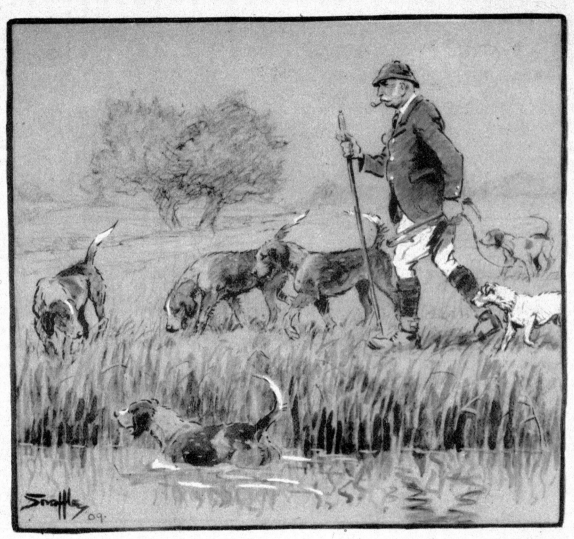

'BLOW ME TIGHT! I NEVER SEES A CHAP ATRUDGIN' ALONG THE RIVER BANK WITH A THICK STICK IN 'IS 'AND AND A PIPE IN HIS MOUTH, BUT I SAYS TO MYSELF, THERE GOES A MAN WELL MOUNTED FOR OTTER 'OUNDS'

Snaffles loved all types of hunting and we have records of him out with beagles, foxhounds, staghounds, otterhounds, and with the military draghounds around Aldershot. Whether he hunted with Cecil Aldin's bassets is unrecorded, but it is probable.

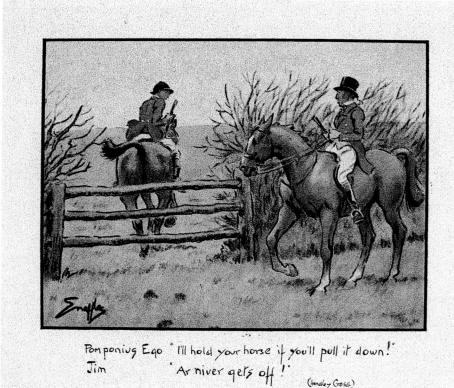

Pomponius Ego "I'll hold your horse if you'll pull it down!"
Jim "Ar niver gets off!"

(Handley Cross.)

"The 'oss loves the 'ound, but I loves both" (Jorrocks)

This pair of Christmas cards was produced by the British Horse Society in
the early 1950s to raise money for the Olympic Fund. When Colonel Ansell
approached Snaffles for suitable paintings to reproduce, the latter indicated
that his best work was by then completed, nevertheless immediately
volunteered a pair of pre-Second World War watercolours for reproduction.

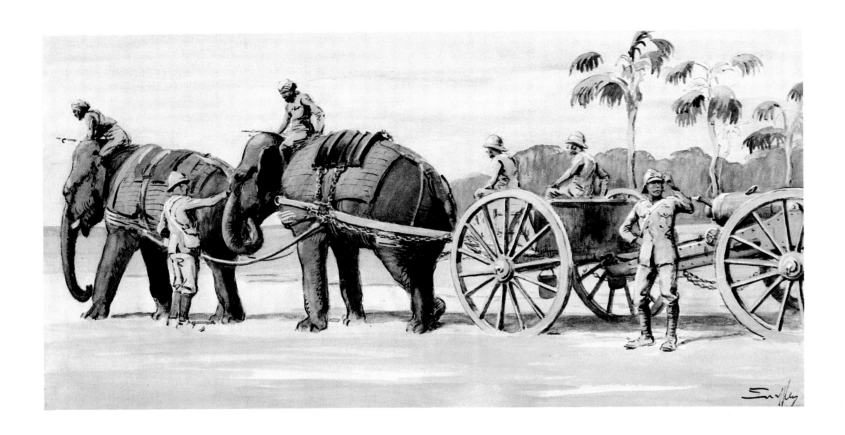

After the Second World War Snaffles produced some interesting watercolours
and drawings of a purely historic nature, mainly of the Gunners in India
between 1850–1900.

'A sheer would cover 'em'

This picture of Grand Military Memories is pure imagination and was
drawn in the late 1940s or early 1950s when Snaffles was looking back to
the great military racing days between the wars. It shows George Paynter
on the leading horse followed by the grey, White Surrey, ridden by Taffy
Walwyn (the same combination can also be seen falling on page 6). The
third person is Bill Bedford on the cast-off Army horse, Pippin, which he
bought from the Army for £8 and on whom he won fourteen out of fifteen
point-to-points. The fourth horse is ridden by Paddy Doyle, already riding
shorter than his contemporaries, just before he became a professional.

too, much of it conducted on the back of cards which he illustrated, and all of it infused with the wry humour that was his hallmark. Of one such, sent to Peter Walwyn and showing a lady sailing out over a point-to-point fence, he wrote: 'This is something like mother so thought you might [like] to have it. It isn't very flattering but I never was much good at drawing the ladies – much as I like 'em.' To another friend, on a Christmas card of the Courtenay Tracy Otterhounds he wrote: 'This is our Lady Master of the Otter dogs. I take damn good care I don't ride in her pocket – S.'

And he maintained his interest in the young, though here his temperament sometimes showed. As a young man, William Chatterton Dickson recalls, you had to 'gauge the wind, to use a nautical expression, and if you got it wrong you got a blast'. Nor was he enamoured of organised religion. Meeting the Chatterton Dicksons returning from church he would ask: 'How many times did you say the Lord's Prayer today?' On hearing that morning service provided for it being said twice, he would snort: 'What do you want to say it twice for? Isn't once enough for you?'

Snaffles felt, too, in those latter years, that he had lost his public, that others had passed him in the race and though amongst moderns he greatly admired Peter Biegel, he had not much use, and he sometimes strongly expressed this, for certain of his contemporaries. None of this detracted from the essential kindliness which lay behind the occasional gruffness. He remained what he always was, a simple, lovable man; he remained too, modest and retiring; he hated being photographed and repudiated all efforts to put him in the public eye. The worst crime in his book was to shout about oneself or one's achievements, 'to brag' using his own word to describe it. To his multitude of friends and acquaintances, and especially the young, he was loyal, supportive and generous. To the very end those signed cards went out, above all at Christmas; many of them still carefully hand-coloured before being despatched. In one, sent in 1960 when he was approaching eighty, he portrayed a hoopoe captioned: 'We were very flattered by the visit of this very rare and beautiful bird in our orchard last spring.' On another card of a jay calling in alarm as a fox slipped away over a wall and ditch below him, he captioned 'The blue-winged Judas', a quotation from Masefield. Though the drawing is rougher and the painting coarser, it demonstrates that the old flair for a scene, a quote and a caption was with him still.

In all he produced seven Christmas cards of birds but the reader must remember that they were all executed after his eyesight was seriously impaired and, although his epitaph as an artist, are in no way a true example of his ability.

The lake and birds were a constant solace to him. He would bring his sketch books down to the lakeside with him, the stub of a pencil always in his ticket pocket, and sit for hours, watching and sketching. And he walked his dogs; in hail, rain or snow, he was out with them every day. In his old age he tried fishing again and was more successful than he had been in his previous attempts on the Slaney in the early thirties, managing to catch the odd trout, but he was becoming frailer with the years. In January 1964 he reached his eightieth birthday, still sketching, still walking, but more slowly now. His love

of the countryside about Tisbury and Fonthill abided, as did his love, admiration and gratitude to Lucy for all she had done for him: he told a friend once that she had saved him from himself and that he owed all to her.

Three years later he was laid up for many months with a heavy cold on his chest. This did not deter him, ill as he was, from colouring his Christmas cards of a running fox and sending them out, with, beneath it, its inscription of Egerton-Warburton's line which indeed summed up much of what he thought about sport and life: 'One fox on foot more diversion will bring than twice twenty thousand cock pheasant on wing.' Five days later, on 30th December 1967, some three weeks before his eighty-fourth birthday, he slipped quietly out of life, just as he would have wished.

Snaffles could quite literally have said, along with his beloved Kipling's Troop Sergeant-Major O'Kelly, that he had 'Heard the Revelly, from Birr to Bareilly, from Leeds to Lahore'. Even if he had not 'ridden in Hell for leather, both Squadrons together that didn't care whether we lived or we died', he had walked tall with those who had done just that, been accepted by them and portrayed them doing it. He had given pleasure to thousands all over the globe; his name lives and will continue to live in his paintings and in the midst of all who love sport and laughter, and in the affectionate memories of all those, young and old, who knew him. His simple and retiring spirit would have asked no more.

'For me the fields of Paradise would be very lonesome and empty places if I found myself there without a little white dog or two at my heels.'

Listed are the majority of the prints Snaffles produced over a period in excess of forty years. Unless otherwise specified the publishers were Fores of Bond Street or Snaffles himself.

The prints are basically listed in chronological order, but for the sake of clarity where possible we have listed them in obvious sets, or by subject matter. We have also, with a view to clarity, listed prints once only, although in many cases they were issued in two, three or four different versions with a wide variety of remarques or vignettes. There was more uniformity after the First World War when the centre colour-piece was printed in considerable numbers by the printing house of Bemrose in Derby, while the remarque boards continued to be printed in small numbers, almost certainly under the supervision of Snaffles, mainly at Gale & Polden in Aldershot. We have noted in our descriptions where similar images appeared in periodicals and it is our opinion that normally an image appeared in a periodical first and was then worked up into a formal print.

By each entry we have noted its number in the catalogue resonné produced by the British Sporting Art Trust to coincide with their exhibition of Snaffles' work in 1981 (**ISBN: 0 9507794 0 7**).

First set of five small prints (1–5)
Various editions, early ones hand-coloured, later ones colour printed

1 Top o' the Season/Morning etc. 1908
Terrierman standing in a gateway with two terriers, raising his cap. The inscription is personalised, i.e. 'Top o' the morning, m'lady/Major/Judge &c.'
8¾ × 6¾ ins. *41*

2 Whatever Ye De, Keep T'owd Tamboureen A-Rowlin' 1908
James Pigg, whip in hand, stands drinking ale. In later editions he has a champagne glass.
11½ × 7½ ins. *36 & 37*

3 Tell Me a Man's a Foxhunter and I Loves 'im at Once 1908
John Jorrocks, M.F.H., sits proudly astride his old horse. Horn in his right hand.
11½ × 12½ ins. *38*

4 I Knows No More Melancholic Ceremony than Takin' the String Out o' One's 'At at the End of the Season 1908
Mr Jorrocks stands, hat in hand, looking forlorn.
11½ × 7½ ins. *35*

5 Ar Never Gets Off 1908
James Pigg leaps a fence head on leaving the field behind.
Many editions.
A variant jumping side on.
12¼ × 9½ ins. *39*

6 Spats and Sporrans c1908
Scenes from a highland tattoo.
8½ × 15½ ins. *Not listed in catalogue*

7 A Point-to-Point 1909
The first fence – slap at it for the honour of hit-'em-an'-hold-'em shire.
In the first edition the horses in the centre are going from right to left. In the other editions (at least five are known up till 1922) they are going from left to right.
Typical vignettes are:
(i) Toss'd about like an old 'at
(ii) Leppin' powder
(iii) The more mud the more glory
(iv) The Wreckers
(v) The Glutton
(vi) Back to the land
(vii) The last fence, tucked up
18 × 26 ins. *25, 26 & 115*

Four Hunting Types (8–11)
Published by Lawrence and Jellicoe. After publication they all appeared in the IS&DN 22.10.10.
Normally printed in colour but there are a few which were hand-coloured. The many editions include some reprinted in the 1980s.

8 Blood and Quality 1910
Lord Ranksborough, riding a thoroughbred, raises his hat.
No background.
15 × 12½ ins. *1*

9 The Gent with 'Osses to Sell 1910
A dealer in a loud check hacking jacket salutes with his crop.
No background.
15 × 12½ ins. *2*

10 Old Tawney 1910
A rotund foxhunter smoking a cigar sits on a quiet cob.
15 × 12½ ins. *3*

11 'Hogany Tops 1910
A first-class foxhunter wearing a black coat mounted on a useful sort.
Later editions have a fox in the background.
15 × 12½ ins. *4*

12 Gee—Gee c1910
George Grossmith, Jnr. the musical comedy actor, poses in loud check breeches, canary yellow waistcoat, resting on his Whangee stick.
No background.
Sometimes a similar print entitled Gee-Gee Junior.
16 × 11 ins. *5*

A large oblong pair (13 & 14) and companion piece (15)
One set is hand-coloured, another printed in Belgium in strong colours.

13 Thrusters 1911
'ustle your 'osses, 'arden your 'earts.
Fourteen members of the field take a hedge from one grass field to another.
12½ × 21½ ins. *6*

14 Roadsters 1911
'ammer 'ammer 'ammer on the 'ard 'igh road.
The field charges along the highroad – children, parson, gigs etc.
12½ × 21½ ins. *7*

15 The Glad Throng that goes Laughin' Along 1913
The Huntsman on foot followed by assorted field.
39½ × 13¼ ins. *49*

A pair (16 & 17)
16 Bang Tails 1911
The back view of a lean follower of the Warwickshire on a thoroughbred.
14½ × 6½ ins. *8*
IS&DN 4.2.11

17 Bob Tails 1911
The back view of a stout gentleman on a cob.
Variations in coat colour and in title.
14½ × 6½ ins. *9a*

Set of eight large hand-coloured hunting scenes (18–25)

18 Not taking any 1911–13

Fair Thruster: 'Come on it's quite
alright.'
Steeplechase Jockey fox catching: 'No
thank you Miss, I don't do that sort of
thing for pleasure.'
Jockey mounted out hunting refuses to
follow lady over large hedge.
18¾ × 20 ins. 21
IS&DN 25.11.11

19 An Irish Yawner 1911–13

Three mounted members of the field
clamber over an Irish bank.
Remarque: Farmer running with stick.
19¾ × 26¾ ins. 42

20 The Bullfinch 1911–13

Black as yer hat on this side and
glorious uncertainty on the other.
One of the hunt staff jumps a difficult
place whilst the field ride up and down
looking for a safer place.
Remarque: Huntsman landing in a
brook.
19¾ × 26¾ ins. 43

21 The Stone Wall 1911–13

Solid and tall was the rasping wall.
On the skyline the stone wall being
jumped, the huntsman and hounds in the
foreground.
Remarque: Fox scrambling over a wall.
19¾ × 26¾ ins. 44a

22 The Stake and Bound 1911–13

Send 'em at it – and get well into the next
field.
The field jumping a stake-and-bound
fence in great style.
Remarque: A fallen horse and rider.
19¾ × 26¾ ins. 45

23 The Whissendine Brook runs deep and wide 1911–13

Two leap the rail and brook beyond.
Remarque: Hounds scramble out of a
brook.
19¾ × 26¾ ins. 46

24 The Oxer 1911–13

Go at it – or go home
Whilst two clear the oxer in fine style, a
third turns to find an easier line.
Remarque: The man on the grey goes
home.
19¾ × 26¾ ins. 47

25 The Stonefaced 'Narrer Back' 1911–13

Two members of the field jumping a
turf-topped stone wall.
Remarque: Farmer on a horse.
19¾ × 26¾ ins. 48

26 The Tiger 1912

Determined jockey winning a
point-to-point.
13 × 13½ ins. *Not listed in catalogue*

27 Tom Isaac 1912

A rum 'un to follow.
The huntsman of the Cottesmore,
mounted on a grey, jumps a double oxer.
17½ × 23½ ins. 14

A true pair (28 & 29).
Both appeared on the same page in the IS&DN 19.10.12

28 The Right Man on the Wrong 'Oss 1912

The wrong horse sticks its toes in on the
edge of a brook.
12¼ × 13¾ ins. 12

29 The Wrong Man on the Right 'Oss 1912

A stout man being run away with by a
handsome brown horse.
12¼ × 13¾ ins. 13

30 High Leicestershire 1913

A lady riding side-saddle jumps a hedge
head on. She wears a violet in her lapel.
16¾ × 14¾ ins. 23

31 Yeomanree Cavalree 1913

You couldn't spot us at 'arf a mile from
the crackest Cavalree.
A group of mounted yeomanry,
dominated by an officer on a grey horse
in foreground, shamble from right to
left.
14 × 16 ins. 55

A classic pair
Both appeared on the same page in the IS&DN 19.10.12

32 The Spooney 1913

Who hunts for the ride out and the ride
home.
An elegant gentleman in top hat and
cutaway pink coat looks at his reflection
in a shop window.
12½ × 12 ins. 18

33 The Sportsman who hunts because he loves it 1913

A top-hatted follower in a red coat waits
patiently at point in terrible weather.
Sometimes wears a black coat.
16½ × 15½ ins. 19

Series of military amateur riders (34–41)
Hand-coloured; very scarce; normally little background.

34 Gay Derg 1911–14

A mounted jockey wins a
point-to-point. The racecourse in the
background.
13 × 13¼ ins. 29

35 The Lancer 1911–14

Jumping a brush fence in a steeplechase.
8 × 8½ ins. 30

36 The Springer 1911–14

Jumping a fence.
8 × 8½ ins. *Not listed in catalogue*

37 Cakes 1911–14

A jockey gallops by on a horse.
7½ × 9 ins. 31

38 Pip Hornby 1911–14

Horse and rider walking along.
8 × 8½ ins. *Not listed in catalogue*

39 George 1911–14

Brigadier General George C. Paynter
galloping by.
7½ × 9 ins. 32
IS&DN 10.4.15

40 Major Junks 1911–14

The Major wins holding his stirrup iron
in his hand.
28 × 33 ins. 33

41 Paddy 1911–14

Paddy Wallace, winner of the
Cottesmore Hunt Race 1914 on Mrs
Jefferson's Huntstown.
 34

42 An Irish Point-to-Point 1911–14

The field jumping a large ditch and
single bank.
Two major versions with many
variations published over an
eighteen-month period.
Typical vignettes:
 (i) Going to the start
 (ii) Jockey stranded in the water
 jump
 (iii) Weighing in
 (iv) Jockey carrying his saddle
 (v) Solitary mounted jockey
 (vi) Fallers
 (vii) Judge holding an umbrella
 (viii) A bookmaker
22 × 29½ ins. 27 & 28
IS&DN 17.5.1913

The Lancer

Snaffles

145

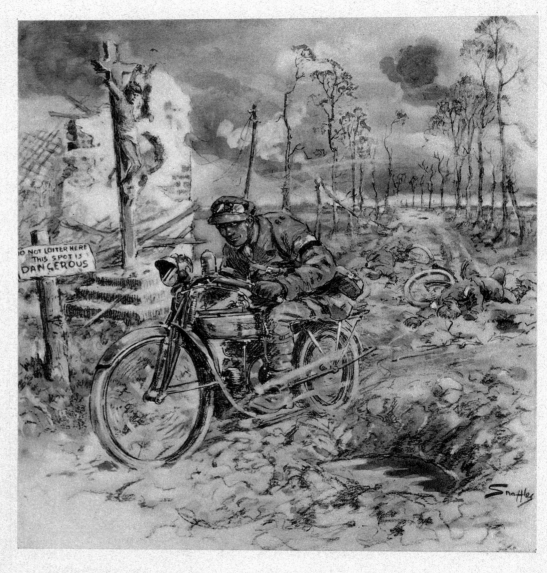

The 'D.R.'

"Remarkable close to the old bus's 'ead to let the stuff go by".

(Rudyard Kipling with the artist's apologies)

Early Polo (43 & 44)

43 Sport in the Shiny 1913

The game of Sahibs and Rajahs.

A game of polo.
Vignettes:
 (i) Stalking
 (ii) Steeplechasing
 (iii) Buying a horse
 (iv) Pigsticking
 (v) Polo
 (vi) Hunting
24⅞ × 26¼ ins. *51*

44 Game of Sahibs and Rajahs 1913

A polo scene.
Vignette: a mounted Indian.
10 × 17½ ins. *Not listed in catalogue*

Early Indian and African Subjects (45–48)

45 Chasing in India 1913

Wearing topees and silks the field take a fence. The leader has fallen and a riderless horse is in third place.
15 × 20 ins. approx. *52*

46 The Ikonas c1913

I don't know whose darn column I'm in, nor where we're trekking, nor why. (R.K.)

A trooper on a coloured horse, pipe in mouth, the rest of the column silhouetted in the background.
16½ × 15¼ ins. *53*

47 On Trek c1913

Across the veldt two soldiers ride their ponies with rifles in the saddle holsters.
Remarque: Antelope's head and an ox cart.
17 × 24 ins. approx. *54*

48 The Coast c1913

Two Nigerian bearers carry a litter in which lies an Englishman.
15¾ × 24¾ ins. *56*

49 Elegant but a flier c1914

A lady mounted side-saddle on fine grey blood hunter jumps a fence left to right.
17 × 17 ins. *24*
IS&DN 19.10.1918

50 A Bruiser 1914

Top-hatted follower in cutaway red coat tightens his girth.
17¾ × 15¾ ins. *17*
IS&DN 21.2.14

51 The Sojer Hosifer 1914

Nasty steeplechasing beggar.

A rider in a point-to-point jumps a hedge and open ditch.
Also appears as 'The Soldier'.
13¾ × 13½ ins. *15 & 16*
IS&DN 28.2.14

First World War period as special artist in France (52–79)

52 The D.R. 1915

Remarkable close to the old bus's 'ead to let the stuff go by. (Rudyard Kipling with the artist's apologies).

A despatch rider on a motor cycle drives past the dead and a wayside shrine.
Remarque: The rider falling off.
19½ × 17¼ ins. *58*

53 Wipers 1915

A wounded soldier stands in front of the burnt Cloth Hall of Ypres, a German 'pickelhaube' impaled on his bayonet.
Remarque: The dead lying in the mud. Some minor variations in the ruins.
17¼ × 13¼ ins. *57*
IS&DN 29.5.15

54 A Heilan Lad 1915–1917

A kilted Scottish officer stands ready in trenches with his troops.
Remarques:
 (i) Throwing a grenade
 (ii) Playing the pipes
 (iii) A group of marching soldiers
17¼ × 13¼ ins. *66*

55 The 93rd 1915–17

A Highland officer.
Remarque: A soldier creeps along on his elbows.
17¼ × 13¼ ins. *67*

56 Le 75 1915–17

French artillerymen fire their 75 – the standard French field gun.
Remarque: An observer sits in the branches of a tree.
17¼ × 13¼ ins. *63*

57 Sans Panache 1915–17

French Cavalry 1914.

An unshaven horseless Cavalryman walks past ruins.
Remarques:
 (i) A trumpeter
 (ii) A galloping horse

 (iii) Riding in the peaceful woods of the Vosges
17¼ × 13¼ ins. *59*

58 Le Poilu 1915–17

A wounded French Infantryman. ('Poilu' is French slang for a soldier.)
Remarques: Four sketches of French soldiers, and one study of two soldiers charging.
17¼ × 13¼ ins. *60*

59 That Far, Far Away Echo 1914–15 1915–17

In the trenches a soldier remembers hunting days, in a dream sequence.
Remarque: A horse with its head over the stable door.
17 × 24 ins. approx. *83*

60 Jock (K.I.) 1915–17

A kilted Infantryman stands amongst ruins cleaning his rifle.
Remarque: Two prisoners of war.
17¼ × 13¼ ins. *65*

61 Jock 1915–17

A kilted sergeant lights his pipe.
Little background. Versions exist with different tartans.
Remarque: A solitary piper.
17¼ × 13½ ins. *64a*
IS&DN 5.6.15

62 The Camerons 1915–17

A kilted officer.
Remarque: A charging soldier.
14½ × 10½ ins. *64c*

63 Bon Voyage 1915–17

An English Gunner about to load.
Remarque: Team of six horses and gun.
17¼ × 16¾ ins. *61*

64 Bon Voyage 1915

A French Artilleryman holds a shell.
Remarque: Team of six horses and gun.
17¼ × 16¾ ins. *62*

65 The Bonnie Blue Bonnets frae ower the Border c1915

A single piper leads wounded troops.
Little background.
Remarques:
 (i) A soldier in the trench aims his rifle
 (ii) A soldier wielding his shovel
17 × 14 ins. *69*

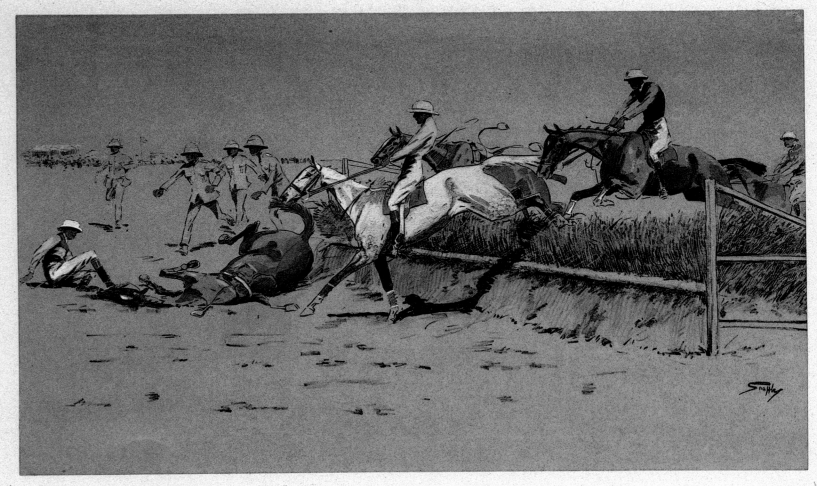

Chasing in India

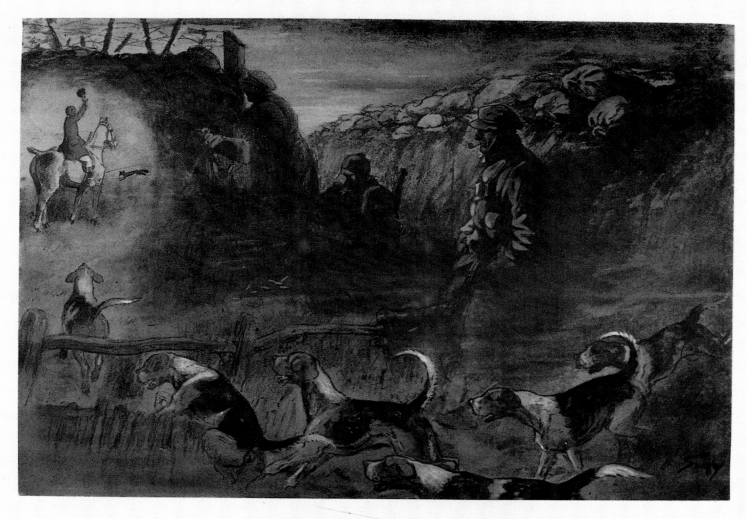

1915 - 16.
"That far, far-away Echo.

66 Vimy c1915

An officer leads an advance from the trenches, other troops in the background.
Remarques:
 (i) Dead and dying soldiers
 (ii) A maple leaf
10¾ × 8¾ ins. 71

67 The Hairy 1915

There lay the driver's brother with 'is 'ead between 'is 'eels.

Two of a gun team with heads in nosebags, a trooper standing by.
Remarque: A trooper leaving a dead horse.
17 × 16½ ins. 81

68 Blighty 1916

and only five and twenty per cent of the danger.

An officer out hunting jumps a fence to land in front of an irate Master hunting hounds.
Two versions 1916 and 1918.
20¾ × 17¾ ins. 85
IS&DN 12.1.18

69 The Gunner 1916

Good Hunting! Old Sportsman.
The Gunner looks up at a passing 'plane.
Remarques:
 (i) Fighter plane
 (ii) Column of guns led by officer on a charger arrive at the gallop
Slightly different versions.
17½ × 9¾ ins. 75
IS&DN 15.1.16

70 That Far, Far Away Echo 1915–1916 c1916

Similar to No 59 except fox is shown in addition to huntsman and hounds.
17 × 24 ins. approx. 84

71 Hit! c1916

A soldier lies wounded in the wire.
Remarque: Carried off on a stretcher.
17¼ × 13¼ ins. 86
IS&DN 28.10.16

72 The Bonnie Blue Bonnets frae ower the Border c1916

Two pipers lead wounded troops through the ruins of a village.
Remarques:
 (i) A soldier in the trench aims his rifle
 (ii) A soldier wielding his shovel

 (iii) A soldier standing wrapped up against the cold
17¼ × 16¾ ins. approx. 68

73 Gunners c1916

There lay the driver's brother with 'is 'ead between 'is 'eels. (R.K.)

A team of six heavy horses and three drivers wait to limber up. One driver examines a horse's hoof.
Remarque: A team drives past a dead horse.
13¾ × 22½ ins. 78

74 The Heavies c1916

Do you say that you sweat with the field guns, by God you must lather with us. (R.K.)

A large number of gunners on foot haul a heavy gun through a wood.
Remarque: A team of horses pulling a gun.
22 × 29 ins. 80
The Graphic 11.12.15

75 Anzac c1916

An Australian in the trenches of the Dardanelles throws a grenade.
Remarque: A hatless Australian charging.
17¼ × 13¼ ins. 72

76 The Canadian c1916

A wounded soldier charges through the wire.
Remarques:
 (i) Lying on the ground, a soldier aims his rifle
 (ii) Head of a soldier
17¼ × 13¼ ins. 70

77 Indian Cavalry (B.E.F.) c1916

Yi-hai!
A Cavalryman tent pegging.
Remarques:
 (i) On a horse he holds a lance aloft
 (ii) The head of an Indian
 (iii) Another Indian
 (iv) Indian with a spade and full pack
 (v) Indian sitting sharpening his lance
15½ × 18½ ins. 73

78 Faugh-a-Ballagh c1917

There were lads from Galway, Louth and Neath, who went to their death with a joke on their teeth. (R.K.)

A major hand to hand battle in the trenches.
Remarque: Surrendering Germans. ('Faugh-a-ballagh' means literally 'clear the way'.)
19 × 19 ins. approx. 74

79 The Guns! Thank God! The Guns! c1917

Ubique means that warnin' grunt the perished linesman knows,
When o'er 'is strung an' sufferin' front the shrapnel sprays 'is foes.
An' as their firin' dies away the 'usky whisper runs
From lips that haven't drunk all day –
The Guns! Thank God! The Guns!
(R.K.)

Along a track in a wood gun teams charge past a group of wounded soldiers. Different versions and remarques.
Remarque: Medium gun and team pulling up.
19 ×27½ ins. 79a
IS&DN 10.4.15

First World War Royal Naval Air Service and Royal Navy (80–88)

80 The Sea Hawk c1917

The Scilly's can say what our road was –
The Hinder she saw where we passed (with the artist's acknowledgement to Rudyard Kipling).

A seaplane tracking a submarine which in turn is tracking a trawler.
Remarque: A crashed German seaplane.
21½ × 27½ ins. 88

81 Gentlemen Unafraid c1917

Sailors in the bows of a fishing boat aim their machine gun at a submarine.
Remarques:
 (i) The Captain speaking from the bridge with a megaphone
 (ii) Trawlers fishing
18 × 26 ins. 90

82 T.B.Ds c1917

Captain on the bridge shouting aft through a megaphone.
Remarque: Fleet moving to the right.
18 × 26 ins. approx. 94

83 Punchin' Through It 1918–20

Looking aft from the foredeck of a small ship.
Remarque: A fleet of ships.
20⅜ × 16⅞ ins. 168

84 Who Whoop! c1918

A kill in the open.

A destroyer knocking out a submarine.
Remarque: A fox being accounted for.
18 × 25½ ins. *89*
IS&DN 2.8.19

85 R.N.R.T. 1919

An old sailor, in blue uniform smoking a
pipe, stands on the bridge of a trawler.
Remarques: .
 (i) Three heads of fisherman
 (ii) Two trawlers
18 × 15 ins. *Not listed in catalogue*

86 Watching the Sweep R.N.R.T. c1919

A fisherman in a duffle coat watches
from the deck of a snow-covered trawler.
Remarques:
 (i) Trawlers
 (ii) Engineer 'Tynesider'
 (iii) A Shetlander 'Muckle Flugga'
 (iv) A Fisherman 'Grimsby'
 (v) The head of the captain
 (vi) The mate
10½ × 21½ ins. *91*

87 R.N.R.T.s c1919

The captain and mate lean over the side
of the bridge.
Remarques:
 (i) The look-out in the crow's nest
 (ii) A trawler
12 × 18 ins. approx. *92*

88 T.B.D. Shepherding a convoy c1919

A sketch from the monkey's island of a
destroyer. The beef convoy. An oilskin
clad captain shouts above the storm
through a megaphone.
Remarques:
 (i) Captain at voice pipe
 (ii) Convoy sailing to the left, one of
 which has dazzle camouflage
15 × 24 ins. approx. *93*

Two multi-plate sets (89 & 90)

89 Landing his wager c1918

Huntsman negotiating a fence, with a
fall.
Four plates:
 (i) Ten to one ar coomsdown
 (ii) A Hundred to one ar
coomsdown
 (iii) Ar am down
 (iv) Owever ar won me bet
Another version featuring only three
plates and a grey horse missing (ii).
Each plate 9 × 10½ ins. *95*

90 A Fire Eater 1919

A heavyweight negotiating a post and
rail.
Three plates mounted together.
 (i) Pull that rail out, m'lad
 (ii) Now the next
 (iii) Look out! Damme I'll get over or
 under it
Remarque: He takes refreshment from
his flask.
11¼ × 33¼ ins. *96*

91 Swagger c1919

but a workman.

Pink-coated follower jumps an oxer.
Many editions over 5–10 year period
with different remarques.
Remarque: Elegantly sitting on a horse.
100

92 Jim 1920

Whatever 'e de keep t'owd tamboureen a
rowlin'.

Whipper-in gives a holloa against a
background of fields.
Remarque: Huntsman crashes through
a fence.
15½ × 16¾ ins. *98*

93 Ubique Meant 1920

Bank, 'Olborn Bank – a penny all the
way. (R.K.)

A gun team in the tropical sun.
Remarque: A gun carriage and team
with palm trees in the distance.
20 × 30 ins. *77*

94 Tally-Ho Back c1920

One of the hunt hacks home, pipe in
mouth, daydreaming.
In the field a ghostly artillery team
passes.
Remarque: Horses in the lines.
16 × 20¾ ins. *86a*

95 The Bender c1920

The rider sits vainly pulling to stop the
horse.
Sometimes inscribed 'The Nut'.
16½ × 19 ins. *102 & 103*

96 The Huntsman c1920

The 'oss loves the 'ounds but I loves both.
The huntsman counts the pack around
him.
Remarque: Huntsman blowing 'away'.
Two different versions 1920 and 1923 –
the latter more common.

Many variations in remarque.
17¼ × 16¼ ins. *113*
IS&DN 20.10.23

The most famous pair (97 & 98)

97 The Finest View in Europe 1921

The picture is presented as if the viewer
is mounted on a grey horse which is just
approaching a superb cut-and-laid
fence. In front is the huntsman and a
pack of foxhounds running hard across
a Leicestershire hunting field.
Remarque: A fence-layer raises his hand
as a holloa.
Many different versions over a ten-year
period.
18½ × 29 ins. *104*
IS&DN 27.11.20

98 The Worst View in Europe c1922

Oh Murther! The dhrink died out of me
and the wrong side of Bechers. Arthur
Nightingall on the winner of the 1901
Grand National approaches Bechers in
the most unhappy circumstances with a
loose grey horse just in front of him and
with a horse having a terrible fall at the
fence.
Remarque: A First Aid man holds up a
flag over a fallen rider whilst a
policeman, facing the viewer, holds a
horse.
Two main versions of the centrepiece
and various versions of the remarque.
16 × 26 ins. *105 & 106*

99 Soldiers 1922

Nasty steeplechasin' devils.

In a point-to-point two runners jump a
hedge close together.
Remarque: Remounting the far side of a
stake and bound.
16¼ × 23¼ ins. *107*
IS&DN 22.4.22

100 The Gent in Ratcatcher 1922

I have my man cleaning my 'osses not my
breeches.

A foxhunter sits pensively on his horse
smoking his pipe.
Two major versions. Different horse and
different background.
Remarque: Groom brushing his horse.
16¼ × 14½ ins. *114*
IS&DN 25.2.22

'I have my man cleaning my 'osses.

nor my breeches.

SOLDIERS.

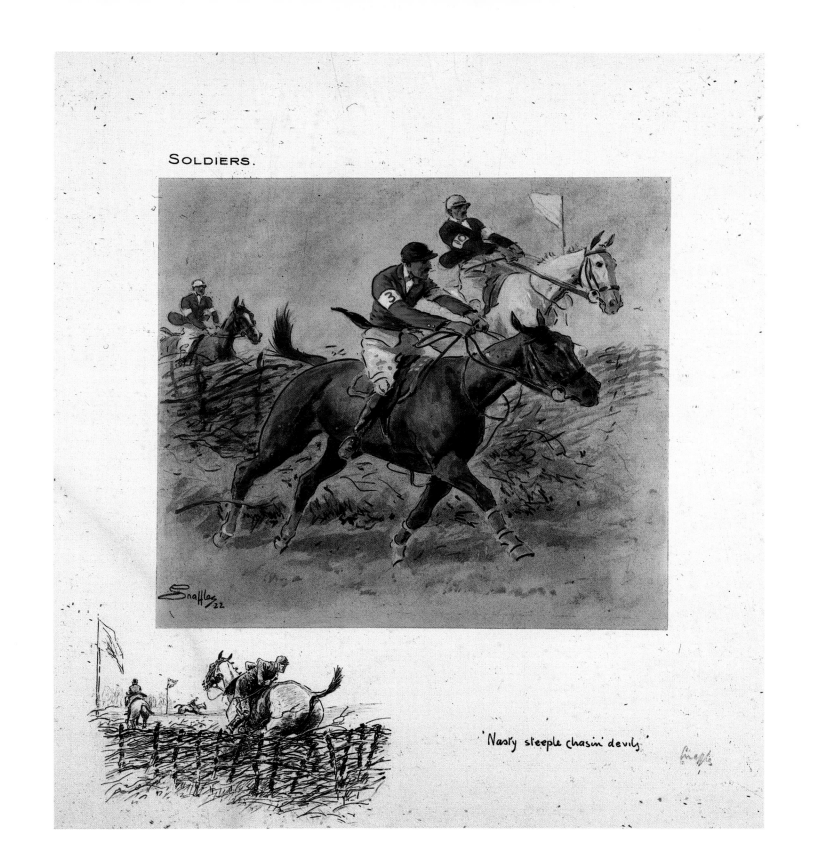

'Nasty steeple chasin' devils'

153

101 Tonnage 1922

And when hounds really run, can show how sixteen stone should o'er a country go.

Back view of cob and stout rider disappearing through a hedge.
Remarque: Farmer inspects a damaged fence.
16½ × 14½ ins. *101*
IS&DN 10.12.21

102 A Little Fizzer 1922

Riding a grey side-saddle, she jumps a hedge and ditch.
Earlier version published without vignette and with a larger image.
16½ × 15 ins. *22*
IS&DN 7.3.14

103 Foxcatchers c1923

For the love of it –
For the ride out and the ride home.

A top-hatted follower in a red coat waits patiently at point overlooking flooded marshland.
Remarque: An elegant gentleman looks at his reflection in a shop window.
N.B. This print is a rework into one print of 'The Spooney' (No. 32) and 'The Sportsman' (No. 33)
15½ × 14½ ins. *112*

104 John Jorrocks, Esq. M.F.H. c1923

Tell me a man's a Fox'unter and I loves 'im at once.

Jorrocks in all his magnificence sits on his horse, jacket unbuttoned, at a cross road to Handley Cross.
Remarque: Fox leaving covert.
15½ × 16¾ ins. *99*

105 Seagulls c1924

A flying boat above the fleet.
Remarque: A flying boat on the water.
21½ × 27½ ins. *87*

106 Prepare to receive Cavalry c1924

Four members of a point-to-point field jump a hedge and the Arborfield Ditch. Two fall.
Remarques:
 (i) The Starter. 'Are you ready'
 (ii) Starter and the departing field, 'Go and heaven be with you'
19¾ × 27¼ ins. *108*

107 Handing it out to 'em c1924

A bowler-hatted young woman (now Nora Pearson) clears a post and rail in front of the field.
Remarque: A young lady clears a stone wall.
18½ × 19½ ins. *110*
IS&DN 23.2.29

108 A Bona-Fide Fox Chaser c1925

A scarlet-coated rider dismounts from the winner at a point-to-point.
Remarques:
 (i) Falling at the water jump
 (ii) Taking his hat off as hounds pass
9¼ × 17¼ ins. *111*

109 The one to carry your half crown c1926

A young lady point-to-point rider in parade ring.
Remarque: A horse jumping a fence (coloured).
21¼ × 17¾ ins. *117*

110 If there is a paradise on earth c1926

It is this! It is this!! It is this!!!

The hounds in full cry followed by the Huntsman and two of the field.
Remarque: Two members of the hunt going home.
18 × 26½ ins. *143*

111 Happy are they who hunt for their own pleasure 1926

and not to astonish others.

The field following the hounds in full cry (unseen), while elderly and stout members go slowly through a gateway.
Remarque: Horse and rider have a crashing fall over large timber.
20½ × 31 ins. *118*

112 The Staff College Drag 1927

Hold 'em back Rammer.

The Master jumps a fence with the field pressing close on his heels.
Remarques:
 (i) Tom Newman in a trap
 (ii) 'Yo' over, The Master 1926–27' (Lord Norrie)
 (iii) 'Jack with the smell'
 (iv) 'That'll larn 'em'. A farmer stands by a stoutly reconstructed fence
 (v) 'Tiny' hacking his way through
 (vi) 'The Arborfield Brook – asking the Government hairies the question'
 (vii) The Pilot 1925/26
21½ × 29½ ins. *119*

113 The Grand National 1927

The Canal Turn – A memory to the Old Sergeant and Geoffrey Bennett.

The Canal Turn, second time round in a race won by Jack Horner in 1926. Capt. G.N. 'Tuppy' Bennett, a vet and the leading amateur jockey, rode 'Sergeant Murphy' to victory in 1923. He died as a result of a fall later in the same year.
Remarque: A leaping horse in colour.
21¾ × 33¾ ins. *116*
IS&DN 14.3.27

114 Merry England 1927

and worth a guinea a minute (*or* and worth a lakh a minute).

A hunt member gallops on in the rain followed in the distance by a young lady.
Remarque: A fox jumping a full dyke. Different remarque in later versions showing an officer resting his leg on the arm of a chair in the Indian heat.
17¼ × 15¾ ins. *120*
IS&DN 8.10.27

115 Sandown 1928

The last fence at Sandown in a Military Steeplechase. Almost certainly a composite.
Remarque: The Empty Plate – a riderless horse.
20½ × 26½ ins. *146*

Set of Twelve

116 Sporting Anecdotes for the Twelve Months of the Year 1928

January: I will do it.
February: You, 'air dresser on the chestnut 'oss, pray 'old 'ard. Hairdresser: I'm an Officer in the 91st Regiment. 'Then you hossifer in the 91st Regiment wot looks like an 'airdresser – 'old 'ard.'
March: 'Oh my vig, vot a vind. Almost blows the 'orn itself.'
April: 'Confound all Farmers say I wot aren't flattered by 'avin' their fields ridden over.'
May: 'I knows no more melancholic ceremony than takin' the string out of one's 'at at the end of the season.'
June: 'Whoever said winter is the season of our discontent is no sportsman – summer is the season of our misery.'

July: 'Dreadful thought – where's the
 Brandy.'
August: 'The buyer has need of a
 hundred eyes – the seller of but
 one.'
September: 'Dash it, wot a mornin' it is,
 wot many delicious
 moments one loses in bed.
 Dash my vig, if I won't get up
 at five every morning as long
 as I live.'
October: 'Hooray! Blister my kidneys.
 It is a frost! – The dahlias are
 dead.'
November: 'Dear, Delightful
 November – the plisantest
 month in all the year.'
December: 'Tell me a man's a foxhunter
 an' I loves 'im at once.'
Published by the IS&DN 1928 and
offered to sale in hog grained leather
case for £1.
6½ × 8¾ ins. *121–132*
IS&DN: 7.1.28.

India (117–127)

117 The Finest View in Asia c1928
Pigsticking; a rider's view of the running
pig. The horse was Carclew and the
hand is that of Major Scott-Cockburn.
Remarques:
 (i) 'Steady Chaps' – give him some
 rope
 (ii) 'One of 'em out of it'
 (iii) 'Ride'
18½ × 25¾ ins. *148*
IS&DN 21.4.28

118 The Wet Nalla 1928
What providence sends he takes in his
stride.
Pigsticking; a horse and rider plunge
head first into a river while another
follows the boar up the far bank.
Remarque: Horse and rider leaping into
the river.
17 × 25 ins. *149*

119 Pig
There's many a slip 'tween the cup and
the pig.
Three wildly chase the pig.
Remarque: A rider falls.
16 × 24 ins. approx. *156*

120 You're bacon to a vast o' Folk and Sportsman
 to a few c1928
A pig charging.
Remarque: A pig in a sty.
17 × 25 ins. *157*

A set of four pigsticking prints (121–124)

121 The Forward Heat 1930
Three spears wait expectantly by the
side of the river waiting to see if it will be
their opportunity to go. Captain Head,
Captain Catto and Brigadier Scott-Cockburn.
Remarque: The boar leaving a thicket
above which the rider's head and
shoulders and horse's head are visible.
17 × 25½ ins. *151*

122 The Wet Nalla 1930
A spear jumps down into a wet nalla in
fine style – leaning back in the saddle.
Remarque: Similar to the centre piece.
17 × 25½ ins. *150*

123 Getting cantankerous 1930
The pig turns on one of the spears.
Remarque: Pig going between the rider's legs.
17 × 25½ ins. *152*

124 Got yer you old Badmash! 1930
A spear accounts for the pig.
Remarque: A dismounted spear
refreshes himself from an Indian water
carrier.
17 × 25½ ins. *153*

125 The Kadir Bandobast 1930
The field mainly mounted on elephants
watches the proceedings of a Kadir Cup.
Remarque: Pigstickers having problems
with a jinking pig.
18½ × 28 ins. *154*
IS&DN 30.3.29

126 The Panee 1930
Major R.F. Ruttledge, 1st Whip of the
Peshawar Vale, jumping the Arsala Khan.
Remarques:
 (i) 'The jumping powder' – Indians
 sitting in a group
 (ii) Riding into the river
19 × 28½ ins. *159*

127 The Peshawar Vale 1932
The gent in the black coat, 'Begad! that
would stop them Meath fellers.'
Galloping across the plains and over the
Jabkinndda Drain after jackal.

Remarques:
 (i) The Meet
 (ii) The Finish
13½ × 30 ins. *160*

Modern Polo (128)

128 Carpet Beaters V. Bobbery Wallahs 1930
Central picture of polo with
multi-coloured vignettes also of polo.
 (i) & (ii) Look out I've got it
 (iii) Rattled
 (iv) Between chukkars
 (v) Get out of it Umpire
 (vi) Through! Whoo-op
 (vii) Forrard, forrard, forr'd
 (viii) A donnybrook along the boards
 (ix) A clean and clever one
19¾ × 29¾ ins. *158*

129 R.A. Harriers 1931
Major C.J.P. Layard and his hounds in
full cry across the Wiltshire downs.
Remarque: Hold 'ard you qualifiers.
Dammit! give 'em a chance.
20 × 26½ ins. *135*

Set of horses (130–134)
Published under the title 'Osses and Obstacles

130 The Timber Merchant 1932
Aye! and owt in the stonemason line
does not come amiss to 'im.
The Huntsman jumps a timber fence to
be with hounds.
Remarque: Huntsman jumping a stone
wall.
18½ × 17 ins. approx. *138*

131 'Andsome is – wot 'andsome does 1932
A dedicated foxhunter on an aged tubed
horse.
Remarque: The horse jumps a wide
brook.
18½ × 17 ins. *139*

132 A National Candidate 1932
By Goom – Canna that owd chestnut
'oss jump.
Jockey and horse in parade ring.
Remarque: Jumping a fence in the lead.
18½ × 17 ins. *137*

133 The Sparrow Catching Sort 1932
A head like a lady – a farewell like a
cook.
Top-hatted, pink-coated follower on fine
heavyweight hunter gallops on.
Remarque: Disappearing through a hedge.
18½ × 17 ins. *136*

THE WET NALLA

'What Providence sends he takes in his stride'

THE FORWARD HEAT

" ? "

134 The Pig-Esticker 1932

A groom attends a grey under a mango tree. The spears rests against the tree.
Remarque: A riderless horse jumps a nalla still chasing the pig.
18½ × 17 ins. *155*

Ireland (135–140)
The great pair (135 & 136)

135 The Biggest Walls in the Counthry was in it c1933

and heaven help them as had to be building them up afther us (Somerville & Ross).

The East Galway Hunt in full cry over a fabulous piece of stone wall country.
Remarque: A top-hatted follower lowers a wall by kicking it down whilst still mounted.
20 × 27 ins. *134*
IS&DN 28.2.31

136 Great Banks there was below in the Fields c1934

Edith Somerville and Martin Ross.

A composite picture painted by Snaffles as a companion piece to The Biggest Walls to show a fine hunt over a bank country.
Remarques:
 (i) A farm labourer, 'Here ye are Meejor – send him along at it'
 (ii) The same Irishman fishes the horse out of the hidden dyke
 (iii) Returns the horse to its owner
18½ × 27 ins. *133*

137 The Informers c1934

Two donkeys prick up their ears as a fox trots by.
Remarque: In the moonlight a fox climbs a stone wall to view a distant farm yard.
17½ × 22 ins. *140*

138 I would bring such fishes back (Kingsley) c1934

The River Slaney with a bridge over which are crossing a horse and cart.
Remarque: A fisherman and ghillie.
20½ × 21¼ ins. *141*

139 The Stone Faceder c1934

Huntsman, on the famous horse The Doctor, jumps a bank followed by one of the field.
Remarque: A fox.
19½ × 16¾ ins. *109*

140 The Varmint Little Lady c1935

On a wiry little 'oss.

A lady riding astride tightens her girth as a fox steals away from a gorse covert.
Remarque: Jumping a dyke.
19¾ × 35 ins. approx. *142*

Later India and Africa (141–145)

141 The Boundary 1937/39

General Sir Peter St. Clair Ford and the Somali Camel Corps riding across the desert.
18¾ × 24¾ ins. *147*

Pair of big game prints (142 & 143)

142 Mister Stripes 1937/39

A tiger stealing through the undergrowth.
Sometimes entitled 'Shere Khan'.
Remarque: A running deer.
21¼ × 18¾ ins. *161*

143 The Dacoit 1937/39

A leopard crouched on a rock in moonlight.
Also entitled 'The Bagheera'.
Remarque: Native boy with goats.
21¾ × 19¾ ins. *163b*

144 Zam-Zammah 1937/39

and the little man himself.

Kim, of the book 'Kim', sitting on a cannon.
13 × 10 ins. *162*

145 Smoking my pipe on the mountings, sniffin' the mornin' cool, I walks in my old brown gaiters along o' my old brown mule (R.K.) 1937/39

A dismounted British Gunner officer climbing the mountains with a dismantled gun on mules.
Remarque: The screw gun going down the mountain.
19¾ × 19¾ ins. *164*

Second World War (146–151)

146 The Season 39–40 1940

The hunt passes two parked 4/7th tanks, the soldier salutes, the huntsman takes off his cap.
Remarque: An officer jumping a hedge well up with hounds.
19½ × 28¼ ins. *165*

147 Pass Friend 1940

A fox passes Charlie White of the Home Guard.
9¾ × 14½ ins. *166*
Punch 6.11.40

148 Blimy! Wot a Life c1940

West of Gib, and north across the bay.
A storm looking forrard from amidships.
Remarque: A destroyer in a storm.
19¾ × 25 ins. *167*

149 Enjoying Yerselves aren't yer c1940

A ploughman resting his team of two horses watches planes dog fighting.
Remarques:
 (i) Ploughing
 (ii) Dog fight
Various captions.
24½ × 30 ins. *170*

150 Ubique Means – (R.K.) 1941

A soldier stands cold and bored in front of a shore battery at Dover.
10½ × 10 ins. *76*
Punch: 24.1.40

151 Forrard on me Lads and hit 'em – 'ard 1942

A farmer, returning home with his horses, waves to a squadron of passing bombers.
Remarque: Huntsman and hounds.
19½ × 23½ ins. *171*
Punch 27.8.41

152 One upon a Time c1943

Sitting by a Vickers light No 6 tank, Brigadier Scott-Cockburn and his driver dream of pigsticking, steeplechasing, polo and hunting.
18 × 24 ins. *172*

Post War (153–155)

153 Oh! To Be in England 1950

now that April's there (Robert Browning).

Jockeys mounting in a point-to-point parade ring.
Remarque: The race over the water jump.
20½ × 26¾ ins. *145*

154 A Sight to take Home and dream about 1950

Three lady point-to-pointers clear a fence and brook.
Remarque: Riding a close finish. 'But old Jorrocks would have had it they were nasty jealous steeple-chasin' little hussies'.
20 × 26 ins. *144*

155 Oh! To be in Ireland now that April's there 1952

As No 153 with different title and a remarque showing jockey jumping a fence from left to right.
20½ × 26¾ ins. *173*

Appendix B

For nearly forty years Snaffles was a regular contributor to various magazines and annuals including *The Graphic*, *The Illustrated Sporting and Dramatic News*, *The Tatler*, *Punch* and *The Hoghunters' Annual*, starting in 1907 and continuing until well into the Second World War.

He also contributed illustrations to various books such as *In My Opinion*, edited by W.E. Lyon and published in 1928 by Constable which included a colour reproduction of his great painting The Grand National 1925 'Evens on the field at Valentine's the second time round', and contributed black and white illustrations, together with Major M.H. Tulloch, to *The P.V.H.* by Captain G.S. Hurst, MFH, which was published circa 1935 by Gale & Polden; while Cecil Aldin chose to use as the colour frontispiece of his superb memoirs *Time I Was Dead*, Snaffles' watercolour of him at a point-to-point published in 1934 by Eyre & Spottiswoode.

Snaffles was also responsible for all the illustrations in the books listed below:

1928 Geoffrey Brooke's *Horse Lovers* published by Constable
1930 *My Sketchbook in the Shiny* written and illustrated by Snaffles and published by Gale & Polden.
1933 M.J. Farrell's *Red Letter Days* published by Collins.
1935 *'Osses and Obstacles* written and illustrated by Snaffles and published by Collins.
1936 *More Bandobast* written and illustrated by Snaffles and published by Collins.
1947 J.K. Stanford's *Mixed Bagmen* published by Herbert Jenkins.
1949 *A Half Century of Memories* written and illustrated by Snaffles and published by Collins.
1951 *Four Legged Friends and Acquaintances* written and illustrated by Snaffles and published by Collins.
1953 *I've heard the Revelly* written and illustrated by Snaffles and published by Gale & Polden.

Modern Reproductions

In the 1980s Mark Flower, of the Court Gallery, Bond Street, London, started to reproduce Snaffles' prints in high quality limited editions, with facsimile printed signatures instead of the original pencil signatures.
Obviously these prints are unlikely to have the same value as the original editions, but as they sell for less than a quarter of the price they give the chance for many people to own a Snaffles.

The following are currently available or will soon be so;